The DAM Book

Digital Asset Management for Photographers

The DAM Book
Digital Asset Management for Photographers

 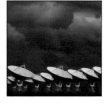

Peter Krogh

O'REILLY®

BEIJING • CAMBRIDGE • FARNHAM • KÖLN • PARIS • SEBASTOPOL • TAIPEI • TOKYO

The DAM Book: Digital Asset Management for Photographers

by Peter Krogh

Published by O'Reilly Media, Inc., 1005 Gravenstein Highway North, Sebastopol, CA 95472.

O'Reilly books may be purchased for educational, business, or sales promotional use. Online editions are also available for most titles (*safari.oreilly.com*). For more information, contact our corporate/institutional sales department: 800-998-9938 or *corporate@oreilly.com*.

Print History:	**Editor:**	Colleen Wheeler
November 2005: First Edition.	**Production Editor:**	Darren Kelly
	Cover Designer:	Michael Kohnke
	Interior Designer:	David Futato

RepKover.™ This book uses RepKover™, a durable and flexible lay-flat binding.

0-596-10018-3
[C]

This book is dedicated to my family.

To Alyson, my wife and best friend, and to my daughters Josie and Maddy.
Thanks for your love, support, and fine entertainment.

Contents

Introduction

Although I am a photographer by trade, I am also a photographer by avocation. After I have finished a workday shooting pictures, there is nothing I would like to do more than... shoot more pictures. Because of this, I have amassed a huge collection of photographs (more than 135,000 digital images in the last three years alone) that have a very high value to me, both personally and professionally.

Digital photography has brought a creative freedom that has rekindled the love of making pictures in nearly every photographer I know. Digital cameras, with their possibilities for limitless shooting, immediate feedback, image creation constrained only by your imagination, and gorgeous archival desktop printing, are wondrous tools for those of us who love to make photographic images.

But in addition to new possibilities, digital photography has presented a whole new set of challenges, accompanied by a strange new lexicon: digital workflow, metadata, digital asset management, color management, IPTC, EXIF, XMP, JBOD, DNG.... All of us must now walk ground that only the geekiest used to tread.

A professional digital photographer has terabytes of image data to store and manage, and before long many avid amateur photographers find themselves with photo libraries comprising hundreds of gigabytes. Even if you shoot JPEGs rather than RAW images and have a less daunting amount of data to manage, you may still need to store, sort, and retrieve thousands or even tens of thousands of images. And, unlike your film and print archive, your digital images can be lost in the blink of an eye.

So, how do you manage all these photographs? How do you put stuff away so that you can find it when you want it? How do you organize it? How do you protect it against loss?

This book answers these questions, for the serious amateur photographer, for the editorial photographer, and for the busy commercial studio. It outlines the underlying principles of rock-solid file storage and demonstrates the effective use of proven *digital asset management (DAM)* techniques. It

addresses management issues both for the short term and for the long term, and offers specific information on how to implement a DAM system.

Of great interest to many of you will be the changes in the Photoshop workflow that arrived with Photoshop CS2. The powerful new tools included in Photoshop offer photographers unprecedented abilities to prepare images for inclusion in a permanent archive, and to do so with great efficiency. But figuring out how to best combine these tools, and in what order to use them, can be an arduous process. Since I worked closely with the engineers at Adobe in designing and testing these tools, I can swiftly guide you through their use.

Of course, there are many ways to do things, and with digital photography it seems that few people do things exactly the same way. There *are* solid underlying principles, however, and attention to these, and to their ramifications down the road, will help narrow the acceptable options. As I discuss each of the various components of safe and efficient digital asset management, I will also present underlying issues that inform the entire DAM system.

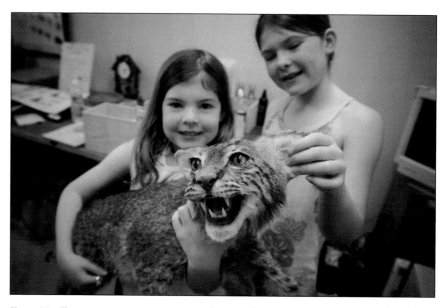

Figure I-1. There are some pictures you want to keep forever. **Keywords:** Josie, Maddy, Vacation, State Park, Bobcat, Kitty

Who Is This Book Written For?

This book is written for people who are serious about their photographs. This includes the professional photographer who has a great financial interest in the integrity of his photography archive, as well as the serious amateur photographer who places a great personal value on his pictures.

Each of these photographers is interested in greater productivity, and in the longevity of his images.

The techniques described here were specifically developed for the challenges presented by digital photography—particularly the large number of images created with similar names. While much of this workflow will also be useful to anyone managing a large collection of scanned images, it is particularly geared toward those who shoot digital, who shoot RAW, and who shoot a lot.

My Assumptions About You

I have written this book for the serious photographer. Consequently, I assume that the reader will be very familiar with the operation of a digital camera, and with the operation of Photoshop. This book is intended to address one particular subject: the integration of sound digital asset management techniques into a streamlined workflow. I do not discuss general Photoshop techniques, photography techniques, color management, or computer maintenance techniques. There are many other fine books about these subjects.

The approach described in this book is not for the casual photographer. It requires, at minimum, access to Photoshop CS2, which is an expensive, professional-level software application. I assume that you are also willing to buy DAM software, which is generally nowhere near as expensive as Photoshop, but isn't free either. I also assume that you will be willing to acquire the hardware necessary to store your photographs safely and efficiently.

Most of all, I hope that you will be willing to make the effort necessary to understand sound digital asset management techniques and to implement a strong DAM system. Once you understand the concepts that are described here, working with your digital photographs will be simpler, more straightforward, and more secure than you can probably imagine now, but it will take some work to get there. You will need to let go of a number of established practices and preconceptions, and that can be a harder process than you might think.

> ——— N O T E ———
>
> *As you implement the practices and theories described in this book, you will need to be familiar with a number of technical issues that are not described here, having to do with the basic operation of your camera, of Photoshop, and of your computer. You should know the differences between various file formats and should be familiar with the other terminology used in digital imaging.*

Contents of This Book

This book is divided into nine chapters, covering a system for digital asset management that leverages Photoshop CS2 and Adobe Bridge. Here's a basic rundown of what the chapters are about:

Chapter 1, What Is All This DAM Stuff?
> In this chapter, I'll give you a general sense of what the practice of digital asset management means for photographers. We'll go over some broad outlines of the system, look at the types of software products used in effective DAM solutions, and discuss why you actually need to think about all this. I will also explain the DNG format and how you can use it as the basis of an integrated collection.

Chapter 2, Metadata

> This data about data—or, in our case, information about images—is one of the most valuable tools in your DAM system. In this chapter, we'll go over the different types of metadata; discuss the application of ratings, keywords, and groups; and consider critical aspects of metadata storage.

Chapter 3, Creating the Digital Archive, Part I: The Information Structure

> In this first of two chapters that discuss the actual "building" of your digital archive, we'll go over the way files are organized in your DAM system. We'll compare and contrast digital and film archives, examine how to design a consistent information structure, and discuss the use of "buckets" for storing images efficiently.

Chapter 4, Creating the Digital Archive, Part II: Hardware Configurations

> In this chapter, we'll discuss the hardware (computer system) you need to house your digital archive. We'll start with a view of my current system, consider a range of system possibilities based on need and budget, and discuss how to build an archive that is efficient now and scalable for the future.

Chapter 5, Setting Up Bridge

> This chapter provides an introduction to the new "helm" of Adobe's Creative Suite, Bridge. The proper configuration of this application is critical to an integrated DAM system. Here, we'll go over what exactly Bridge does and doesn't do, how to set up Bridge's preferences, and how to use some of Bridge's powerful tools and menus.

Chapter 6, The Editing Workflow

> In this chapter, we'll go over the specific workflow in Bridge. Following a checklist I use in my own work, we'll discuss the specific steps in each phase of the editing workflow, from acquiring images, to preparing them in Bridge, to creating the DNG files.

Chapter 7, Using Cataloging Software

> In this chapter, we'll discuss the use of cataloging software in a DAM system. I'll pass along my own advice for how to evaluate cataloging software, provide some orientation to the DAM interface, and use my current preferred program—iView MediaPro—to demonstrate how it works in some case-study scenarios.

Chapter 8, Derivative Files

> This chapter considers the different types of files you may have to create for various tasks, from archiving RAW files to creating proper delivery files. We'll consider the different conversion options, discuss how to choose the proper file formats for each need, and go over cataloging strategies.

Chapter 9, Strategies for Successful File Migration

Once you have created your DAM system, how do you move images from the "old days" into your new digital world? In this chapter, we'll discuss the migration of files from film to digital, from RAW to DNG, and from one storage medium to another.

Conventions Used in This Book

This book was written by a Mac user, but PC users shouldn't be confused because most menu commands in Photoshop are identical regardless of your platform. (When keyboard commands are used in the text, PC users should substitute Ctrl for Command and Alt for Option.) Menu commands discussed in this book are separated by the → symbol; for instance, when we're discussing Bridge, View→Sort→By Filename means click on the View menu, choose Sort from the drop-down menu, and then choose By Filename.

Plain text is used for menu titles, menu options, menu buttons, and keyboard accelerators (such as Alt and Ctrl).

Italic is used for new terms, URLs, email addresses, filenames, file extensions, and pathnames.

Keywords are included in the captions of many of the images that appear in the book. I put these here to encourage you to think about the kind of information that can be useful to store with your images when you file them away. (Note that these are not comprehensive lists of all applicable keywords for these images.)

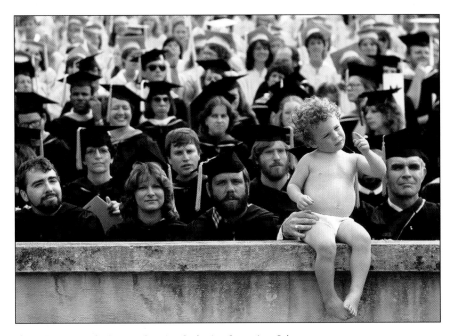

Figure I-2. **Keywords:** Curiosity, Question, Graduation, Generations, Baby

Comments and Questions

I have created a web site for this book that will provide a resource for downloads, updates, and other kinds of links. It can be found at *http://www.theDAMbook.com*. I've also set up a forum there for the exchange of ideas. You can contact me there, or through email at *peter@theDAMbook.com*, but please bear in mind that I will generally not be able to answer specific questions about workflow issues that you face.

You may also choose to contact the publisher:
O'Reilly Media, Inc.
1005 Gravenstein Highway North
Sebastopol, CA 95472
(800) 998-9938 (in the United States or Canada)

Errata, examples, and additional information will be listed at:
http://www.oreilly.com/catalog/dambk

For more information about books, conferences, Resource Centers, and the O'Reilly Network, see the O'Reilly web site at:
http://www.oreilly.com

Acknowledgments

This book would not have been possible without the full support of my family: Alyson, Josie, and Maddy. Thanks, girls. I am also grateful for the tenacious support of my friend and mentor Steve Uzzell, who has believed in this project all along and has provided invaluable advice and assistance for 25 years. I also need to thank Darren Higgins for keeping the wheels of Peter Krogh Photography turning as I was busy writing this book, and for his valuable contributions to the development of my workflow.

I would like to extend special thanks to Russell Brown and John Nack of Adobe, who bring fine wit and intellect to the arduous process of software development and evangelism. It's been a joy and a privilege to work with them.

My editor at O'Reilly, Colleen Wheeler, is smart and insightful, and her contributions have been instrumental in organizing the subject matter covered in this book. My friend and technical editor Michael Stewart also brought much-needed clarity to this project, and I thank him for his perseverance. I'd also like to thank everyone else at O'Reilly who helped bring this book to fruition, especially Steve Weiss for recognizing and believing in the project.

Lastly, I would like to tip my hat to my own personal beta testers and advisors—Thad, Sam, Irene, Prakash, and Richard—for their help in creating the system presented here, and for helping me to hone the language. To this list, I would also like to add the Adobe Alpha and Beta testers, and the contributors to D1scussion, OpenRAW, APA Digital, and Photodigital, who are truly pushing the frontier of digital photography.

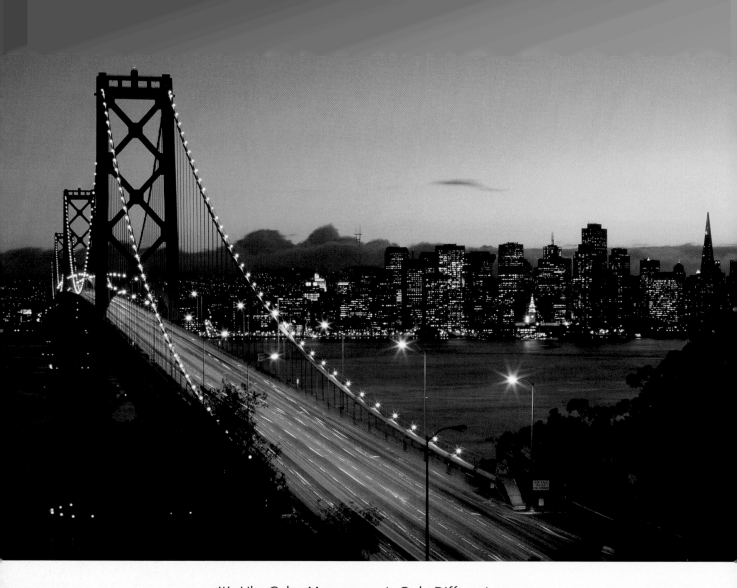

What Is All This DAM Stuff?

1

When I first heard about digital asset management (DAM), my reaction was similar to when I first heard about color management—I could see why the end product would be valuable, but the road to get there seemed incomprehensible. There was a jargon that sounded like English, but I'd never really heard those words strung together in that way. There was also hardware and software to be cobbled together, and it looked like it would be pretty expensive and brain-bending to do this correctly.

Eventually, as I got more familiar with the concepts, and as the tools got better, my impression of color management changed from "It's an inscrutable mystery" to "It works very well most of the time." And so it can be with digital asset management: the tools have finally come of age, and the concepts you need to familiarize yourself with are right here in this book. There's even a pretty well-defined recipe here for taking images from the camera to, well, the grave and beyond.

NOTE

Even if you have not yet mastered color management, you still need to work on digital asset management. Ensuring the integrity and survival of your image files—along with an efficient workflow—should be the first order of business for the digital photographer.

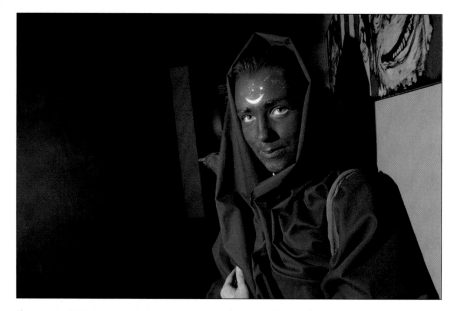

Figure 1-1. Digital asset management is no longer an inscrutable mystery. **Keywords:** Halloween, Haunted House, Blue Witch, Witchcraft, Woman, Mystery

It's Like Color Management, Only Different

The analogy between color management and digital asset management can be taken further. For example, one of the hardest parts of learning color management for me was figuring out what things to let go of. Certain practices, like "just making my monitor match my printer," seemed intuitive, and they seemed to work just fine. Fortunately, I was soon instructed that this was a shortsighted strategy—my images needed to be sent to other people's computers, and the settings might not match. I needed to start conforming to universal standards for images. If you are a professional, it's imperative that your images take advantage of these standards. Even if you are not a professional, it's likely that your images will also end up on other people's computers, and integrated DAM will help everyone keep track of the pictures.

It was also pointed out to me that settings that worked well in my existing closed-loop system might not be good settings for my future equipment. By adopting universal best practices, I could maximize the value—both personal and artistic—of the work I do with my image files. (In fact, it turned out that the un-color-managed images I created back then are of significantly less value to me now. The color on some of those files is nearly unusable.)

If you are using poor asset management techniques, you may find at some point in the future that your images are a thoroughly disorganized mess. Worse yet, you may find that many of them are lost. It's time to do something about that.

Help Is Here

Adobe Bridge, Camera Raw 3, the new IPTC tools, the Digital Negative (DNG) file format, and cataloging software can bring to integrated digital asset management the same coherence that ICC workflow brought to color management. DAM can become something that is not yet totally automatic, but no longer requires a PhD in computer science. As a matter of fact, a photographer can use these tools to make digital photography much more productive than film-based photography ever could be.

This chapter provides an overview of the entire DAM system, to try to get you thinking big. In later chapters, we'll examine the nuts and bolts of building, operating, and upgrading an integrated DAM computer system.

Do I Really Have to Do That?

There will undoubtedly be practices or theories presented in this book that will make you say to yourself, "Oh, darn. It would take me a lot of work to change from what I'm currently doing to Peter's system." I strongly suggest that you make a note of this caution, set it aside for the moment, and keep on reading.

If your goal is the construction and maintenance of a long-term photographic archive, you are probably going to have to make at least *some* changes to how you do things. It may turn out that it's best to make a clean break from your current practices. Once you have the entire new workflow settled, you can then bring your older material in line with the new way of doing things. With that in mind, let's get started.

What Is Digital Asset Management?

The term "digital asset management" refers to the protocol for downloading, renaming, backing up, rating, grouping, archiving, optimizing, maintaining, thinning, and exporting files. It covers a lot of ground.

In the world of digital photography specifically, DAM refers to the entire process that occurs after the taking of the picture, through final output, and on to permanent storage. You may not realize it, but if you are shooting or scanning digital photographs, you are practicing some form of digital asset management. The question is, are you using your time and resources wisely?

Your DAM system is fundamental to the way your images are known, both to you and to everyone else. Can you find your pictures when you need them, or are they sitting unseen on a hard drive or in a file cabinet? Are you able to easily assign and track important content data? Do your photos carry your copyright and contact information, or are they floating around the marketplace with no controls whatsoever? Among other things, DAM practice defines the way in which your pictures are brought to the world.

There are a number of principles that should apply to any DAM system that you implement, regardless of which software and hardware you use. If you understand these principles, you can create a system that will grow with you, and let you get the most from your photographs. Ultimately, a DAM system should be designed for speed and efficiency, as well as longevity. In this book, I'll present just such a system.

An Overview of the DAM System

A sound DAM system comprises several interrelated components. These include a naming and filing protocol, a storage medium (including backup), organizational tools, and editing and output tools. The integration of these subsystems enables a comprehensive approach to sorting and working with your collection of images as a whole. Think "Omniscient Puppetmaster"— you know where everything is, and you can control it from a single place (Figure 1-2).

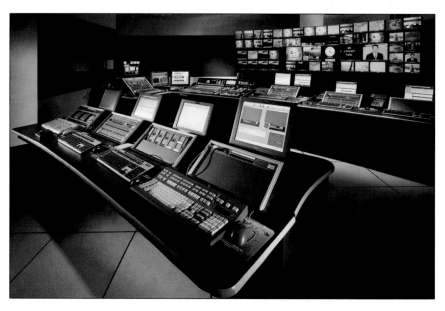

Figure 1-2. You no longer need a dedicated control center to manage even terabytes of images.
Keywords: NOC, Network Operating Center, Network Operations Center, Television Production, Control Room

Perhaps the most useful feature of sound DAM practice is that it enables you to make better use of the work that you already do anyway. Inevitably, you are doing some kind of sorting and some kind of evaluation of the quality of your photos. In this book, you'll see how you can use a set of tools to make that work go faster, and also save that work to reference in the future. By implementing an integrated workflow, you will be better able to leverage your work, reduce inefficiencies, and gain full value from everything you do to your pictures.

Rules of Sound Digital Asset Management

Some of you will adopt the exact nuts and bolts of my system wholesale; for others, it will be important to adjust the system to reflect your different needs. In any case, there *are* fundamental principles at work that everyone can take advantage of:

Systematize

One of the most common mistakes that photographers make when building digital archives is the use of a hodgepodge of DAM practices. Of course, your system will change over time, as you get smarter about digital technology, as your tools change, and as your collection grows. It's

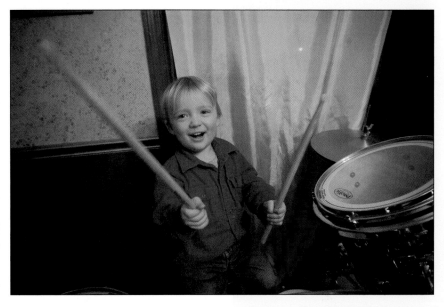

Figure 1-3. **Keywords:** Sounds, Music, Drums, Play, Gus, Joy, Child

important, however, to bring work done under older protocols in line with your new techniques. If you leave lots of work organized in different ways, you won't be able to leverage its value fully, and you risk being unable to ensure its integrity over time. My system will provide an excellent framework for the systematization of your DAM.

Don't rely on your memory

Humans have a wonderful ability both to remember and to forget. For example, although my kids are now only 10 and 11, it seems long ago that they were infants. At that time, I felt like I would never forget the details of their early daily lives. Only a few years later, all those details are now a fuzzy half-memory.

I have had photographers tell me that they don't need a DAM system because they can remember everything: the entire contents of their collections, where all the pictures are stored, and what each version was created for. Realistically, though, not only are you unlikely to be able to remember *all* of the details (especially as your practice changes over time), but if you try to do so you will be missing out on many of the benefits that a catalog-driven DAM system offers.

The content information that is collected about photographs in a DAM catalog can be useful for many things, and to many people. It can help you efficiently find photos when you want them. It can help your clients conform to their licenses, and it can help to automate the marketing and distribution of images. It can also help family, friends, or business associates locate and identify pictures if you're not around to help.

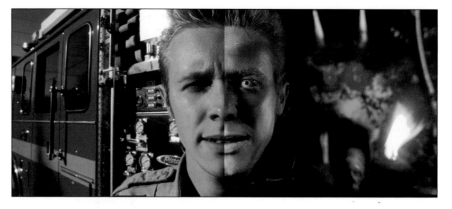

Figure 1-4. Sometimes the whole is greater than the sum of its parts: images can be more valuable if they are part of a collection. **Keywords:** Halloween, Fireman, Haunted Trail, Alter Ego, Secret Life

Be comprehensive

The more universal your cataloging structures and practices are, the more value and efficiency you can get from your images. (DAM systems have a particular ability to add value to a collection as a whole.) Consistency of organization enables faster and more reliable searching of your collection, and collecting together related images maximizes the value of each individual image. A collection of visionary landscapes, for instance, has a greater value than an equally visionary collection of images that do not share a subject or any stylistic elements.

Build for the future

The most obvious ramifications of this principle have to do with storage, longevity, and scalability. Computers have been around long enough now that the challenges related to storage media are pretty well known. We *know* that we will have to migrate our files eventually, and that storage media can fail. We also can see that the amount of storage we will need will grow exponentially over time. It's important that a system be able to grow orders of magnitude larger without having to be completely restructured.

Do it once...

Here's where DAM can actually start aiding productivity immediately. It starts when you rate the files for quality and annotate them for content. By enabling you to quickly narrow down your search results to just the best and most appropriate images, it immediately streamlines the image preparation workflow.

Every time you identify characteristics of your images—from quality, to content, to usage—you add value. If you use integrated DAM tools to do this organizational work, you can save and reuse the valuable information that you have recorded.

Think of times that you have sorted images for one reason or another. Once you re-sort those images, all of your prior sorting work is lost.

DAM cataloging software, however, lets you sort into virtual sets, so that you can save a nearly infinite number of groupings of images. By using these virtual sets, you save search time and add value to your entire collection.

But don't overdo it

Once you see the control that good management gives you over your collection, you might find yourself going "DAM happy." You need to strike a balance between what's useful, and what's a waste of time. Noting who is in a photo is very useful; labeling each image "looking right" "looking center" or "looking left" is probably overkill. The methodology I present starts with the tasks that offer the highest return for your work, and gradually works down through less cost-effective tasks.

Figure 1-5 shows an overview of a DAM system. It might look daunting, but we'll cover each of the elements in this book.

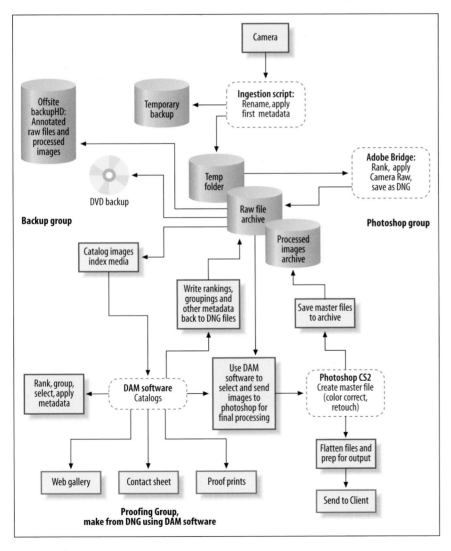

Figure 1-5. The DAM flowchart. (Hey, this is the simplified version. And if you had to make a flowchart of what you did for film and print handling, it would probably be just as complicated.)

Understanding Digital Asset Management Software

DAM software helps you sort, track, back up, convert, and archive your photographs. Its function is to store, view, control, and manipulate all the information you have collected about your photos, as well as the photos themselves.

Figure 1-6. You have to get this digital stuff into your head. **Keywords:** Digital, Cyber, Virtual, Software, Programmer, Tech-head

Digital Asset Management Terminology

There are two primary types of DAM software: browsers and cataloging software. A *browser* reads information from a file but does not store it separately. *Cataloging software* stores information in its own separate file (bear in mind, however, that the software, and the catalog document it makes, are distinct from the photos themselves).

Over the life of your collection, you may end up using several different DAM applications, either sequentially or concurrently. For example, you might use Adobe Bridge to do initial sorting of your photos, but do your main, permanent cataloging in iView MediaPro, Canto Cumulus, or an enterprise-level application such as Telescope. And some years down the line, you may switch to another software package entirely to administer your catalog. It's important to remember that it is the information about your photographs, not the software you use or the catalog document itself, that is of real value.

NOTE

Throughout this book, I will be writing about both cataloging software and browsing software. I will use the term "cataloging software" whenever I am specifically referring to a program that makes a visible, namable, transferable catalog. I will use the term "browser" to refer to any DAM software that does not make a catalog, but rather indexes files on the fly. Whenever I use the terms "DAM software" or "DAM application," I am referring to both types of software.

Browsers versus cataloging software

At first, a browser and a cataloging application look similar. Each one can display multiple files, sort according to multiple criteria, and send off the files to be worked on. But behind the scenes, there is an important difference. A browser extracts data from the files on a more or less "real-time" basis and builds its utility around this information. (Figure 1-7 (left) shows a typical browser screen from Adobe Bridge. DAM cataloging software, however, keeps a permanent catalog of information about the images, including thumbnails. You can see a screenshot of one of my catalogs in Figure 1-7 (right).)

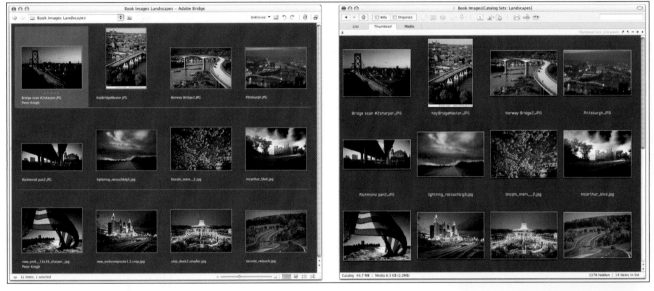

Figure 1-7. At first glance, there doesn't seem to be much difference between a browser (such as Bridge, on the left) and a catalog application (such as iView MediaPro, on the right).

Why is this difference between browser and cataloging applications important? The differences between the application types don't really become apparent until you have a large number of files to work with. Because cataloging software keeps the extracted information in a database, it has several important advantages over a browser:

It's DAM faster

One thing cataloging software can do better than a browser is to return search results much faster. Because cataloging software keeps all the organizational information in a database document, it only needs to do a local search to find, for instance, all images with "Josie" written in the keywords. A browser may have to look through the keywords of 100,000 files stored on several different drives to return the same results. And if the software is structured to continually update the search results, it will be constantly reindexing this information.

It allows you to have virtual sets

More important, however, is the ability of good cataloging software to create and keep *virtual sets*. Virtual sets are like folders that you keep images in, except that they all point to the same original file. This enables you to include an image as part of multiple sets without having to copy the file multiple times—for instance, the same file can live in the *Vacation* group, the *Grand Canyon* group, the *Pictures of Josie* group, the *Stock Photos* group, and the *Mom's Favorites* group.

The best of the cataloging applications will also let you organize your groups into groups (see Figure 1-8), so that, for example, within the *Personal Work* group is a subset called *Projects*, and within that is the *Bindlestiff Family Cirkus* group. This set of images can, in turn, be organized into *Everything*, *Select*, and *Web Page* groups. I call this organization *nested virtual sets*, and I think it's essential to good organization of your image files.

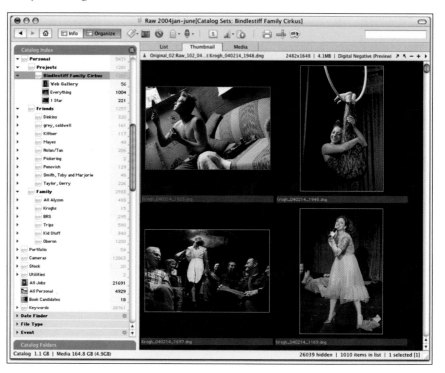

Figure 1-8. On the left side of this window, you see something that looks like a directory structure. These are not actual folders, but rather virtual sets. These can be used to keep track of images in many different ways.

It knows where stuff is supposed to be

Another critical advantage of cataloging software is that it knows where files are supposed to be, so it can assist you in keeping track of images that may have been erased, renamed, or moved accidentally. A cataloging application will be able to tell you that an image is missing and should be found or restored from your backup, while a browser will

simply omit the file. Cataloging software therefore helps you to truly *manage* your files.

It allows faster backup of important sorting work

Cataloging software has a further advantage: it allows you to back up your valuable sorting work quickly and thoroughly. Because the cataloging application stores all the information in one place, it is easy to back up your work after every sorting session. If you are using a browser to do the sorting work, you will need to write a sorting term—a *keyword*—back into the original files themselves. You may then have a bunch of widely distributed files that you need to back up, if you want to be sure that you are saving this work. This adds quite a bit of time and complexity to the process of saving your work, compared to simply saving the catalog document. (Of course, as we'll discuss later, good cataloging software also enables you to write that sorting work back into the actual files when you want to.)

It allows you to work with offline images

Finally, cataloging software can work with offline image files, such as images at a different location, or photos that are on disks that are not currently connected to your computer. This offline capability lets you, for instance, copy your catalog to your laptop and take it with you on a trip, in order to either work on it or show it to other people.

If I am traveling and expect to have some downtime in airports along the way, I often use this opportunity to catch up on my image organization without having to bring the actual files with me. The ability to work with offline images also lets me "spin down" several of my hard drives—particularly those with older work on them—and still be able to see the images in my catalog. This saves energy and increases the hard drives' lifespans.

Cataloging software has a lot going for it, but don't take this to mean that a browser is not valuable. The Bridge browser, particularly coupled with the new Camera Raw in CS2, is a powerful tool for the initial rating, bulk metadata entry, and image correction that should be done with any RAW files. Bridge is also helpful for finding images if the search will be confined to a small and known directory subset.

Adobe Bridge

Now that Adobe has integrated a multiple-file Camera Raw workflow with robust tagging and sorting capabilities in Bridge, the choice of a browser has effectively been narrowed to one. All of the workflow described herein will assume that you will be using Bridge as your image browser. Your choice of cataloging software is a little broader, depending on your specific needs. I'll first outline the functions that you want DAM applications to perform. In Chapter 7, we'll examine how to evaluate various software offerings.

You Might Be Wondering...
Which Is Cataloging Software, and Which Is a Browser?

Here are a few lists to help you get your head around the difference between an image browser and cataloging software.

The following are browsers:

- Bridge
- Photomechanic
- Fotostation 4.5

And the following are cataloging applications:

- Canto Cumulus
- Extensis Portfolio
- iView Media Pro
- iMatch
- ACDSee
- Fotostation Pro5
- idImager

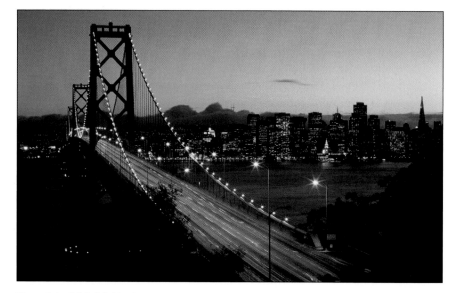

Figure 1-9. Adobe's Bridge is a great way to move your images into a permanent archive. **Keywords:** Landscape, Jobs, Oakland Bay Bridge, Traffic, San Francisco, Sunset

Photoshop CS and DAM Apps: What We Have Here Is a Failure to Communicate

If you have worked on RAW files in Photoshop CS and then tried to see that work in your cataloging application, you have probably experienced a communication breakdown. The browser in CS is an excellent application to sort images in, principally because it gives you a speedy, accurate, reasonably high-res preview to work with. When you try to access that work in another program, however, you find that nothing can read and make use of the work that CS does to RAW files.

This is because CS stores this work in the XMP sidecar files (or in its centralized cache), which no other applications can read. The missing element is a vector for the transfer of that information. Now that the editing tools in CS2 are even more powerful, a smooth interchange of data is critically important. As we will see later in this chapter, the DNG file format provides a vector that an increasing number of programs can both read and write to.

Communication between DAM applications

If you are using two or more DAM tools concurrently, it's critical that they be able to "talk" to each other—that is, that the work you do in one be fully usable by the other. Because the capabilities of the software are ever-changing, the only way to tell if two applications will play nicely with each other is to test them. Make changes to file information in one application, and see if they are visible in the other. In some cases neither application will be able to see the other's changes, in some cases the changes will be visible one direction but not the other, and in some cases both applications will be able to see each other's changes.

In this book, I use the DNG format (which we'll discuss in the next section) to enable work done in Bridge to be visible to other DAM applications. This is a key to RAW file workflow.

Benefits of the DNG Format and Digital Asset Management of RAW Files

If you are a RAW file photographer, you've probably encountered a number of DAM frustrations when working with your images. As a matter of fact, it is my belief that prior to the development of the DNG format, there was no truly sound way to work on and archive RAW files for permanent storage. Adobe's DNG file format has changed the way RAW files are handled, promising universal access to images and the information you create about them. Let's take a look at this revolutionary development.

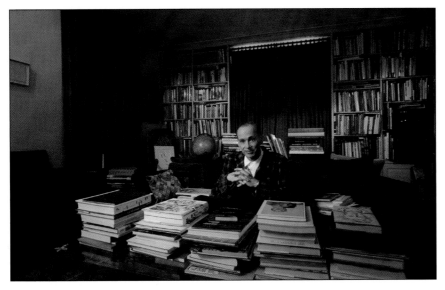

Figure 1-10. **Keywords:** Jobs, John Waters, Library, PBS, Art21, Environmental Portrait

What's a RAW File?

Consumer-level digital cameras typically store the images they create only in the JPEG or TIFF file formats. These file formats are pretty much universal: they are *openly documented*, so software developers know how they are structured. The image data of the file, and the information the camera creates about the file, are generally written the same way inside the file.

Many of the better digital cameras can also write RAW files, in the NEF, CRW, ORF, RAF, and MRW file formats, among others. These RAW files store the data from the camera's sensor in a more or less unprocessed state. Generally, digital cameras only record one color per pixel sensor, and when these files get converted to a standard digital file, the rest of the color information is interpolated from surrounding pixels.

Each RAW format is actually a variation of TIFF, but each is slightly different. In fact, when produced by different model cameras, each of these RAW formats is also different from others of the same name—for example, a NEF file from a D100 is different from a NEF file from a D70.

Not only are these file formats constantly changing, but they are not openly documented. Every time a new camera model is introduced, the software developers must reverse-engineer the RAW file again (i.e., look at the data and decode how it is being stored).

The Benefits and Drawbacks of Shooting RAW

Because the RAW format stores the data from the camera sensor in a nearly unprocessed state, it offers the most versatility. If you want to change the

color balance, or if you want to greatly enlarge the image, you will generally get a better result by working from the original source data—that is, the RAW file. In this regard a RAW file is not unlike a traditional photograph, where the best print will be obtained from the original negative, rather than by copying a print made from the negative.

That said, the multitude of RAW file formats present some critical problems:

- Users of new camera models must wait until all the software they use has been updated to handle the new format.

- It can be dangerous for third-party applications to alter these undocumented formats.

- It may become difficult or impossible to open these files as time goes by—indeed, in the short life of digital photography, we have already seen manufacturers drop support for certain RAW file formats.

- Painstaking adjustments made to RAW files (color balance, brightness, etc.) by certain software may become unavailable once the manufacturer drops support for that software or file format.

Sometimes the solutions to these problems can be almost worse than the problems themselves. For example, because Adobe does not want to alter undocumented RAW files, they have chosen to use *sidecar files* when altering RAW files. A sidecar file is a small text file that contains the adjustments that you have made to the file and that lives in the same folder as the original file. So, if you increase the brightness of an image in Camera Raw, the original image file will not be altered, but the sidecar file will contain a small instruction to increase the brightness when the file is opened again in Camera Raw.

While sidecar files help Adobe to maintain file integrity for you, they throw up a huge roadblock if you want your cataloging software to be able to see and make use of any of the work you do in Photoshop. No cataloging software—or any other software that I am aware of—can use the information contained in a sidecar file.

Fortunately, there is now a solution to nearly all of these problems: DNG to the rescue!

DNG as a Workflow and Archiving Solution

Adobe developed the DNG format to address the drawbacks of using RAW files. DNG is an openly documented file format that can contain the RAW image data, plus lots of other useful stuff. You can convert your RAW files into DNG files and be confident that you are putting them into a good format for inclusion in a permanent archive.

You Might Be Wondering...
Are You Saying to Never Use Sidecar Files?

No—what I am saying is that sidecar files are a poor tool for permanently archiving your RAW files. I believe that sidecar files are the preferred way to store adjustments of RAW files prior to conversion to DNG files. I'll go into exactly what sidecar files are, and how to create and manage them, in Chapter 5.

A digital job jacket

Although Adobe has named the format the Digital Negative, I prefer to think of it as a "digital job jacket." In fact, the DNG format is a wrapper that can contain all kinds of useful information about your file. Let's take a look at what can be stored there:

The negative

> The DNG file can contain all the RAW image data that the camera puts into its own RAW file. This means that you can open a DNG file in Camera Raw *and have the full range of adjustment options that you had with the RAW file.*

Paperwork

> Because the DNG format is openly documented, all sorts of metadata (discussed in the next chapter) can safely be written to the file, with no danger of it becoming unreadable or of corrupting the file.

A pretty good print

> In the DNG file, you can store not only the "negative," but also a "print." Camera Raw can create a preview of the file that reflects all the adjustments you have made. Take a look at Figure 1-11. On the left is the original embedded preview (as created by the camera). On the right, the DNG shows up the way I've adjusted it in Camera Raw. You can correct the color, brightness, and contrast—even crop or apply a curve—and the resulting image will be stored inside the DNG file. This embedded preview can be of several sizes, including one that is the full dimension of the RAW file. We'll look at how this "pretty good print" can be useful in Chapter 8.

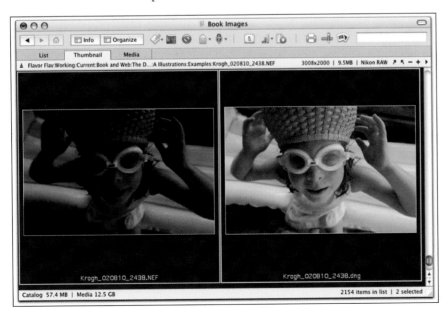

Figure 1-11. One of the best benefits of using the DNG format is that it enables you to embed an accurate preview into the file.

Private maker notes

If a camera manufacturer comes up with a new way to process a file, and they wish to keep the details secret, they can encrypt this information into the DNG file. Thus, DNG files can be universally accessible, while at the same time offering manufacturers protection for their proprietary image-processing algorithms. This will be useful as more manufacturers let users choose DNG as a RAW file format to be produced straight out of the camera.

Undocumented maker notes

Version 3.1 of Camera Raw (and the freestanding DNG converter) will copy the undocumented maker notes to the DNG file. While Camera Raw cannot make use of this information at the present time, it saves it for a day when camera manufacturers will embrace DNG as a solution for file storage, or for a day when third-party software can decrypt this information. (Because this is undocumented information, the full integrity of these maker notes is not absolutely guaranteed.)

The original RAW file

Those of you who can't bear the thought of throwing away your original RAW files can simply embed them into the DNG file itself. You will then be able to extract this file at any later date, should you choose to. (I don't keep the original RAW files, because the DNGs include everything I want to keep. And, of course, embedding the RAW files will make the resulting DNG files quite large.)

Beyond simply *what's* stored in the DNG is the issue of *how* it's stored. Because the DNG format is openly documented, any application that can use DNGs can see your Camera Raw adjustments, read and use the "paperwork" you have enclosed, add more data to the paperwork, and create a good-looking JPEG or TIFF of the file, *even if it can't read the original RAW file type.*

There's another benefit to using the DNG format for image storage, too: it offers significant file-size reductions *losslessly,* with no loss of quality. The compression that DNG offers (one of the "save" options) can reduce the size of an image file by up to one third. This translates into nearly immediate savings for the photographer.

Drawbacks of DNG

There are a couple of drawbacks to saving files as DNGs. On balance, they are not of great concern to me, but you should be aware of them.

RAW files saved as DNG cannot be opened by the manufacturer's software. Some people, for instance, like to use Nikon Capture for processing their RAW files. At the moment, if you save your files as DNGs, you will not be able to open them in Nikon Capture. You could choose to embed the RAW file into the DNG, but that makes for a pretty large archive.

If you like the idea of embedding RAW files for certain photos but don't see the need to embed them for every image, you can use the workflow tools I outline in Chapter 6 to embed only the RAW files for images that are rated as very high-quality photos.

Another option is to make it known to your camera manufacturer that you would like them to support DNG. Currently, Leica and Hasselblad both use DNG as a native RAW file format right out of the camera, and there's no reason that manufacturer's software such as Nikon Capture cannot work with Adobe-created DNG files—they simply choose not to support DNG.

The second drawback to using DNG is that (for most cameras) you must convert your files to this format, which requires an extra step. However, I believe that this is well worth the hassle, given the benefit that you receive.

DNG as an archival storage format

I believe that DNG is, by far, the best bet for ensuring the long-term accessibility of your RAW image files. Although it is brand new, because of the benefits it offers the format is likely to be adopted rapidly. Once you see how Bridge and DNG enable you to build an integrated DAM workflow, I predict that you will switch to saving your RAW files as DNG files and tossing away the originals.

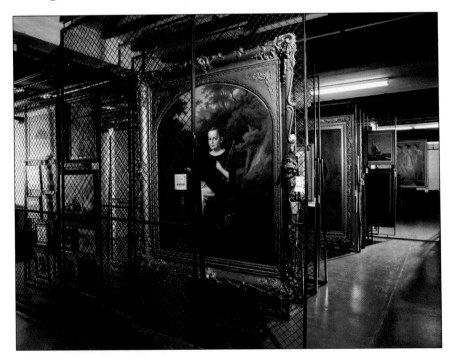

Figure 1-12. DNG is your best choice for long-term archival access to your RAW files. **Keywords:** Art Storage, Warehouse, Security, Archive, Paintings

As I have been working with my legacy RAW images, it has astounded me how much more useful a DNG file is than a RAW + sidecar file. Browsing the DNG files in my catalog software reveals the images—those "pretty good prints" I made in Camera Raw—the way I intended them to look. Plain RAW files can only display the preview embedded by the camera. Sometimes the color is way off, sometimes the exposure needs adjusting, and sometimes the image is intended for black and white. DNG files will always be displayed in my catalog software the way I intend them to be displayed.

I believe that there will be more DNG files in existence by the end of 2006 than there will be of any other single RAW format, and that the DNG format may eventually be as widely supported as TIFF (another open format promulgated by Adobe). What's more, the wonderful functionality of DNG files will cause this format to be supported long into the future. Your current digital camera (and hence your current RAW format) is unlikely to enjoy such longevity. In 20 years, it will be hard to even remember what cameras you have used, and you probably won't want to constantly update your software to support these obsolete formats. Imagine if you had to buy a special device to be able to look at the images you shot with a Pentax K-1000 in high school 30 years ago! (Okay, so I'm old: you will be too, if you're lucky.) Switching to DNG now will almost certainly save you a lot of hassle in the future.

The Benefits of Sound Digital Asset Management

Whether you are a professional photographer or an avid amateur photographer, you invest in the creation of your images, and you want to get a return. That return may be in the form of monetary payment or personal satisfaction. Either way, setting up a solid DAM system will greatly improve the return on your investment.

While creating a comprehensive DAM system may seem daunting at first, it's really no more work than using a cobbled-together system. I've actually found that it's a lot *less* work, once you get everything streamlined. Once you wrap your head around the differences between analog-world management and digital-world management, the dividends will come rapidly. The benefits of your DAM system include aiding your productivity, adding value to your photos, ensuring longevity of your work, increasing your profitability, and allowing you to adapt to the changing technological landscape.

Sound DAM Aids Productivity

Digital photography has caused an explosion in the number of photographs that people take, and therefore have to process and keep track of. At the inception of the digital revolution, it was commonplace for digital editing tasks to take much longer to accomplish than their analog-world

Figure 1-13. Sound DAM can save you time. **Keywords:** Time, Clock, Productivity, Jobs, Speed, Accelerate

counterparts. The creation of good DAM software and the incorporation of the Bridge browser in Photoshop CS2 have made this inefficiency a thing of the past.

Cataloging software aids productivity by letting you cross-reference different kinds of information about your pictures and save the resulting groupings as sets of images that you can come back to later. For instance, you can cross-reference assessments you have made about the quality of your images (ratings) with content information you have assigned to those images (keywords, for example).

The new Bridge software that replaces Photoshop's File Browser includes some powerful organizational tools that streamline this process. I'll show you how good DAM practices will let you import your sortings from Bridge, and leverage them to the fullest. By using Bridge's rating and grouping tools, you will quickly be able to confirm:

- That you have chosen at least one image from each situation

- That you have chosen the best image from each situation

- That you will not be throwing away any images that you did not intend to throw away

Cataloging software can go a step further than simply organizing images, however. It will also let you perform work on your files—such as making a web gallery, slide show, or contact sheet—right in the same window that you use to sort. Once you get comfortable with the capabilities of Bridge and your cataloging software, you will be able to spend much less time sorting and preparing files, and much more time shooting.

Proper DAM Adds Value to Your Photographs

Consider for a moment the Bettman Archive. Much of that collection was comprised of images discarded from publishing houses: images considered valueless at the time. By systematically organizing these images, Otto Bettman was able to turn them into a highly valuable collection of photographs and other commercial art. Corbis purchased this collection of "discarded" images for millions of dollars in 1995. Let's think about that.

Figure 1-14. **Keywords:** Globe, World, Earth

A photograph at the bottom of a landfill and one in the Bettman files may each have the same artistic and intrinsic value. One, however, has a vastly greater *market* value. The difference is one of accessibility and organization—properties that are dependent on the images being part of a larger collection, and upon there being searchable classifications within that collection.

The market value of a photograph is dependent on your ability to get that image into the hands of someone who wants it. Digital asset management practices give you the ability to sort and retrieve photographs according to many different needs, and therefore enhance accessibility to the pictures.

What's the Market Value of a Needle in a Haystack?

One way to answer this question is to say that the market value is the worth of the needle, minus the cost of finding it in the haystack. If the cost of finding the needle is greater than the value of the needle itself, it has no market value, because it doesn't even make sense to start searching. However, the effective use of metadata can make the search quick and efficient, so that you can afford to compete in markets where it would otherwise be uneconomical.

Like so much of DAM, this concept of value applies to personal as well as professional images. Say you were invited to Caldwell's house for dinner, and you wanted to bring him a print as a gift. With a properly cataloged collection, you can quickly review the good pictures you have made of Caldwell and select an image or two to print. If the sorting is a chore—"I know that photo is on one of those CDs in that drawer over there, but I'm not sure where"—you may not even attempt to find it.

All of the work that you do to rate and group your images will add value to them, by making them easier to find and bring to market. Because DAM software lets you easily assign and leverage the work of rating and grouping your images, it expedites that process and creates value.

Figure 1-15. Being able to find that needle in the haystack can be quite valuable. **Keywords:** Daisies, Daisy, Stock, Flowers, Unique, Special

Sometimes the client is you

In addition to market value, good DAM practice will enable you to get the maximum personal or artistic value out of your photographs. Digital photography, coupled with good DAM techniques, lets you find and work with your photographs much more easily (and enjoy them more) than you ever could have when working with film. In fact, for much of the work I do with my photography collection, *I am the client*, and the value that I strive for is personal value, rather than market value. Keep that in mind as you read through the workflow solutions offered here.

Effective DAM Enhances the Longevity of Your Work

Good digital asset management is essential to the long-term well-being of your archive. It will help you maintain the completeness of your collection of pictures, and it will be invaluable when it comes time to migrate your pictures from one system/media/format to another.

The most basic part of DAM practice, the storage and backup of image files, is obviously integral to the long-term survival of your photography collection. Figure 1-16 shows my grandfather's graduation picture from the Naval Academy, which has great personal value for me. Now that it has been scanned and included in my digital archive, I know that I, and my children, will be able to enjoy that picture forever.

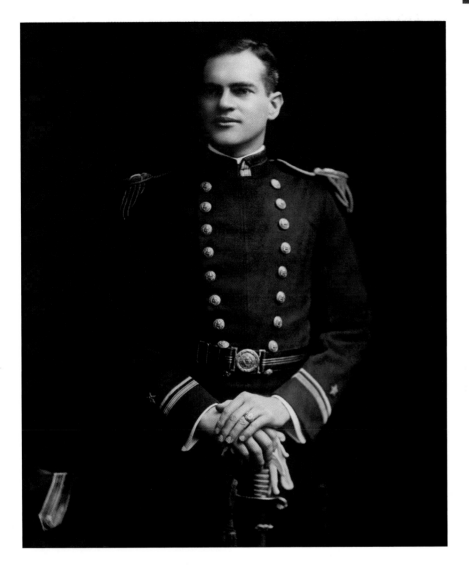

Figure 1-16. Captain H. G. Donald, my grandfather (Naval Academy graduation picture, 1907). **Keywords:** Harry Gordon Donald, Naval Academy Graduation, Family

It's essential that you have a simple, redundant structure for your photographs so that you don't lose files due to any of the ever-present threats of theft, fire, media failure, lightning strike, computer virus, or human error. If your images are stored in an orderly manner and are well cataloged, you will be able to recover from these hazards with a minimum of loss and hassle.

DAM Prepares You for a Future of Profitable Professional Photography

This section is intended to put a DAM system in perspective for independent professional photographers. If you don't do this kind of work, you can skip ahead to the next section.

The licensing model

Many professional photographers have found that the fairest and most profitable way to "sell" images to clients is through the licensing model. This enables photographers to charge more for images that the client will get high-value usage from, and clients to pay less for images that have a lower usage value. In fact, the licensing model is entirely responsible for the creation of the stock photography market.

It is clear that the licensing model is the driving force behind the information economy. If everyone who bought a book could copy and resell it, there would be no profit in publishing books. For most intellectual property, from editorial publications such as magazines to products such as software and movies, the revenue models rely on the multiple licensing of the same material. Look at Bill Gates, a multi-billionaire. He has started two companies in his life: one, Microsoft, writes and licenses software; the other, Corbis, aggregates the rights to license photographs.

For photographers to economically thrive in a licensing-based economy, I suggest following a strategy that enables you to take part in the relicensing process, and hence share in the revenue stream. If you choose to follow this path, DAM will play a critical role in your own well-being, just as it plays a critical role in your clients' businesses. It's up to photographers to understand these challenges, to structure internal tools to deal with these challenges, and to help clients implement systems that work in everyone's favor.

DAM help for your clients

Let's look at this from the client side for a minute. If you think you have trouble keeping track of your images, imagine what your clients are experiencing. Like you, they have a rapidly expanding collection of images in which they have a considerable investment. These range from images with a high acquisition cost, such as custom photographs for advertising, to images that have little individual cost but a large aggregate value over time, such as historical employee photographs, progress photos, and other photographic recordkeeping items.

Figure 1-17. Sound DAM can help you, and your clients, find what you are looking for. **Keywords:** Jobs, Stock, Path, Quandary, Confusion, Executive, Choices, Crossroads, Decision

Your clients, however, don't have access to the most important tool that most photographers currently use to keep track of their images: the photographer's memory. Fortunately, DAM software has the ability to keep track of hundreds of pieces of information about a particular file, from the photographer's name, to the date taken, to GPS info and more. The new IPTC panel even has a field, shown in Figure 1-18, specifically for the license granted to the client. Use it: it's there for *everybody's* benefit.

Figure 1-18. The IPTC panel has a field for license information—the "Rights Usage Terms" field—that can help your clients remember the terms of their license.

As photographs (and all other types of media) are collected by a corporation, often by different purchasers under differing usage contracts, the task of keeping track of what images have been licensed, and what rights have been purchased, becomes unmanageably complex unless there is some system to track it all.

Increasingly, companies with any digital assets of value (which is pretty much *every* company, and especially any that commissions, licenses, or buys photographs) are implementing metadata-based DAM systems. To

encourage the continuation of the licensing model, it's up to licensing-based photographers to integrate with their clients' DAM infrastructures. How can photographers expect clients to respect their ownership interest in images if they don't respect it themselves?

Photographers must lead the way

As the sources of photography, we must integrate effective DAM practices into our workflow from the very start. We need to first understand DAM, then practice it ourselves, and then help our clients with it. The practices outlined in this book will help with all three of these tasks. And when you are in the position of offering valuable solutions—even ones that raise the price of your invoices to your clients—you become more valuable to those

> **NOTE**
>
> *Professional photographers in the portrait and wedding business can also add value to their images by good DAM techniques. Aside from the productivity boost—which adds profitability in itself—DAM can help you do more with the photographs that you have. You can, for instance, use your DAM application to create a QuickTime movie and sell a DVD of a portrait session or wedding, in addition to prints. You can also more efficiently keep track of customer orders, and identify customers who are good prospects for additional sales.*

Figure 1-19. **Keywords:** Executive, Rollercoaster, Business Metaphor, Ride

clients. As you read here about how good DAM practices can help you find images and track licenses, keep in mind that these disciplines will add value for your customers (and can make you money).

DAM Will Allow You to Roll with the Technological Changes

You may not yet have thought about another challenge that will surely come your way: file migration. Eventually you will need to move and/or change the format of all of your files, because of the obsolescence of your chosen storage media, operating system (OS), or file format. Of the three, your choice of storage media will generate the need for some sort of upgrade migration the most often (probably at least every two years). Chapter 9 deals with these challenges in more detail, but let's get an overview now.

Figure 1-20. Sound DAM practices help you respond to technological changes. **Keywords:** Technology, Electronics, Wires, Connections, Upgrade

Storage media

As new technologies for file storage emerge, it will make sense to move all your files onto the new media (sometimes merely onto bigger drives). This will be desirable due to decreased cost, increased speed, increased capacity, increased reliability, or some combination of the four. If your archive is well organized, this process can be entirely painless.

Operating system

Migrating a well-organized collection onto a new OS should also prove to be relatively painless. Transferring the files should be no big deal; the biggest potential hurdle here is making sure that all of your sorting work can be ported to your new operating system and cataloging software.

File format

Migrating your collection to a new file format will be the trickiest of the bunch. Most likely, it will be necessary because you have switched to a DNG workflow, or because you've found that a RAW format that worked fine in 2005 is no longer easily readable in, say, 2010. (It is my expectation that once I convert my legacy RAW files into DNG files, I will not be doing file format migration again for a very long time, if ever.)

We'll go over some of the migration issues in Chapter 9. First, let's take a look at how we can construct an integrated archive. The first tool we will use is metadata, which you can read about in Chapter 2.

Types of Metadata

Applying Ratings, Keywords, and Groupings

Storing Metadata

Metadata 2

Now that we have a handle on what we are trying to accomplish with our DAM system, let's take a look at one of the most powerful tools at our disposal: metadata.

Metadata is a term that generally refers to data about data: for digital photographers, it means information about your photographs. This ranges from the mundane (what format an image is in, or where it's located) to the sublime (what kinds of concepts it helps to illustrate).

Many photographers think that metadata is interchangeable with IPTC information, XMP information, or EXIF information. The universe of metadata, however, is larger than that: it encompasses everything that is known by anyone about an image. Thus, metadata can include information you will never be aware of, such as your client's internal comments about your images.

Many photographers like to rely on something I call *virtual metadata*—that is, information about a photograph that they keep only in their memories. I have heard many people say that they don't need to or have time to enter metadata into their catalogs or files. The problem with this approach, of course, is that they are then the only people who have full access to the information about their photos.

Figure 2-1. You think you have a data storage problem? Consider the U.S. Patent Office! **Keywords:** Darren, Polaroid, Patent Office, Files, Record-Keeping, Data Storage

Types of Metadata

Metadata can be divided into three tiers. Each successive tier adds more value but requires more work to input. Let's look at the various types of metadata, what is involved in their generation, and how they can be useful.

What's So Important About Metadata?

In general, metadata adds considerable value to your photographs, because it helps you and others to find them when they're needed (say, during a stock search). The relationship between metadata and market value is pretty direct. I posit the following equation:

Market Value = Intrinsic Value (Artistic Value, Photographer Reputation, or Subject Matter Value) x Metadata Value

The best photograph in the world has no market value if it's sitting unknown in the bottom of a file drawer; likewise, a terrible photograph that is well cataloged has little market value. Follow this axiom: to maximize the value of your photography collection, identify the images with the highest intrinsic value, and augment them with the highest metadata value that is practical. I suggest that this holds true whether you are talking about the monetary value or personal value of images.

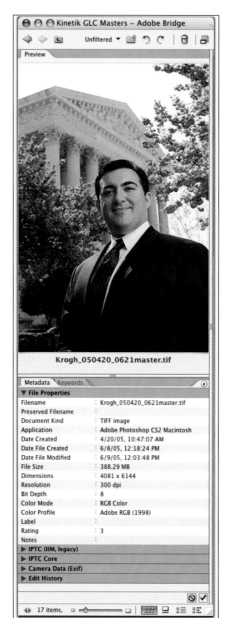

Figure 2-2. The metadata file properties screen gives you basic information about your file.

Metadata Type 1: Automatically Generated

The first kind of metadata we will look at is information that can be harvested by your browser or cataloging software without you doing anything. There are two types of automatically generated metadata: information about the file properties and EXIF information.

File properties

The file properties (also called media info) are the most basic pieces of information about your files. This includes information such as location, file size and format, and other file characteristics. You can see a basic metadata properties screen in Figure 2-2.

This information is useful for general file identification and management. For instance, you can compare sizes to see which copy of a file has a higher resolution, or you can compare file modification dates to see which is more recent.

EXIF

The other kind of automatically generated information (for digital capture, at least) is the EXIF information. EXIF (Exchangeable Image File Format, pronounced ex-if) is a standard used by camera manufacturers to store properties such as shutter speed, ISO, date/time shot, and so on. Although manufacturers

don't store all of this information in exactly the same way, the bulk of it is easily accessible and indexable by most DAM software.

You can use EXIF data for a number of purposes. For instance, you can use EXIF data to sort your images chronologically (e.g., lining up all the images from a multi-camera shoot in the order they were taken and renumbering the entire set in that order), or to find all images shot with a particular lens (say, if you wanted to check for quality problems with that lens). Figure 2-3 shows a typical EXIF data screen.

Metadata Type 2: Bulk Entry Data

In the second tier of metadata information, we move into the category of user-supplied information. This data is not automatically generated and must be entered by hand. The most basic of this, *bulk entry data*, is that which can be applied to many images at once.

This could include information such as the name of the subject, the location where the photographs were shot, the client's name, and other characteristics that don't involve individual evaluation. Certain kinds of bulk metadata should be entered for all images, because doing so is quick and provides a very good return on the time invested.

I suggest that the following bulk-entry information be recorded for all digital originals (note that the time and date of capture are recorded in the EXIF data and do not have to be entered by hand):

- City, state, and country where photograph was taken

- Name of photographer, and contact information

Figure 2-3. The EXIF data panel. Because each camera manufacturer writes EXIF data slightly differently, you may not see exactly the same fields in your EXIF panel.

Getting Rid of EXIF Data

There are times when a photographer might not want to share information about the capture of a photograph with a client. This might be because you consider your technique to be a trade secret, or because you don't wish to reveal information about exactly when the photograph was made.

With a few exceptions, EXIF data is not editable in Photoshop or other DAM software. There are a few freestanding EXIF utilities that will let you change the EXIF values, though. In general, if you want to hide the EXIF data from the viewer, the best course of action is to select the entire image, copy it, and paste it into a new image file.

- Broad classification of images (e.g., "Personal Work," "Jobs")

- Original intended use, if applicable: (e.g., "Personal Work," "Assignment Name," or "Stock")

- Name of people or subject pictured (when practical)

- General descriptive keyword (e.g., "Vacation," "Magazine Story X," "Brochure Job Y")

- Client name, if any

- License agreement, if any

This information can typically be entered in a matter of seconds, even for hundreds of images.

Figure 2-4 shows a picture from my collection and its metadata screen. In Chapters 5 and 6, I'll show you how you can use the tools in Bridge to quickly enter information into the metadata for many images at the same time.

Figure 2-4. The new IPTC Core Metadata pane is where bulk metadata shows up. You can see that I have made several metadata templates for different types of images. We'll go over how to make these in Chapter 5.

Metadata Type 3: Higher Metadata

The most valuable metadata—but also the most time-consuming to generate—is higher metadata. This includes the higher-touch information you

Figure 2-5. **Keywords**: Jobs, Annual Report, NCB, ESOP, Food Service Industry, Donuts, Bakery, Group Shot, Portfolio

generate when you rate, assign keywords to, and group image files so that you can find them quickly when you're searching. Typically, this information takes longer to assign because it is part of a more complex evaluation process. In the next section, we'll take a closer look at these higher levels of metadata information.

Applying Ratings, Keywords, and Groupings

Ratings, keywords, and groupings are different categories of evaluation that can be cross-referenced with each other to narrow down your searches to a small number of likely results. For example, if you are looking for "good pictures of Josie" for some purpose, your work assigning ratings, keywords, and groupings can be very helpful.

If you use a comprehensive rating system, the concept of "good" can be defined by the rating (e.g., "search all three-star or better images"). The term "Josie," if it appears in the keywords, enables you to search through only those images that have something to do with Josie. If you have saved previous groupings of "good pictures of Josie"—images used in a birthday slideshow, for instance—you can narrow your search even further. Let's examine these tools a little more closely.

Tagging Images for Quality: The Ratings Pyramid

Figure 2-6 shows one visual representation of a collection of images. As you can see, if the images were not organized in any way it would be very difficult to find the particular one that you were searching for—a bit like looking for a needle in a haystack.

Figure 2-6. Finding a specific image in an unorganized collection is like looking for a needle in a haystack.

As you can see in Figure 2-7, that haystack becomes a lot easier to search if it is divided into sections. By making broad classifications of subject matter (the vertical lines) and adding ratings (the horizontal divisions), you can more easily find what you are looking for. You can, for instance, search just your best images (at the top of the pyramid) for a particular photo. If you find something that's close to but not exactly what you want, you can follow that thread downward to see if there is a more appropriate image included in that subject-matter group.

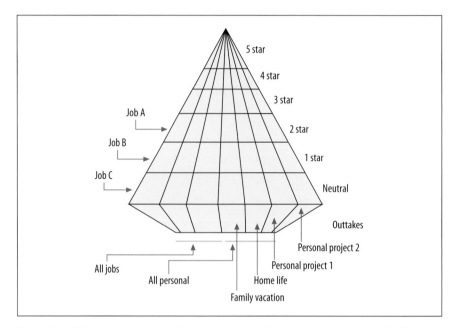

Figure 2-7. Dividing up the haystack allows you to more easily pinpoint the image you're looking for.

The most basic component of higher metadata is the rating. *Rating* is the evaluation of images based on relative quality. This is what you do when you look through a group of images and indicate that some are better than others.

As you rate your images, you are assigning a higher value to better pictures, and you are making it easier to find the high-value images within the groups at a later date. Rating an image as superior will make it much easier to pick it out from amongst its more ordinary brethren during a search.

In general, when you are searching for images, you will first want to look through pictures with the highest rating. If you are unable to find a suitable image among those, you can move down the pyramid, broadening your search to include images with the next-highest rating, and so on. By using ratings this way, you can instantly reduce the size of the haystack you are looking through in order to find your needle.

In addition, rating your images will help you ensure that you spend more production time on your highest-quality images and less time on images that

are of lesser value. (We'll discuss this further in Chapter 6.) Ratings will also be valuable if you ever want to thin out your archive at a later date.

Having a systematic, organized rating process will streamline the tasks of searching for pictures and identifying images to throw away. For instance, you might want to throw out any images labeled as "outtakes" once the job has been delivered and paid for, or you might want to delete all neutral images from shoots with a large number of similar frames at some date in the future.

Figure 2-8 shows the most basic view of the ratings pyramid. As you can see, organizing an undifferentiated mass of photographs into a rated pyramid lets you easily separate out the best ones. This will be helpful throughout the entire lifecycle of the images—it helps you in determining how to adjust and store the images, how to thin them out later, and how to search them.

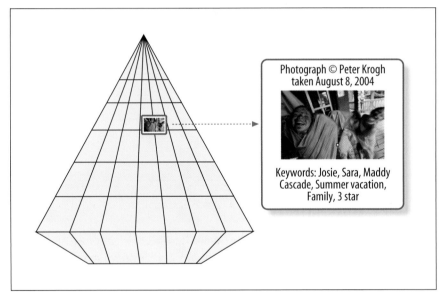

Photograph © Peter Krogh
taken August 8, 2004

Keywords: Josie, Sara, Maddy
Cascade, Summer vacation,
Family, 3 star

Figure 2-8. By using a comprehensive ratings system, you divide your collection into subsets that are more easily searchable.

To determine how to apply ratings, we need to examine some of the concepts behind them. Let's take a look at the DAM rules from the last chapter and how they relate to ratings:

Systematize

Fortunately, our friends at Adobe have given us some very good tools to rate images in a systematic way: the star ratings. The Bridge star ratings are easy to understand and use, and they are likely to become a standard among all DAM software. The work you do with rating stars in Bridge can serve as the foundation of a collection-wide quality designation for the life of your photos.

What's so great about those Bridge stars? In addition to their front-runner status in becoming the worldwide standard, they are simple, well designed, and flexible. You can use the stars to build a set of top-down inclusive groups. What does that mean? It means that at any given time, you can chop off the top of the ratings pyramid and confine your search to that top-level subset. In effect, it lets you choose a smaller haystack to search through.

The filtering in Bridge—which I will show you how to translate to almost any other application that reads metadata—lets you confine a search to, say, images with three stars *and better*. Thus, you can very efficiently start a search narrowly (only the best images) and then widen it out to the next level if you have not found exactly what you want. Figure 2-9 shows how this "top-down filtering" is superior to "filtering by the slice."

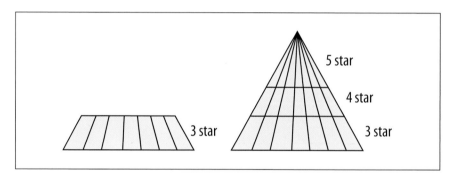

Figure 2-9. Top-down filtering (right) makes searching for "all three-star and above images" more efficient. If you were to filter "by the slice" (left), you would have to search three times to get the same results.

Don't rely on your memory

Most photographers I know have had the experience of finding images that they'd forgotten about: sometimes these have become favorite images. By rating images for quality when you first edit them, or any other time you look through them, you keep great photographs from "slipping off the light table."

Be comprehensive

The stars make systematizing easy; you'll have to exercise your brain a little to be comprehensive. In order to do this, you will need to make very broad definitions for each of the rating designations. These definitions will need to span across all the different types of photography that you do—for example, you wouldn't want three stars to mean "very good" for commercial work, and "pretty good" for personal work.

Remember that these designations will be helpful not only for searching, but also for image handling. In a minute, I'll show you the designations I use, and how I came to those definitions.

Build for the future

When deciding what designations to use, bear in mind that your collection will grow many times larger over your lifetime. You need to leave some headroom to grow. For instance, I am not using the fifth star in Bridge yet, because I want to save this designation for a time when my collection is much larger.

I think the greatest danger in terms of carrying a rating system into the future is that of the metamorphosis of the "ratings pyramid" into a "ratings light bulb" (Figure 2-10). A ratings light bulb would be much less useful.

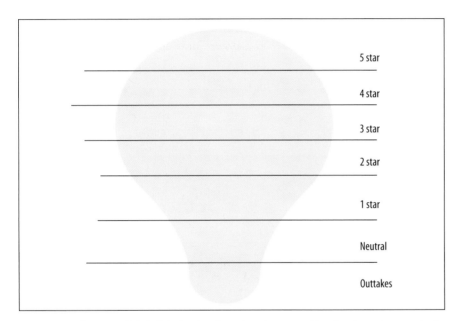

5 star

4 star

3 star

2 star

1 star

Neutral

Outtakes

Figure 2-10. The ratings light bulb isn't as handy as the ratings pyramid—there's much more value in being at the top if it's lonely there.

Do it once...

Because rating is a valuable tool that helps you determine how much work to do to a file, you should make a good effort as early as possible to assign ratings to your images. If you rate right away, you can spend the largest part of your Camera Raw adjusting time on the best images. Likewise, your time creating custom keywords will be much better spent if you work mostly on your best pictures. Rate your images as soon as possible after renaming, and make that work permanent.

But don't overdo it

Ratings are rough groupings, applied across your entire collection. I suggest trying to split by orders of magnitude (1 four-star image for every 10 three-star images, 10 three-star images for every 100 two-star images, and so on), not by subtle degrees. Of course, this doesn't work

for every shoot, but if you keep this goal in mind, you have something to aim for. I'll outline later why this works from a mathematical perspective, a file-handling perspective, and a searching perspective.

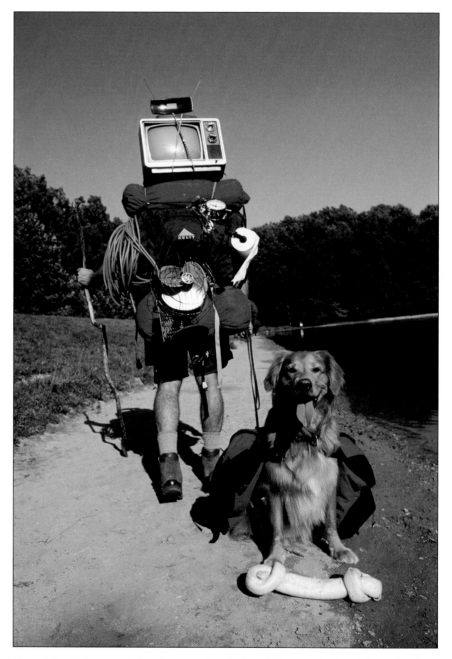

Figure 2-11. It's important to keep in perspective what's useful for the task at hand. **Keywords:** Hiker, Overpreparation, Dog, Creature Comforts, Missing the Point

Setting up your ratings system

It's important for you to decide what you mean when you give an image a particular rating. That rating will be a general quality guide and a file-handling guide. In this section, we'll look at the ratings I use, and the criteria that go into making the rating evaluations. Figure 2-12 shows examples of how I use my various ratings.

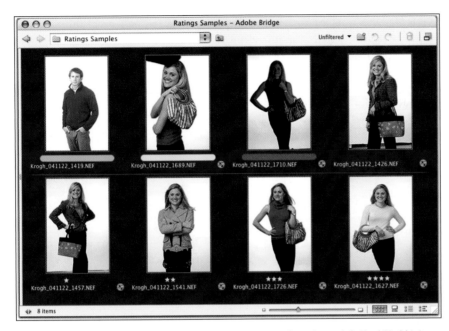

Figure 2-12. Examples of my ratings system in action. Clockwise from the top left: TrashMe (this is a "Polaroid"), Outtakes, Unrated (I need to examine in Camera Raw to rate this one), neutral, one star, two stars, three stars, and four stars.

In database geek-speak, the *value* is the name or meaning of the variable you assign—in this case, the label. Ratings can be neutral, positive, or negative. Neutral images receive neither a positive star nor a negative label. At this point, for positive ratings I use four of Bridge's five possible star ratings, right out of the box as Adobe intended. As I mentioned earlier, this is a very efficient way to use the rating pyramid, because when you're searching it lets you start at the top and work your way down quickly.

I use the colored labels in Bridge to enable me to rate negatively and to indicate images that have not yet been rated. In my system, for instance, I assign the red label the value "Unrated." I discuss what I use the various labels for below, and I'll show you how to set these values in Chapter 5. (In Chapter 6, we'll go over the rating workflow, and I'll show you how you can transfer your ratings for use in other applications.)

My decision criteria for assigning the positive star ratings are presented in the following list. Note that I use slightly different criteria for personal images and for commercial images, but that the general quality assessments and the workflow ramifications integrate well together.

These are the designations that I use:

Neutral

Neutral images are ones that are neither good enough to rise above the crowd and get a star, nor flawed enough to deserve a negative rating. This is the most common rating for my personal images, encompassing more than 50% of my personal work. Some of these images are "diary" images, ones that I keep to help me remember what things looked like, who was there, or what happened. These will probably never be printed, or shown to many people in any form, but I want to keep them nonetheless.

Neutral work-related images are more defined by what they are *not*: they are not bad enough that I want to throw them away once the job delivers, and they are not good enough to send to the client in proofs or web galleries. For an editorial job, I may keep many of these neutral images in case the editor wants to "go deeper" into the take for some content reason. For a tightly structured portrait job, I don't generally give many images a neutral rating—the images tend to be either good enough to present to the client, or flawed enough to be tossed once the job has been paid for.

One star

I use the one-star designation for images that are good enough for inclusion in a web gallery to be presented to the client. For personal images, one star means that I might want to use them in a web gallery, slideshow, or print. Through the life of the archive, these images will get much more attention than the neutral ones—even the broadest searches will generally be confined to one-star or better images.

Assigning one star to an image is a very rough cut. If I am in doubt as to whether the image deserves it, I assign the star. I think of it as a kind of large group that I put photographs into to evaluate later. Because neutral and worse images are searched only rarely, if you aren't sure about an image, it's probably best to err on the side of inclusion and give the photo a star.

Two stars

For business images, I assign two stars to photographs that I think are the best of the shoot. An executive portrait shoot might generate 40 images to present to the client (each of which receives one star) and 4 that I think are really the best (which receive two stars). For most business applications, this is all that I feel I need out of a rating system: good enough to present, and recommended by the photographer. As I go through images in Bridge, I try to keep a 10:1 differentiation in rating in mind (i.e., 1 two-star image for every 10 one-star images). I find that this is a very useful way to narrow down the shoot. Of course, if the shoot is large enough, this rubric may not narrow down the shoot enough. In those cases, I may use three stars.

For personal work, the calculation is similar: images get an additional star if they are the best of the take, and this designation should be used sparingly. Images that get a second star effectively become the "best of" the collection or group. The difference between one and two stars doesn't really mean anything unless you use the additional star sparingly, so be frugal.

Three stars

I use the three-star designation even more sparingly. An image gets a *permanent* third star in one of two ways: either I like it enough that I think it's a strong stock image or portfolio candidate, or the client has chosen it as an image to be prepared as a master file. In the latter case, I might not even like the image that much, but because of the work done to it and its value to the client, I think it makes sense to tag it as particularly valuable.

Note that images that have been selected by the client for batch conversion do not get this designation. By definition, there are more of these images, and I put less work into them.

Four stars

The four-star designation is reserved for images that are worthy of the "best of collection" designation.

Five stars

I am currently resisting the urge to use the fifth star. One day, it will be useful to further divide images within the four-star best-of-collection group.

As you can see, I don't give out high ratings very freely. When you're working with a large number of images, it's best to set the bar high and really think about the quality designations that you make—if you find yourself putting half your images into the three-star or higher categories, it's definitely time to regroup. Remember, the pyramid is most useful when it retains its proper form.

Figure 2-13. **Keywords:** Stock, Portfolio, 4Star, Bethesda, Architecture, Traffic Light

I use the labels in Bridge to apply the following negative ratings and status designations (I also use the same designations within my cataloging software). The number and color in parentheses are the label assignment key and the label color in Bridge:

Unrated (6, red label)

This status tag indicates that the image has not yet been evaluated. This designation is very helpful from an evaluation standpoint, because it lets me distinguish between an image that is neutral (deserving neither a good nor a bad rating) and one that has no rating because it has never been evaluated. From a workflow standpoint, the Unrated label can also be useful as a marker to show where you left off when evaluating images.

If you are on a tight deadline and are able to evaluate only a small subset of the entire shoot, use the Unrated tag to note which images still need rating. Additionally, I sometimes use this tag to remind myself that an image needs to be rated for critical focus issues in Camera Raw, where I can get a full-sized preview of the image. I often also apply this tag to personal images, because they have less "deadline pressure" associated with them—I tend to save these for a day when I can go through them at my leisure.

Outtakes (7, yellow label)

This is the first of the negative ratings. This designation is for images that I probably won't need, but I'm not ready to trash just yet. I use this designation for images that I expect to erase eventually, but that may

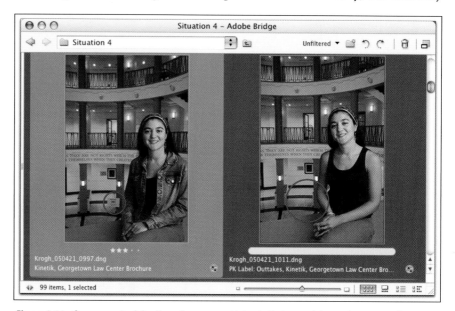

Figure 2-14. One reason to delay throwing away outtakes is that you might need to use an element from one picture in another picture. In this case, the client wanted the sign removed from the final photo. The best image to clone this area from happened to be an image that was an outtake.

contain a useful element such as a hand, an item of clothing, or a part of the background (Figure 2-14). An image that is backfocused, for instance, might be useful to copy and paste elements from. In general, this designation is for images that can be tossed once the job has been delivered.

> ─── N O T E ───
>
> *If you systematically label images as Outtakes, you will have a one-button solution for thinning out your collection at a later date.*

TrashMe (8, green label)

This rating is for images that are to be thrown away immediately. Of course, you could throw away images individually, but there are a couple of reasons not to do this. First, it takes more time to throw away individual images as you edit, and it breaks the workflow pace. Additionally, if you are throwing out many images, you might find yourself accidentally throwing out the wrong one as you move through a set. Third, and most important, using the TrashMe label lets you view your trash selections in the context of the entire shoot, and confirm that you do indeed want to delete the designated images forever. You can confirm, for example, that you are keeping a photograph from every situation—all the pictures of Jim may be pretty bad, but you may decide that you want to keep at least one.

Temp (9, blue and purple)

I save the last two labels for temporary usage. If I want to make some kind of selection of images, I can assign one of these labels a temporary value and use it to quickly apply a designation to the pictures. For instance, if I am looking over a shoot with a client, I can temporarily define the blue label as "Client X Select" and apply it to the images that he likes. I might also use this label to designate an "Alt Pick" (an image that I like, but that I don't think the client will want to use).

Getting the proportions right

As we think about the designation of ratings—what they mean and how to apply them—it's useful to go through a little bit of math. In order for the star ratings to be of value (and to keep the ratings pyramid from turning into the ratings light bulb), make some mental notes about how many image files should be getting a particular rating. I'll use my own collection as an example. (These are rough numbers.)

Table 2-1 shows the current breakdown by rating of my current collection of digital originals, taken in the last three years. If I keep the shooting rate and the rating system constant over the next 30 years, I could expect to see a collection with the numbers listed in the righthand column. You can see that putting a bunch of images into the high rating categories would make these divisions much less useful in the long term.

Table 2-1. Breakdown by rating of my current and projected collections

Star rating	Year 2005	Year 2035
Total images	135,000	1,350,000
Neutral (no stars)	68,000	680,000
1 star	50,000	500,000
2 stars	15,750	157,500
3 stars	1,000	10,000
4 stars	250	2,500
5 stars	0	500

Using a disciplined rating system will enable you to find the images you want more quickly and easily. If you cross-reference a simple rating system with bulk metadata, or with keywords (see the next section), you'll be able to search for your needle in a much smaller haystack.

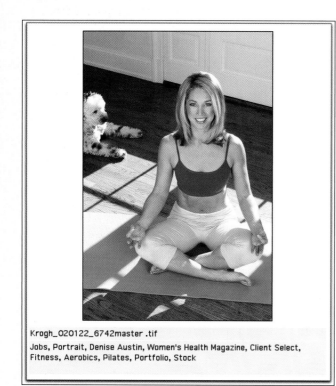

Krogh_020122_6742master .tif
Jobs, Portrait, Denise Austin, Women's Health Magazine, Client Select, Fitness, Aerobics, Pilates, Portfolio, Stock

Figure 2-15. I have associated several different kinds of keywords with this file, ranging from general ones (such as "Jobs") to specific ones (such as the name of the subject).

Assigning Keywords

Keywords are words or phrases that you associate with a picture to describe the subject matter, style, usage, or connotations of the image. These descriptions can be of great use when organizing and searching your picture collection.

Keywords can be abstract terms (like "victory") or subject-oriented terms (like "cat" or "Maddy"). Subject-oriented terms are generally easier to apply because they require less careful consideration. Abstract terms are generally economical to apply only to the very best images, such as ones that will be made available in a searchable stock photography database.

Figure 2-15 shows an image from my collection, with the keywords I've assigned. (As I'm sure you've noticed, I've also assigned keywords to many of the images that appear in this book.)

What's a keyword?

The term "keyword" can have two meanings: it can refer to the term itself, or it can refer to the place where the keyword lives (in the IPTC Keywords field, or in the virtual sets in your DAM program). It's important to understand these differences—just because you want

to associate a term with an image does not necessarily mean that you want that term to live in the IPTC Keywords field.

Some of the keywording that you will do should be best left as *private metadata* (information intended for your use but not to be shared with others). Anything you write into the IPTC Keywords field becomes *embedded metadata*, and is therefore public. (See the "Storing Metadata" section for further discussion about private and embedded metadata.)

Controlled vocabulary

As your collection grows, finding an image by its associated terms (keywords) will become more useful and feasible than trying to find an image by remembering when you took it or where you stored it. To maximize the value of your sorting work, you should develop a method of tagging that is consistent.

Your designation for both ratings and keywords should be standardized, so that you are performing only one search—collection-wide—to find all applicable images. To do this, you will need to use a *controlled vocabulary*. A controlled vocabulary is simply a set of descriptive terms or keywords that has been standardized into a list.

Figure 2-16. **Keywords:** Jobs, Annual Report, Executive Photograph, Group Shot, Portraits

Advanced Grouping: Making Virtual Sets

Ratings are qualitative assessments of images, whereas keywords are content-based or usage-based assessments. *Groupings* can be rating-, content-, or usage-based assessments, or some combination of all three. Groupings are collections of images that share a particular quality, such as "these came

Benefits of Using a Controlled Vocabulary

The best controlled vocabulary will not just be a "flat" list, but will also include synonyms and parent/child relationships. For instance, if you assign the word "cow," you would also assign the word "cattle" (a synonym) automatically, as well as the parent categories "farm animals," "mammals," and "animals."

By using a well-engineered controlled vocabulary, you add maximum value to your image collection —particularly if other people will be doing the actual searching, or if you intend to aggregate your stock collection with other photographers (good stock photography databases are often collaborations).

Currently, no comprehensive tools for controlled vocabulary keywording of RAW files are available to individual photographers. You can, however, begin to use a limited controlled vocabulary in your rating and grouping work right away.

By using standardized terms for your rating and keywording whenever possible, you maximize the value of that work. For instance, you should standardize the way you write people's names in your catalog: is it Lastname, Firstname or Firstname Lastname? Whatever method you use to indicate your ratings should also be standardized.

If you would like to check on the development and availability of controlled vocabulary tools, check out my web site, *http://www.the DAMbook.com*, or David Riecks's site, *http://www.controlled vocabulary.com*.

from the shoot today," "these are my best pictures from the last year," "make 4×6 prints of these for Mom," or "these are all my pictures of Josie."

Some groupings may be generated by a simple keyword search, such as pictures of "Josie," or a keyword search combined with a rating search, such as "two-star and better pictures of Josie" (Figure 2-17). More complex—and valuable—groupings may be made by hand-picking images from these search results and saving them as a virtual set ("Selected images of Josie for slideshow").

Figure 2-17. Cross-referencing quality with some kind of subject matter information can let you generate a specific set of images. (This screenshot is from iView MediaPro.) Using cataloging software, you can take these cross-referenced sets and do further selection.

Groupings are valuable because they turn your collection of images into smaller, subject-oriented "haystacks" (called *virtual sets*). Using virtual sets can greatly increase the speed and efficiency of any searching or browsing that you do. By systematically creating groupings of images as you look at and work with your pictures, you will gradually add considerable value to the collection.

The ability to create multiple "virtual" groupings of images is one of the most important capabilities of cataloging software. All assignment photographs, for instance, can live in a virtual set (*Jobs*) that can be expanded and collapsed for easy viewing. Because the virtual grouping adds little data to the catalog file, and does not involve making duplicates of the images, you can make a practically unlimited number of these virtual sets, and you can nest them together in multiple hierarchies.

Examples of virtual sets that I use are *Jobs, Personal, Collections of images to print, Collections to send to my stock agency*, and *Collections to consider for portfolio use*. These groupings are quick and durable identifiers of my most valuable images. I also find that the best of my images may live in many groups (e.g., *Web Portfolio, Print Portfolio, Stock Submission 050202*, and so on). When I want to find an image quickly, one of the first places I look is in groups that I have already made.

Individual shoots can be split into groups for easier handling, too, as shown in Figure 2-18. A large job or personal project may be divided by location, subject matter, usage, or other factors. For example, inside the *Client* group

may be the *Projects* subgroup, and inside that can be subgroups *Court*, *Neighborhood*, and *Wizards*.

As you consider making groups, again remember a few of the DAM rules:

Do it once...

The most effective way to make groups is simply to save the results of every search or division of images that you do into a virtual set. In the course of doing your regular work with your images (for example, doing a stock or portfolio search, making a slideshow, or selecting images that the client want to have made into master files), you will often find that you are culling images into groups. If you use your cataloging software to make and save these groupings, you will be creating valuable virtual sets that can speed up your work for the lifetime of the collection.

But don't overdo it

Groups are very useful, but don't go too crazy here. Don't make groups just because it's possible; instead, make them (and save them) as you actually need them, and not before. The groups you make because you *need* them are the ones that will turn out to be most valuable to you.

Remember that by assigning bulk metadata, keywording images, and rating your pictures, you can generate some pretty specific groups automatically.

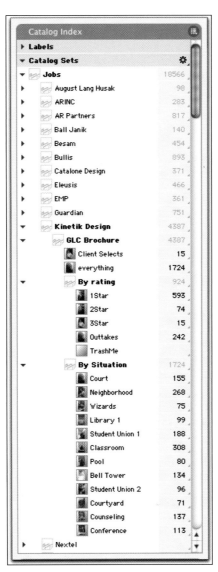

Figure 2-18. Using nested virtual sets makes it very easy to find any particular image you're looking for. In this case, all of these images live in Jobs→Kinetik Design→GLC Brochure, and they are divided by rating and by situation.

If you are a professional, or ever foresee licensing your photographs to anyone, deliver files with the license and your contact information embedded in the photos, and keep a record of those licenses. As an aside, you should also register copyright. You can find a complete tutorial on how to copyright images at *http://www.theDAMbook.com*.

The Most Valuable Metadata You Can Add to Your Photographs

Trust me on this. The most cost-effective cataloging you can do to your image files is bulk metadata entry. After you have done that, rate your images for quality. Then add keywords, and save groupings of images as virtual sets.

Figure 2-19. There's a place to put nearly every kind of information you want to keep about an image. **Keywords:** Jobs, School, Motion, Lockers, Students, Long Exposure, Blur

Storing Metadata

Okay, so where does all this valuable metadata live? Broadly speaking, it lives in one of four places, as illustrated in Figure 2-20.

Where the metadata lives depends on what kind of metadata it is:

Cataloged metadata

> The broadest classification of annotations a photographer keeps about image files is *cataloged metadata*. This encompasses all the information you have cataloged about your image files, such as ratings, bulk metadata, and keywords. There are two classifications of cataloged metadata:

Private metadata

> *Private metadata* is information that lives only in your catalog and is not embedded into the files. You might want to keep information private because you don't want anyone else to see it, or because it is not useful to anyone else. If desired, private metadata can be "pushed" into the file to become embedded metadata.

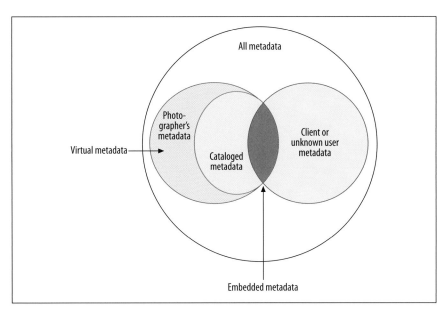

Figure 2-20. Metadata lives in one of four places.

Embedded metadata

> The most durable and portable place to store the information about a file is in the file itself. This is called *embedded metadata*, and it is accessible by anyone who has access to a copy of the digital file. You need to embed metadata that you want any other programs, computers, or users to be able to see and use.

Virtual metadata

> *Virtual metadata* is what I call information about your photographs that exists only in your memory or in totally unattached, unreferenced paperwork. It can't be used by any other program, computer, or user, and it can't really follow the files very well.

Other people's metadata

> The last category of metadata is *other people's metadata*. The core of this is the embedded metadata that you include with the file, which is the only metadata that you can be sure others actually have access to (so, for your best interest, it should include your ownership information). This information can be augmented with any embedded, private, or virtual metadata that others might have created.

Now, let's take a closer look at private and embedded metadata.

Private Metadata

One of the most important capabilities of cataloging software is its ability to generate and use private metadata. Browser software can *only* use embedded metadata, because it has no independent, freestanding place to put other information. Cataloging software, by contrast, lets you decide what information to keep private and what information to push back into the files.

> ——— N O T E ———
>
> *You can store almost everything you know about an image in your DAM catalog. You can keep some information private, but information you want others to see should be embedded into the file. Embedding metadata makes information about the file portable to different computers, programs, and users.*

Information that you want to keep private generally falls into one of two categories. The first is data that you don't want others to see, such as client information or unflattering annotations. For example, you may want to be able to search your catalog to find examples of unattractive people, to show that you can make *anyone* look good. However, you wouldn't want to embed the word "ugly" into the keywords of the images for all to see.

NOTE

When you don't want to make your groupings public, cataloging software offers an option that browsers do not: you can simply collect the images into a virtual grouping that exists only in the catalog.

You may want to keep many kinds of client information in your image database that you won't necessarily want to make public. Because cataloging software lets you associate an immense amount of information with a file, it's likely that some of that data will be sensitive in some way.

The second kind of information you may want to store as private metadata is information that won't be useful to anyone else. A favorite image, for instance, might be added to numerous portfolio groupings. I have some images that are included in several dozen virtual sets of portfolios, web site galleries, or stock submissions. Writing all this information to the keywords field would only add confusion and dilute the value of the important information that exists there (Figure 2-21).

Figure 2-21. **Keywords:** UMD, UNC, Cole Field House, Overtime, Celebration, Victory **Private Metadata:** Sales: ACC Athlete, Sports Illustrated, Maryland Terrapins History, Fine Art Prints

Embedded Metadata

Almost all digital storage formats (TIFF, JPEG, NEF, CR2, etc.) have places to store quite a bit of data about the individual image within the file itself. This data includes the EXIF, IPTC, and XMP fields.

As your images move through your workflow—through Bridge, through Photoshop and your cataloging software, between computers, and off to clients—other applications and other people will want to make use of and add to the metadata. The best way to make sure that the information that is important to you is associated with the file is to embed the metadata right into the file. You may have a superbly cataloged set of images in your digital

asset manager, but if that information does not travel with the files, it is of no use to any program except the original, and to no user but you.

The system that you use to view, sort, store, retrieve, and convert your images must be able to reliably embed metadata into a place where other applications can read and make use of it. At present, that place is most often in the IPTC (International Press Telecommunications Council) fields, because these are the most universally recognized repositories for that information. IPTC fields have places for all the ownership information (such as copyright, contact info, and license info), as well as places for descriptive information (such as the "Keywords" and "Caption" fields).

Embedded metadata and RAW file formats

A few cataloging applications, including iView MediaPro and Canto Cumulus, will let you write IPTC data to the RAW file itself. The advantage to doing this is streamlined file management—the data will follow the file into any conversions you make from it. The disadvantage is the possibility of corruption of the file because the software is writing to an undocumented file format. In fact, there are several instances where this has happened when RAW files have been modified by third-party software.

Bridge does not write IPTC data to RAW files—it writes to XMP sidecar files instead—so no other software can see the metadata created for RAW files in Bridge. You will need to convert the RAW files to another format in order for that work to be visible.

As you will see in Chapter 6, I suggest that you do your initial work—bulk metadata entry, ratings, Camera Raw adjustments, some keywording if appropriate—on the RAW files (with that work stored in XMP sidecar files), and then convert the files to DNG. This will ensure that your important metadata work is more visible and more permanent.

New capabilities of IPTC data

The most commonly supported type of embedded metadata is IPTC data. The International Press Telecommunications Council developed the first system to embed information about a photograph into an electronic file in the 1970s, for wire service transmission. In 2005, a new group of IPTC Core fields were introduced to address the increased metadata needs of all users. The new schema contains many new fields, including several that are of direct benefit to the creators of photographs. The new IPTC fields are fully supported in Photoshop CS2 and will help photographers and clients alike to track photographs.

Let's take a look at the new IPTC Core and what kinds of metadata its fields can hold. The relevant panels are depicted in Figure 2-22 through Figure 2-28. I have entered a short description in each field to indicate what kind of information is supposed to go there. The panels are:

--- N O T E ---

The individual fields have specific purposes. I suggest that you do not "hijack" the fields for your own purposes. If you can't find a place specifically designed to hold the information that you want to embed, see if there is a way to write it into the Keywords field.

The Description panel (Figure 2-22)

Gives an overview of information about the file. Many of these fields are linked to the other panels, where this information is annotated in greater depth.

Figure 2-22. The Description panel, with descriptions of what should go in each field.

The Categories panel (Figure 2-23)

Displays some IPTC fields that are no longer part of the current IPTC Core.

Figure 2-23. The Categories panel, with descriptions of what should go in each field.

The IPTC Contact panel (Figure 2-24)

Enables you to enter lots of information about how you can be contacted. This is probably the most important new addition to the IPTC Core.

Figure 2-24. The IPTC Contact panel, with descriptions of what should go in each field.

The IPTC Content panel (Figure 2-25)

Shows the fields that can store higher metadata.

Figure 2-25. The IPTC Content panel, with descriptions of what should go in each field.

The IPTC Image panel (Figure 2-26)

Includes information that can generally be entered in bulk about a set of images.

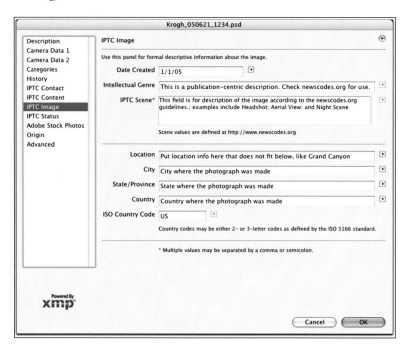

Figure 2-26. The IPTC Image panel, with descriptions of what should go in each field.

The IPTC Status panel (Figure 2-27)

Gathers information about the rights to the image.

Figure 2-27. The IPTC Status panel, with descriptions of what should go in each field.

The Origin panel (Figure 2-28)

Holds information about where and for what purpose the image was shot (like the Origin panel in CS1).

Backward compatibility

The new IPTC Core has a place for nearly every legacy IPTC field, and it will cross-reference those fields. So, if you had entered information in the CS (or earlier) File Info panels, those entries will show up in their proper places in the new IPTC Core.

A few legacy fields ("Urgency," "Category," and "Supplemental Categories") have been deprecated, though, meaning that they are not part of the new IPTC Core. If you want to see what was entered in these fields, you will have to look in the IPTC (IIM, legacy) panel in Bridge, or in the File Info dialog box.

If you're still using the older legacy panel to enter IPTC data, you should switch to using the new IPTC Core panel. If you would like to read more about the capabilities and standards of the IPTC Core, have a look at David Riecks's very thorough discussions at *http://www.controlledvocabulary.com*, or go to *http://www.theDAMbook.com* for more links.

Creating the Digital Archive Part 1: The Information Structure

3

In the next two chapters, I present strategies for building your digital archive. I find it's very helpful to break this discussion into two topics: the information structure and the data storage structure. At first, these two concepts may seem to be synonymous, but in fact they are very different. *Information structure* is the term I use to describe the way the files are organized. It should be stable and scalable; it should not fundamentally change, only be added to. The *data storage structure* is simply the media that happens to be hosting the information structure at any given time, and this will change as you add storage or move to an entirely new medium.

We'll start this chapter with an overview of the digital archive, and then we will examine the elements of the information structure.

The Archive: An Overview

In my studio, there is an entire room devoted to my film and print archive (shown in Figure 3-1). It was expensive to buy all that stuff—from the filing cabinets, to the slide pages and hanging folders, to the light tables and loupes—not to mention the film and processing required to make the pictures themselves. Add to that the cost of the real estate—having an entire room that is dedicated to that purpose alone—and it becomes obvious that shooting and storing film is an expensive thing to do.

Figure 3-1. Maintaining a traditional film archive can be expensive and time-consuming. This photo shows only a portion of the space dedicated to my film and print archive.

In addition to all the expense involved, a large amount of maintenance and organization is necessary to keep a film archive up to date. New images must be filed appropriately, and as images are pulled for various reasons they must be tracked, and ultimately refiled in the correct spot. The climate must also be controlled to prevent mold, moisture, or heat damage.

Similarities Between Film and Digital Archives

A digital archive has many of the same needs as a traditional film and print archive, but those needs are fulfilled in very different ways. The good news is that if you follow the steps in this book, building and maintaining your digital archive will be easier, faster, and more efficient than creating a film and print archive ever could be.

Like my film archive, my digital archive also has a dedicated space: a two-foot square box locked in my equipment storage room. It must be protected from excess heat buildup, and the power must be surge-protected. In this box sits a G4 Macintosh that used to be my fastest computer, attached to a big drive box. Now its only job is to keep the hard drives spinning, and to serve up the files to whichever computer in the studio needs to access them. And any computer in the studio (or even my laptop in a remote location) can be my light table. (See Chapter 4 for a complete description of the hardware I use.)

My digital archive also has a dedicated space in my camera storage area, shown in Figure 3-2. It draws ventilation from a crawl space that remains cool all summer. There is both passive and active ventilation, and the

Figure 3-2. My digital archive.

thermometer gives me a reading of both the internal and external temperatures.

As with the film archive, the digital archive must be organized and maintained. Images must be filed in an orderly way so that they can be found when needed. They must also be rated, grouped, keyworded, backed up, converted, adjusted, and finally delivered to their final destinations. Maintenance includes ensuring file integrity, hard drive health, and future file migration.

In fact, the most important component of any archive, film or digital, is the administrator. If you are sloppy or haphazard about how you organize your images, you will not be able to find them when they're needed. If you fail to do proper maintenance, you will have problems that can lead to loss of images. You need a plan—it must be simple, achievable, and scalable, and you must stick to it.

Structural Differences Between Film and Digital Archives

Many photographers make a basic mistake when they set up their digital archives: they try to replicate their physical filing structure with their digital filing structure. While it seems to make sense at first, this strategy fails to take into account some important considerations.

Physical assets require a physical filing structure

In the physical storage world, the information structure and the data storage structure are essentially identical. Filing structures for film generally use *location* for organizational purposes. An original piece of film can only be in one place, so it is often put in a place that communicates something about that image, such as "This is from Job X," "This is one of my portfolio images," or "This was shot in April, 1989."

Some photographers have implemented database systems to manage their film libraries, but this is relatively rare—and even in these instances, the original film can still only be in one place.

Metadata can be used to organize digital files

Digital archives don't need to use location to indicate picture content information, because metadata and cataloging software can do that much more flexibly and efficiently. Cataloging software allows us to organize the same set of files in numerous ways. We can look at an entire archive and view it according to multiple criteria, including date created, commissioning client, portfolio images, quality rating, subject pictured, and, yes, where it is stored.

Cataloging software frees us from having to use the directory to keep track of content information about that image. This is a good thing, because the digital archive structure should be organized with other issues in mind:

- The archive structure you set up today should be scalable in a way that will meet the challenges of decades of storage.

- The directory structure should be simple: quick to scan and quick to add to.

- It should also be easy to determine if a file has been backed up, and easy to restore in the event of a problem.

Figure 3-3. **Keywords:** Jobs, Stock, Recreation, River, West Virginia, Greenbrier River, Jump in, Take the Plunge

You Might Be Wondering...

You Keep Using the Word "Scalable"—What's up with That?

It's not a fish thing, and it's not about how much you weigh. The term scalable is an IT-geek term referring to the ability of a system to grow with you. In fact, it's not hard to imagine how the growth of your digital archives could make many of the tools you currently use obsolete.

The most obvious tool that will break with archive growth is the comprehensiveness of your "virtual metadata" (my term for a photographer's memory about the contents of her images). While it may be easy to remember what's in your archive when there are only a few thousand recent images, this will become much more difficult when you've amassed a 20-year archive of a million photographs.

You may also hit scalability limits with numbering systems, storage configurations, and software capability. Everything I present here has been designed with an eye toward the inevitable scaling challenges presented by long-term archiving.

Take the plunge

Letting go of a filing hierarchy based on image content can be difficult. But once you surrender yourself to the concept that the directory structure does not have to be the keeper of important content data about your images, a very simple preferred data structure emerges—a structure that leverages the particular qualities of digital media. It saves time, reduces confusion, and will really pay off when you hit one of those practically inevitable bumps down the road (such as drive failure or format migration).

So, now that we've covered a few of the basics, let's take a look at the information structure of your digital archive.

Information Structure

There are several characteristics of the archive that fall into the category of information structure as opposed to data storage structure. What sets these elements apart in a digital archive? The information structure is the organizational construct that you use to keep the files orderly. The data storage

structure is simply the configuration of the digital medium that happens to be hosting the files at the moment.

Consistent Information Structure Is Your Friend

Think about your collection of saved email files or word processing documents. You have probably upgraded computers before, and had to transfer your old files from one machine to another. If you had all your documents in a folder—or perhaps a folder full of folders, as shown in Figure 3-4—this part of the upgrade process was probably not too difficult, because all you had to do was copy the parent folder from one machine to another. The information structure (the way the letters are organized) was able to stay constant, even though it was moved to an entirely new data storage device (the hard drive in the new computer).

You'll want to structure your image storage system so that you can move it as easily as your folder full of documents, and you'll want to be able to find things when you're done. Your image storage structure should be simple, unified, and scalable, and it should be independent of the storage medium on which it happens to be hosted. Essentially, what we will be designing in the rest of this chapter is a structure to hold all your image files, and a way to name the files within that structure.

Figure 3-4. My word processing documents are organized so that I can move this folder of folders to a new machine and keep my files organized in exactly the same way.

Designing a Unified Information Structure

The structure outlined above—a simple alphabetized list of files and folders—is fine for small text files. But when you try to apply this structure to a large data set of digital photographs, it breaks down. In order to design a unified information structure for a digital photography archive, we have to consider a number of factors:

- What kinds of files go together?

- When do images get added to the permanent structure?

- How do you configure the structure to be scalable?

- How does the structure relate to the storage medium?

Let's take a look at these issues, and see how they can inform the creation of our archive.

Ironically, the first step to building a unified archive structure is to decide how to divide up the files. As Figure 3-5 shows, I divide my image files into *Working* and *Archive* groups, and I divide the Archive group into original (RAW) files and derivative files. Each of these groupings is then further subdivided into smaller groups. I'll show you the logic behind this division later in this chapter.

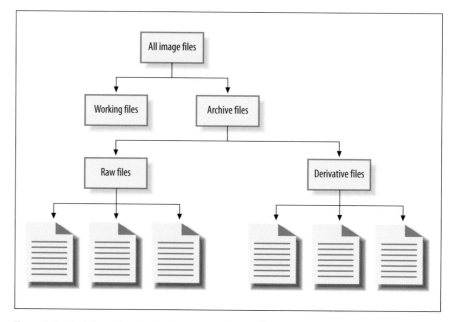

Figure 3-5. The information structure I use to store image files.

I know it sounds obvious, but images should be put into the archive only when they are ready to be put there. For original RAW files, I suggest this should be done once you have renamed the files, rated them, entered bulk metadata, made Camera Raw adjustments, and made your DNG conversion files. Original JPEG files should be added to the archive once you have renamed and rated them and added metadata. Derivative files are generally ready to be put away once you have finished working with those particular versions of the files. By putting images away as soon as possible, you reduce clutter and confusion, and simplify the backup process.

YOU MIGHT BE WONDERING...

What's an Original, and What's a Derivative File?

In the world of film-based imaging, these terms were clear: the film that went through the camera was the *original*, and any print, scan, or film duplicate of the original was a *derivative* file. (Of course, we didn't need to use that term—a derivative was simply called a *print*, a *scan*, or a *dupe*.)

In the world of digital imaging, it's a little different. Since an unlimited number of perfect copies of an image file can be made, we need a new way to think about successive copies of files. A copy of the original file that is unchanged in any way is actually a second original file, and it can also be referred to as an original. A copy of the file that has been manipulated and no longer contains the original information in its original form, on the other hand, is a derivative file.

At this point, you may be wondering about RAW files that have been converted to DNG files. Are they not manipulated versions of the original that don't contain all the original information in the original form? Well, that's true, but in this case the DNG becomes the *functional* original—henceforth referred to as the original. As described in Chapter 8, DNG files can be manipulated again and again as though they were the originals. You can think of them as original image files that have been snipped out and placed in a job jacket with some paperwork and a pretty good print of the image.

A JPEG file that is a camera original is a slightly different story. To remain as an original, the image data must be unchanged. You can duplicate the file, and it will remain an original. But if you open and resave the file—even without changing it—you

will reapply the JPEG compression and degrade the image.

There are only a few things that you can do to an original JPEG file that do not adversely affect the image quality. These tasks have to do with metadata. Some programs (Bridge is one) have the ability to add or replace metadata in the file without opening and resaving it.

Bridge also has the ability to "losslessly rotate" a JPEG. This is also done with metadata, but a more obscure kind: there is a field in the header of the file that can be used to instruct any program that is displaying or opening the file to rotate it, and this header information can be changed without altering the image data. A JPEG that has been opened, rotated, and resaved is *not* an original file, but a JPEG that has been losslessly rotated by changing the header data can be considered an original.

Figure 3-6. Which is the real thing, and which is a copy? Maybe they're all derivatives. **Keywords:** Personal, Halloween, Key West, Fantasy Festival, Marilyn Monroe Impersonators

Files that are not ready to be put away yet are *working files*. Because they are still in the workflow pipeline, they need to be easily accessible and backed up frequently. *Archive files*—those that are in their final forms—can be placed in their permanent homes within the information structure. Figure 3-7 illustrates the relationship between the two types of files.

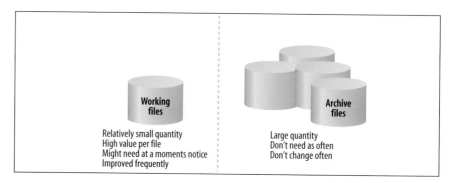

Figure 3-7. Your working files should be separate from your archive files because of their different storage needs.

As your collection of digital images grows, a larger percentage of it will be archive files rather than working files. When you start shooting digital, none of your files are archive files. By the time you have been shooting digital for a decade, your collection will be over 95% archive files. This, of course, is similar to film archives, where only a small portion of your photography collection is new: most of it is archived images.

By splitting your files into working and archive sections, you can more easily and affordably allocate the proper resources for file storage, access, and protection, thereby reducing the cost and the workload of storing your images.

We'll go deeper into this when we talk about storage media. For the moment, keep in mind that the archive structure we are discussing is for files that have been taken as far as they will go in a particular format.

Segregating Original and Derivative Files

From a file-handling perspective, the next division we want to make after working and archive is the division between original and derivative files. Figure 3-8 shows two hard drive directories: one for original files, and one for derivative images. I suggest making a large directory or folder structure for each kind of image. This division will assist in streamlining the download and backup procedures, as well as maintaining file integrity and simplifying future file migration.

For those who are still thinking in analog terms, it may seem to make sense to keep all the *Shoot X* files together in the same folder and on the same drive. I suggest, however, that you should segregate all files into groups of

originals and derivatives. There are some clearly identifiable file-handling reasons that make this a good way to organize your files:

- When the need arises to migrate the files (such as for the conversion of legacy RAW files to DNG), it will be easier to batch everything on an entire drive, rather than having to migrate original RAW files commingled with derivative images.

- For images shot as in-camera JPEG files, it will be immediately clear which are the originals and which are the derivative files, so you won't accidentally overwrite the originals.

- If you are looking for a file, generally you will know before you start searching whether you are looking for an original file or a derivative one. Thus, your search will already be narrowed.

- Most importantly, the conversion from original to derivative may not happen for quite some time, particularly for personal work. In this case, commingling file types complicates the backup process, as you will be scattering the new files among a much larger group of older, already backed-up RAW files. If you build a directory structure that lumps together old and new files, your backup procedures will be much more expensive, complicated, and time-consuming.

Directory Structure: Enter the Bucket Brigade

Now that we have divided our archive images into two main groups, we need to come up with an internal structure for those groups. As in all of our archive, we will strive here for simplicity, durability, and scalability.

Don't Organize Your Directory Structure Around Content

As I mentioned earlier, many photographers mistakenly structure their digital archives like their physical archives, using the directories (folder names) to keep track of important information about the images. They often alphabetize the folders, keeping a sequence of client or subject folders where everything gets stored.

There are a few problems with using this approach for a digital archive. One is that you can only really keep track of a few facets with folder names before the system becomes unwieldy. Do you organize the folders by client, project, rating, keyword, or grouping? How do you handle images that belong in more than one folder? The evaluations you have to make, and the work you have to do to remain consistent, become large tasks in themselves.

Additionally, you needlessly complicate the backup and restoration workflow, as new files get commingled with backed-up ones. If you haven't separated them out, you'll have to back up the entire archive, rather than just your most recent work. While this is not such a big a problem if your archive can all fit on one disk, it gets to be a much bigger problem as the collection grows over time.

Finally, if you try to keep track of content based on just location, it's easy to lose this valuable sorting data if you move files to a different folder. For example, if you designate images as "selects" by putting them in a *Selects* folder, this information will only stay with the files as long as they remain in that folder.

What you need to implement is a way of dividing up files that takes advantage of the capabilities of digital storage: namely, the ability to use metadata and a DAM catalog to keep track of content. Your system should also help you address the challenge of managing an ever-growing collection of digital images—it should be scalable and easy to back up and restore.

What you need are some buckets.

The Bucket System

The entire system described here, which I'll call "the bucket system," is based on simplicity. Because we look at the *data*—the 1s and 0s of a digital file—entirely separately from the *information* about the file—what it's a picture of, whether we like it, and so on—we can pack up the data in ways that make sense for packing, rather than packing it up for *content* sorting purposes. And the best way to pack up data is to put it into a virtual bucket.

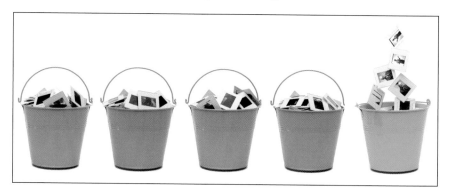

Figure 3-9. Putting images in buckets is a handy way to organize them in a way that helps you address the challenges of long-term storage.

The bucket system of data storage and backup is a deceptively simple technique that addresses a number of the challenges that face the digital photographer. Here are some of its primary characteristics:

- It's simple, and it lets you put away images into their permanent homes quickly.

- It's visually orderly.

- It's scalable: you just add more buckets to add more images, and you can easily combine smaller buckets into larger buckets if you upgrade your storage media.

- It provides an orderly progression of your image files from working files to archive files, and from the recent archive to the deep archive.

- It's easy to confirm the existence of backups.

- It's easily restorable in the event of calamity.

- It forms an information structure that's well suited to migration through multiple data storage configurations over the life of the archive.

Okay, so what do these magical buckets look like? One of my original file storage drives is shown in Figure 3-10.

— NOTE —

Although this chapter deals primarily with the information structure and not with the media storage, the entire bucket system is designed to take advantage of some media storage techniques described in the next chapter. By using this system, you will be able to maximize the reliability, clarity, scalability, and ease of management of your archive system.

Digital photography can seem like a never-ending spending treadmill, so I have developed techniques that enable you to get as much functionality and reliability as possible, as economically as possible.

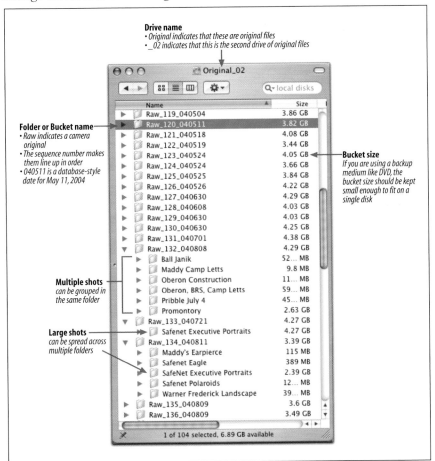

Figure 3-10. My directory structure for original files is quite simple.

You Might Be Wondering...
Why a Three-Digit Sequence Number?

You might be inclined to use a date instead of a simple sequence number to make your files line up. Indeed, if you use a database-style date (i.e., year/month/day, or YYMMDD) instead of the month/day/year (MMDDYY) arrangement that Americans favor, the files will line up in order. However, in my opinion that system has a few drawbacks:

- The first is that a name such as *RAW_123* is easy for me to remember when I need to refer to that folder to find an image. I can essentially ignore the date and only look for the three-digit sequence number. It would be a bit harder for me to remember that I was looking for a folder such as *RAW_050627*.

- Another benefit of using a sequence number is that it makes correlating the original to the backup very easy, as you can see in Figure 3-11.

- Finally, because each folder represents a DVD's worth of information, the organization of the DVDs is very straightforward—*RAW_165* is the 165th DVD in my set of DVD backups. Again, Figure 3-11 shows how nicely this lines up. If you used dates, it would be harder to tell if there was supposed to be a bucket between, say, *RAW_050627* and *RAW_050713*.

Making buckets

At the heart of the bucket system is a very simple idea: put your images into folders that line up in sequence. When a folder gets full (as described below), you simply make a new folder with the next sequence number.

By structuring your directory in this way, you create a natural progression from old files to new. As you add new images to your collection, they show up at the end of the sequence, and older images are "pushed" deeper into the archive. This information structure makes adding files easy and logical. It keeps your files organized, provides easy confirmation of backups, and simplifies the workflow.

Determining the bucket size

There are a number of strategies for determining what size bucket you need. To find the size that's right for you, you'll need to take into account how you shoot and what your storage medium is. (We'll discuss storage media in more detail in the next chapter, but we'll go over the basics here.) Here are a few tips for determining the appropriate bucket size:

Sizing your buckets according to your backup medium

I recommend using write-once media as part of your backup strategy. So that this works as cleanly as possible, each of your buckets should fit neatly onto your chosen storage media. As shown in Figure 3-11, this makes for an easy correlation between the original bucket and each of the backup copies. (You will see how nicely this logic works in the next chapter.) Each "bucket" is a self-contained group of files, and it's easy to see that a copy of each is present by its sequential organization.

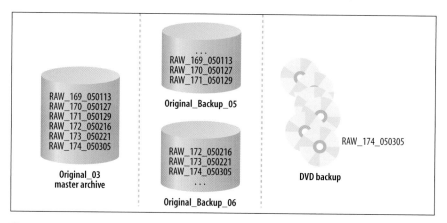

Figure 3-11. The bucket system enables easy confirmation that you have backed up your image files, even if you are using different-sized storage devices—or different media entirely—for your backups. From left to right, these figures represent: the large hard drive with the master original files, the hard drive backups of the originals (on smaller disks), and the second backup copies on DVDs.

Obviously, before you determine how much data to put into each folder, you should decide what backup media you will be using. Because I back up my images on DVDs, I limit the size of each folder to what will fit

comfortably on a DVD, which is about 4.4 GB of data. (Remember to leave room for the Bridge cache files.) If you shoot only JPEGs, you may want to limit the size of your folders to what will fit on a CD (about 700 MB of data). If you are using the new Blu-ray or HD-DVD storage media, you can use considerably larger buckets (from 15 to 50 GB).

Sizing your buckets according to other criteria

If you use only hard drives for backup—not DVDs, CDs, or Blu-ray or HD-DVD discs—you have a bit more flexibility in terms of folder size. You may want to use some limiting factor other than size to organize the buckets, such as time. For example, you may want to start a new bucket weekly, monthly, or bi-monthly, depending on how much you shoot.

The important thing is to systematize so that you have some constant organizing principle. If the buckets are sequentially numbered, you'll get the full benefit of the system.

Naming the buckets

The naming scheme for the buckets needs to do a couple of things: it needs to tell you in broad terms what kind of files the bucket contains (for instance, original or derivative files), and it needs to make the buckets line up sequentially. As long as your names accomplish these two tasks, you have quite a bit of flexibility in choosing a naming scheme. Figure 3-12 shows an example of the format I have chosen for the folders containing my original files.

Here's a breakdown of my naming scheme:

"RAW" prefix

I put the term "RAW" at the beginning to tell me that these are camera originals. In my case, originals can be either RAW files (which I convert to DNG), in-camera original JPEGs, or the *.mov* movie files that my point-and-shoot camera makes. My derivative files get the prefix "DVD," which I'll explain later.

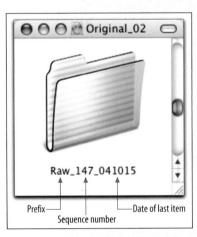

Figure 3-12. The anatomy of a bucket name.

Sequence number

I use a three-digit number as a sequence number for easy identification. Note that I will be able to use this numbering system only until I get to folder 999. I expect, however, that I will have to switch to a larger bucket size (more on that below) before I get to 999.

Date the last item was added

I use the final six-digit number to represent the date on which the *last* item was added to the folder. You could choose not to include a date, or to include a date representing when the folder was created rather than filled. I have found it slightly more useful to show an end date rather than a start date, but the only really important thing is that you are consistent about how you use the date.

I don't include any notation in the bucket name that indicates its contents (such as the client name, the project name, or a notation that the work included is either personal or work-related), but you could easily do so. Feel free to append whatever information is useful to you at the end of the bucket name—it's only the beginning that should be rigidly sequential, as it governs how things line up.

There are many naming strategies that could work for these top-level folder names. You might decide, for instance, to make a note of what's in the folder in the top-level name (e.g., *RAW_165_Client1* or *RAW_197_SummerVacation*).

YOU MIGHT BE WONDERING...

Can't I Just Name My Folders and DVDs According to the Client?

There are a couple of problems with naming top-level folders after clients and not including a numerical designation, particularly if you use CDs, DVDs, or Blu-ray or HD-DVD discs as your backup media. The first is that few of your jobs will be the right size to fill up their own discs. This means that different jobs will probably get grouped together on a single disc, and some jobs will be have to be divided between multiple discs. In addition to being inefficient (because you're likely to wind up with various partially used discs), this makes for a confusing filing system. If images from Job D are grouped with images from Job X, where does the disc get filed—under D or X? This gets even trickier for personal work: do you file it under *Family*, *Vacation*, or *Grand Canyon*?

An additional problem with client naming is that it is nonsequential, which will make it harder to ascertain which images have been backed up. With the numerical bucket system that I advocate, it's very simple to determine that folder *Raw_156* has in fact been copied to your backup hard drive as *Raw_156* and burned to backup DVD *Raw_156*.

Restoration of your archive, should you ever have to do it, will also be much easier if you are simply loading sequential folders from a hard drive or from a set of DVDs. Keep in mind that you will be needing these backups because you just experienced a fire/theft/virus/hard drive failure. This will be a stressful time, and simplicity will be your friend.

The most important reason to implement my system, however, is that it's easier in terms of day-to-day workflow. You simply look at the most recent folder, drop in images if there's room, and make a new one when it's full. No important decision-making as to whether the folder should be named for the agency, the client, or the subject matter is required.

Figure 3-13. **Keywords:** Jobs, Stock, Sigma Lenses, Assateague National Seashore, Wild Ponies, Beach, Maryland

Bucket names for derivative images. Since I use different directory structures for original and derivative images, I have a slightly different naming convention for each. I call the derivative image buckets *DVD_001* and so on. (I use the term "DVD" because I started this naming strategy before I got a professional digital camera. At that time, I did not have RAW files, so it made sense that the buckets were simply DVDs.) You can use "DRV" if you wish, or any other combination of letters that makes sense to you—as long as you're consistent it doesn't make a huge difference, although I do recommend that you keep it short. Figure 3-14 shows how my processed image buckets look.

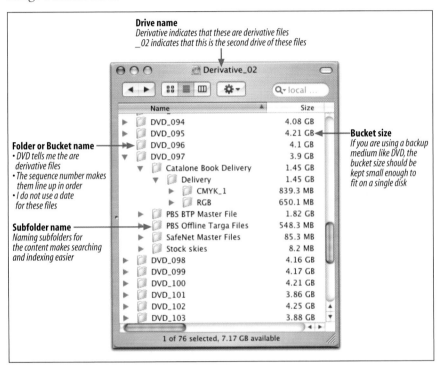

Drive name
Derivative indicates that these are derivative files
_02 indicates that this is the second drive of these files

Folder or Bucket name
• *DVD tells me the are derivative files*
• *The sequence number makes them line up in order*
• *I do not use a date for these files*

Subfolder name
Naming subfolders for the content makes searching and indexing easier

Bucket size
If you are using a backup medium like DVD, the bucket size should be kept small enough to fit on a single disk

Figure 3-14. My derivative files drive is structured in much the same way as my original files drive, except that I don't use the date as part of the bucket name—you may want to include it, but I find the date created less useful for derivative files than for the originals.

Subfolder naming. The subfolders within my DVD-sized buckets are each titled with a short reference to the subject matter they contain, such as client, agency, subject matter, or some combination thereof. This is the only directory-based content management that I use. Keeping this information nested inside a sequential directory structure means that it's still available, but it doesn't confuse the information structure.

As you download images from your memory cards and prepare them for their permanent homes in the information structure, you can put keywords into the subfolder names. As in all of your archive workflow, you will do yourself a favor to use a controlled—or at least consistent—vocabulary. For instance, you might call personal images of your family *Kids, Family, FAM, home,* or something else along those lines. Decide on a term you like and stick with it.

― N O T E ―

Make sure you don't use any nonstandard punctuation in your folder names. You might be tempted, for instance, to include a / in a date name. This may cause hard-to-diagnose problems to appear sometime later. To be safe, only use dashes or underscores in your folder names.

Figure 3-15 shows how I use subfolder names to indicate basic information about the files inside. This directory-based information is particularly useful as I make my first groupings with my cataloging software. By searching the directory for all image files with "Family" somewhere in the pathname, I can quickly make virtual set that includes all these files.

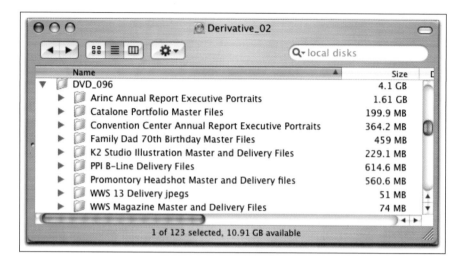

Figure 3-15. Subfolders can be named to include basic information about the contents.

YOU MIGHT BE WONDERING...

Why Do I Have to Keep So Many Files?

Some photographers find it very tempting to erase lots of files, rather than keeping them. What's wrong with that?

The first problem is that it is very difficult to accurately gauge what will be valuable in the future. Remember that the Bettman Archive is filled with images once considered trash. As time passes, images may gain new economic or artistic value as "retro" images, or their subject matter may suddenly become surprisingly more valuable.

Dirk Halstead (*http://www.digital journalist.org*) has an illuminating story about the photograph of Bill Clinton and Monica Lewinsky that won him the Pulitzer Prize. It was considered an outtake and stored deep in his film archive. Only later, after the development of events unforeseen at the time, did the very high value of this photograph become apparent. It's simply impossible to know all the future factors that will affect an image's value.

Hard drive storage is currently running at 1/20 cent to about 1 cent per image stored, depending on the image resolution, storage format, and redundancy. This means you have to delete between 100 and 2,000 images to save a dollar. Unless you are systematically tagging images for future deletion, it generally doesn't pay to do much deleting. (I will discuss thinning the archive in Chapter 9.)

Figure 3-16. It's impossible to know how future events might affect the power of an image. **Keywords:** Jobs, Stock, Landscape, Sigma Lenses Ad Campaign, Twin Towers, World Trade Center, WTC, American Flag, New York City

Combining Buckets

As technology marches along, larger storage solutions will come to market. Those of us who started out using 44-MB SyQuest cartridges have seen the advent of numerous storage media improvements: 100-MB Zip disks, 680-MB CDs, 4.4-GB DVDs, and, very soon, HD-DVDs and Blu-ray discs with capacities of up to 45 or 50 GB. The beauty of the bucket system is that it's infinitely scalable—you can simply combine smaller folders together to make bigger ones, so that the information structure stays stable.

There are two different ways to combine smaller buckets into larger ones: you can either place existing folders intact into a new, larger folder, or you can dump the contents of the folders together into the new folder (Figure 3-17). The critical issue is that your cataloging software needs to be able to keep track of the changes. As long as it can still "see" the image files in the new directory structure, you will have an easy transition.

I think it makes the most sense to place the folders intact into the larger buckets, as shown in Figure 3-18. This is what it might look like when I change to Blu-ray for backup. I will go over this more thoroughly in Chapter 9.

Figure 3-17. Because you can put smaller buckets into larger buckets, your collection will scale well.

Name	Size	Da
▼ 📁 RAW_Blu_024	23.46 GB	
▶ 📁 Raw_116_040427	3.98 GB	
▶ 📁 Raw_117_040501	3.84 GB	
▶ 📁 Raw_118_040511	3.85 GB	
▶ 📁 Raw_119_040504	3.86 GB	
▶ 📁 Raw_120_040511	3.82 GB	
▶ 📁 Raw_121_040518	4.08 GB	
▼ 📁 RAW_Blu_025	23.53 GB	
▶ 📁 Raw_122_040519	3.44 GB	
▶ 📁 Raw_123_040524	4.05 GB	
▶ 📁 Raw_124_040524	3.66 GB	
▶ 📁 Raw_125_040525	3.84 GB	
▶ 📁 Raw_126_040526	4.22 GB	
▶ 📁 Raw_127_040630	4.29 GB	
▼ 📁 RAW_Blu_026	21 GB	
▶ 📁 Raw_128_040608	4.03 GB	
▶ 📁 Raw_129_040630	4.03 GB	
▶ 📁 Raw_130_040630	4.25 GB	
▶ 📁 Raw_131_040701	4.38 GB	
▶ 📁 Raw_132_040808	4.29 GB	

Original_02 — Q▾ local ...

95 items, 6.89 GB available

Figure 3-18. As you move to a larger bucket size, you will want to combine the smaller buckets into larger ones. This keeps the information structure stable and provides for reasonably simple data migration.

The Fine Art of File Naming

File naming is the most basic component of your information structure. As such, it's important that you choose a method of naming files that you can use for a long time and grow with.

As I will demonstrate in Chapters 5 and 6, there are some powerful batch-renaming utilities in Bridge that enable you to rename an entire folder full

Figure 3-19. Naming can be an art unto itself. **Keywords:** Jobs, Portrait, Studio, Painter, Trompe l'oeil

of files at once. All batch-renaming utilities enable you to select among various types of text and data to use in the renaming process. We will take a look at the desired end result here, and we'll go into how to achieve it in the later chapters.

Renaming Original Files

Digital cameras generate huge numbers of files with similar or identical names. As of this writing, no cameras that I am aware of will give you sufficient options to automatically generate unique filenames. And even as they do begin to offer this option, you will still have to decide on a naming system that you like.

Here are the most important characteristics of a naming system:

Each image file should get a unique filename
> This helps in all sorts of ways, from preventing accidental overwriting, to assisting in any client communications about the files, to archive reconstruction. Using the date taken as part of the filename is probably the easiest method of making sure that you do not give a file a name that has already been given to another image.

Each filename should end in a three-letter extension preceded by a period
> For Windows users, this will be second nature. For Mac users, explicitly including file extensions (e.g., *.NEF*, *.CRW*, or *.JPG*) is still optional; however, using the extension ensures greater compatibility.

Filenames should be no more than 31 characters long, and the only punctuation should be underscores, dashes, and a single period just prior to the file extension
> Although various computer systems can support names longer than 31 characters, we want to structure our practices to be universal. Keep it to 31 characters (plus the extension), and you will be safe. Again, Mac users may have to get used to not including spaces and other punctuation in filenames, but this will ensure greater cross-compatibility.

The naming system should be regularized and universally applied
> If you implement a standardized naming convention, you'll save time and avoid errors.

Including a database-style date component in the name can help you line up all your files in the order they were taken
> Database-style dates start with the year, then the month, then the day. This keeps files in chronological order.

> The notation for the date format usually comes in the following form: YY or YYYY indicates the year as either a two- or four-digit number, and MM and DD indicate the month and date, respectively.

Your naming system should be compatible with the renaming function in Bridge or in whichever DAM software you are using to rename

Obviously, your naming system must work with whatever program you are using to generate the names.

It should be easy to apply names without having to check if they have been used previously

Again, using a date in the filename can streamline this process.

Tags or Codes should be appended to the filenames to indicate derivative versions of image files

Successive versions of the same file—a master file, for instance, or one converted to black and white—should have some kind of tag added to the filename to note the enhancements. This is generally preferable to renaming the entire file. (There are times when you might want to rename a file entirely, though, as discussed in Chapter 8.)

*The filename does not have to carry important **content** information about the file*

Putting content information in the filename can get complicated, and it takes up valuable character space. However, I do suggest appending format information about the derivative files to the filenames.

A file naming system that incorporates your name can help your clients keep track of your images

As discussed below, adding a string (a sequence of letters) in the filename that identifies a file as yours will help your clients remember where it came from.

Figure 3-20. Give those babies good names. **Keywords:** Josie, Maddy, Birth Announcement, New Year, Baby, Arrival

Okay, so that's a lot of considerations. To see them in action, let's take a look at my favorite naming system and examine why it works. The convention I have settled on for naming my digital camera files looks like this: *Krogh_050428_2728.dng* (Figure 3-21). Here are the elements:

The originator string

I start the name with the string "Krogh," because I want people to know the image came from me. This works for me because I have a short and reasonably uncommon name, but if your name is something like Smith or Jones, including it in the filename might be less valuable (I do know one photographer who has a common last name but an uncommon first name: he uses his first name in his filenames). If your name is long—Schwarzenegger, for instance—you might also find that it's unworkable to include it in the filename. You might decide to use your initials instead, or to use no name component at all.

When deciding on a string to use, remember that you will be appending other strings to these filenames as you work with the files, and that you'll need to keep the entire name below the 31-character limit.

The date string

After my name, I place an underscore in the filename to set it apart from the next element, which is the date. The underscore is just a little visual marker that makes the filename easier to read. I then place a database-style date in the filename. My preferred naming format, as indicated earlier, is often noted as Date (YYMMDD)—thus, in the earlier example, 050101 is January 1, 2005.

It's a bit hard for us Americans to read this date format quickly at first, but for sorting purposes it makes much more sense than the way we usually write dates (month/day/year, or MMDDYY).

Figure 3-21. As you can see, if you use a database-style date near the front of the filename, your files will line up in order. This is even more important if you use the DNG format, because the date created will be the date the DNG was made, not the date the picture was taken.

The unique identifier sequence number

The next part of the filename—again, separated by an underscore—is the *unique identifier* number. In many cases, this number is the number that was incorporated in the original filename (e.g., *DSC_1234.NEF*). As a matter of fact, when I am shooting with only one camera, I almost always use the unique identifier number from the original file. I do this so that I have a smaller number of files with the same identifier. The original unique identifier is written to EXIF metadata, and many applications can extract it and use it as part of a batch-naming process.

You may be tempted to rename each batch of photographs with unique identifier sequences starting at 0000, but this will yield a very large number of files in your collection with unique identifiers of, say, 0011. Using the original, camera-assigned unique identifier gives you a range from 0001 to 9999. This makes any Finder-based searches for image files much faster and easier to do.

There's one circumstance when I don't keep the original unique identifiers: multi-camera shoots. Because I want the image files to line up in the order taken, I need to reassign entirely new unique identifiers. First, I line up all the files in chronological order by EXIF date (which includes time to the second), and then I renumber the files. (This procedure is covered in detail in Chapter 6.)

Because all my filenames start with my name and the date taken, they line up in order very nicely. You could instead use a four-digit number for the year (e.g., *Krogh_20050101_1234.NEF*), but I don't think it's necessary. While I'd like to think that I will be shooting pictures when I'm 140 years old, the odds are against it. I have therefore chosen a format that will only really work for images shot up until 2100. Also, by dropping the first two numerals off the year, I gain two more characters to use when renaming files as derivative files (as outlined below).

Special Naming Considerations for JPEGs

One of the benefits of shooting a RAW file is that you know that no application will write over that file (no program can, for instance, reduce the size of the file and then resave it as a RAW file, forever changing the original). The only applications that can resave RAW files work only on the *metadata* of the file, not the underlying *image data*.

If you shoot in-camera JPEG originals, however, your original image files are at risk—it's possible to accidentally reduce the size of the file, or make some other destructive change to it, and save over the original. It's important, therefore, to have some way to prevent saving over your originals, as well as to have good backups of the files in case you ever need to restore the originals.

I use a combination of careful handling and archive structure to keep from overwriting in-camera JPEGs. We'll go over archive structure and backups in the next chapter; for now, let's examine what we can do with file naming to address this situation.

You might choose to append the terms *Orig* or *CO* (for Camera Original) to the names of your original JPEG files, as shown in Table 3-1, so that you can tell by looking at a file if it is the original. Of course, that means that you will need a way to remove this designation from the filename when you batch out the images. Bridge does not have an easy way to *remove* elements from multiple filenames at once, but iView and some other DAM applications do.

Table 3-1. Some possible ways of naming JPEGs

File type	Filename
Original files	*Krogh_050101_1234_Orig.jpg*
	Krogh_050101_1234_CO.jpg
Derivative files	*Krogh_050101_1234_Copy.jpg*
	Krogh_050101_1234.jpg

If you're using Bridge, as an alternative to removing the distinguishing extension when batching out the images, you could instead choose to *append* a designation to the filename to distinguish it from a camera original. You could, for instance, add "PY" to the end of a filename ending in "CO" to get a filename that ends in "COPY." Bridge does make this a fairly easy process.

As you decide on your file naming system, you need to evaluate how confident you are in handling your files so that you can determine whether your JPEG camera originals will need special designations in their names.

Appending Filenames for Derivative Files

The method detailed above is the basic naming structure I use for original files. I suggest that the core of the filename (in this example, *Krogh_050101_1234*) should never change for internal uses. By keeping this part of the name constant, you will streamline the file-handling process. A single search on this string, for instance, should be able to identify every version you have ever made and saved of this file.

When you make a new version of the image, I suggest appending a string to the name. For instance, when I prepare a master file—a color-corrected, retouched master version of the image—I append the word "Master" to the filename (e.g., *Krogh_050101_1234Master.tif*). If I make a black and white conversion, I add the letters "BW" to the filename.

You Might Be Wondering...
Shouldn't I Put the Client's Name, or the Subject Matter, into the Name of the File?

I originally thought this was a good idea, but I soon found that it didn't work for me. Right off the bat, from a workflow standpoint, it was difficult. Should I use the client, agency, project, or location in the name? What if I've used the agency name, and I now want to sell this as stock to another agency? It also started to be a real hassle to remember what codes were used for what subject matter, particularly for personal work.

More importantly, I was interested in having the client be able to associate me with the photographs. I figured it was more important for them to know that the image was from Peter Krogh than that it was prepared for Agency X.

Most of all, putting my name in the filename was just simpler. This meant that a large memory card full of personal images shot in many locations could simply be batch renamed, without first evaluating the subject matter.

Table 3-2 shows some examples of the strings I use to note different types of derivative files. As we discussed in the last chapter on metadata, you should be as consistent as possible so that you always know what each designation represents. You should think about your workflow, and the kind of photography you deliver, as you decide on the naming convention you will use for derivative files.

Table 3-2. Sample names for derivative files

Filename	Type of file
Krogh_050101_1234.DNG Krogh_050101_1234.NEF Krogh_050101_1234.JPG	Camera original file.
Krogh_050101_1234Master.tif	Color-corrected, retouched file.
Krogh_050101_1234BW.tif	Black and white version of the color master file.
Krogh_050101_1234MasterBW.tif	Master file that was converted to black and white straight out of Camera Raw and does not include any color information.
Krogh_050101_1234CMYK.tif	Image that has been converted to CMYK for offset printing.
Krogh_050101_1234Flat.tif	Flattened version of the master file.
Krogh_050101_1234.tif	File intended for client delivery, or prepared for printing or proofing. I typically remove any suffixes I've appended to the filename (except "CMYK") before I deliver the file to the client, to reduce confusion.
Krogh_050101_1234.jpg	In-camera original (for in-camera JPEG originals), or a file to be delivered to a client over the Web or by email.

When to Change Filenames

You might be tempted to rename image files with more descriptive terms at some point (say, changing *Krogh_050101_1234* to *NewYearsDay.tif*). With a few exceptions, I recommend never changing the name of a file after it has been given a unique name and been worked with. Keeping file naming constant will reduce confusion between you and your clients, and also between your present self and your future self.

One exception is if you *know* that your client will be renaming the files—for instance, if file naming is part of the specifications of the job. In this case, it will be helpful for you to rename the file yourself, and to put the "real" name into the metadata of the file so that you can reference the original if needed. This ensures that the real name gets placed in the metadata, performs a service for the client, and (since I suggest keeping copies of all delivered files, even if they are just flattened copies of master files) provides a way to link a renamed file to its original master file.

The other time I rename is when the destination of the image file is my web site, and I want the image to be discoverable by image search engines. A descriptive name, rather than a date/sequence name, makes the file more easily locatable by Google and other search engines. Google Image Search uses the name of the image file as an important determinant for search results, so descriptive terms in filenames can be of real value here.

Aside from these situations, it's good DAM practice to keep filenames permanently, because the filename is the foundation of the information structure.

File Naming Recommendations

I have outlined below a few different RAW file naming protocols.

The following are highly suggested:

- *Krogh_050101_1234.NEF* (OriginatorName_Date(YYMMDD)_UniqueID.Extension)
- *PHK_050101_1234.CRW* (OriginatorInitials_Date_UniqueID.Extension)
- This is also a good one, especially if the date reads easier to you. *Krogh_20050101_1234.CRW* (OriginatorName_ Date(YYYYMMDD)_UniqueID.Extension)

These naming protocols, on the other hand, are not suggested:

- *DSC_1234.NEF* (original camera name)
- Krogh_010105_1234.NEF *(OriginatorName_Date(MMDDYY)_UniqueID.Extension)*
- Acme_1234.NEF *(Client_UniqueID.Extension)*
- Beach_1234.NEF *(Subject_UniqueID.Extension)*

Creating the Digital Archive Part 2: Hardware Configurations

<div style="text-align: right">**4**</div>

In this chapter, we'll look at how to configure a digital storage system to host the information structure that we created in the last chapter.

Keep in mind that whatever configuration you are using at a particular time is likely to be only a temporary host for the information. As I mentioned earlier, your hardware configuration (how your computer system is set up) will probably be the most often-changing part of your digital archive. Storage solutions that work today will likely be too small in a year or two, and will probably seem quaint in five years' time.

In this chapter, we will investigate some storage solutions that are available now, while at the same time presenting useful concepts for evaluating new technologies as they arise. I'll start by briefly discussing the system I currently use. Then we'll take a look at the considerations behind the choices I made: what kind of storage to use, how to configure the hardware, and how to create backups that provide adequate protection for your images.

The methodology that I outline in this chapter will provide for a scalable system (one that can grow with you from a single hard drive of images, up to terabytes stored on a client/server network) that protects your photographs and provides you with quick and reliable access to your images.

My Rig

Figures 4-1 and 4-2 show the computer systems I currently use. These configurations have evolved over the course of nearly 20 years, and they continue to change and be improved. Obviously, your systems will vary with your needs, temperament, and budget, but looking at a functioning setup can be a useful way to start to get your head around designing a hardware configuration that will work for you.

We'll go over the specifics of designing a successful hardware setup later in this chapter, but to get you started let's take a look at the configurations I use both on location and in the studio.

Location Hardware

On location, I download my media cards onto my laptop with a FireWire card reader. I then immediately back up the files onto an external FireWire hard drive, and I also download the cards again onto a portable storage device known as a "digital wallet." (This is explained further in Chapter 6.)

Figure 4-1. My location setup includes a FireWire card reader, portable storage device, external FireWire drive, and laptop.

In the Studio

Back in the studio, I transfer the files to my Photoshop workstation, where I add metadata and adjust Camera Raw settings. I then convert the RAW files to DNGs and put them into their permanent "buckets" on the server.

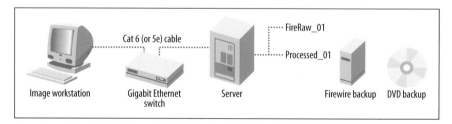

Figure 4-2. These are the components of the system that I use in my studio.

The server is an older computer connected to a big drive box. This drive box holds up to 8 hard drives and currently has a possible capacity of 2.5 terabytes (TB). The drives inside this box are configured as follows:

- Three drives (1.1 TB total) for original files

- Three drives (750 GB total) for derivative files

- One 250-GB drive as a backup for the current working files

There is also an open slot in the big drive box that I can use to swap out backup drives on removable caddies.

All of the original and derivative files on the drives above are backed up to hard drives that live off-site at my assistant's house. These backup drives get new files added weekly. All of the images are also backed up on DVDs.

I also have a bootable backup of each boot drive, stored on FireWire drives (shown mounted on my computer in Figure 4-3). These are copies of all my applications, exactly as I have them configured. If I lose a boot drive, I can recreate it from these backups.

This may sound complicated—perhaps even unnecessarily so—but let's take a look at the reasoning behind this configuration.

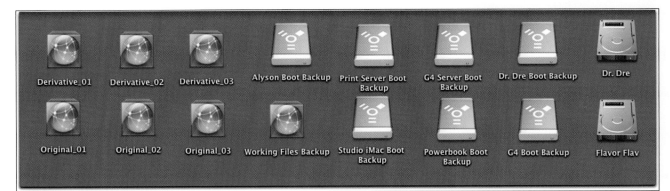

Figure 4-3. My desktop with my server drives and my backup drives mounted. The ones on the left are server volumes, the yellow ones are FireWire volumes, and the ones on the right are internal drives on the workstation.

Choosing a Storage Medium

I strongly suggest that the media holding your photographic archive be dedicated to that purpose alone. This enables it to cleanly host the information structure that we went over in the last chapter, and it is a much neater arrangement in terms of care, handling, and backup.

Regardless of what technology is currently available, there are universal factors to consider when choosing your storage media. In determining if a particular technology is appropriate to the task at hand, you'll need to consider:

Speed
> Can you move your files onto and off of the storage medium fast enough for the way you shoot, work with, and deliver files?

Scalability
> What is the cost, in both time and trouble, involved in adding more storage capacity? Must you reconfigure the entire device/system, or can you simply add more storage? How does your system grow with your collection?

Reliability
> What are the inherent risks of device failure? Can you reduce these risks by altering your setup, configuration, or behavior?

Single Point of Failure Versus Redundancy

One of the concepts that professional system administrators use to evaluate risk is the *single point of failure* (SPF). This refers to a mission-critical component that, upon failure, brings down the entire system. It's an interesting exercise to look at your computer system—indeed, at your entire photography system—and identify these SPFs.

If you own only one computer, every part of that computer is an SPF, because the failure of any part of the computer (hard drive, power supply, monitor, RAM, etc.) will leave you dead in the water. If you have more than one computer, on the other hand, you have redundancy for some of those failures.

Photographers have always believed in *redundancy*, because we have always relied on machines to do our work. And we know that machines can fail, often without warning. Because we now rely on complex electronics to create and deliver our work—and because our clients expect it to be done so much more quickly—it's more important than ever for us to have redundancy built in throughout the entire system. Evaluating on the basis of SPFs will help you to anticipate problems before they arise, and to be prepared to address them when they come up.

Protection against hazards
> Your digital data will be exposed to a limited set of known hazards. As you evaluate a storage or backup medium, consider how well it protects against these dangers.

Plays well with others
> How do your various storage media compliment each other? How easily can they be ported from one computer to another?

Mission-critical operations and components
> Tasks that *must* be completed for the job to succeed or for the archive to have integrity (and components whose security must be ensured) are *mission-critical*: that is, they are critical to the success of the mission at hand. Failure of a set of backups, for instance, will be mission-critical only if it is the sole existing copy of the images.

Keeping It Live and Local

First, let's figure out where all your "buckets" (discussed in Chapter 3) are going to live. When determining what storage configuration to use for your information structure, there are several key points I'd suggest:

- Keep all digital images on "live and local" hard drive storage.

- Start your archive with a dedicated internal drive or a dedicated external (FireWire or USB2) drive.

- Get an additional external drive to use as backup, and store it off-site if possible.

- Burn backups of all archive "buckets" to DVDs or other write-once media.

To me, the clearly superior storage solution is the "live and local" hard drive, with two backup copies. "Live" indicates that it has not been frozen by existing only on write-once media (such as CDs or DVDs). "Local" means that it is currently accessible by your computer—that is, stored on an internal drive (or drives), an external drive (or drives), or a local network file server.

Storing images on local hard drives has a number of significant benefits:

Faster archiving and retrieval
> It is much faster to write to a hard drive than to CD, DVD, or digital tape, so the image files will get into their permanent homes in the fastest possible way. It is also much faster to retrieve an image from a hard drive than from any other storage source. Even if your CDs/DVDs are meticulously cataloged and sitting on a "jukebox," it can take hundreds of times longer to pull up an image from one of these storage media than from a connected hard drive.

When they need to be migrated, your files will be available and at the ready
> Migration will eventually be required, because of the obsolescence of your storage media, operating system, and/or file format. You'll thank

yourself if you can do this migration relatively quickly and easily. (If you have any 5.25″ floppies or MAC OS 6–era disks sitting in your desk drawers, you know what I mean. Yes, you could find a machine somewhere to open the files they contain and translate them into a format that can be used today, but it might take quite a bit of time. And because you have no way of knowing exactly what's in those files, or if they are even readable, the calculation tilts toward not making the effort. Every year that goes by makes opening those files harder and less likely to happen.)

You'll be able to periodically check on the integrity of the files

If the primary versions of your files are stored locally, you can easily confirm that files are uncorrupted without having to load a CD (which, by the way, incurs a risk of handling damage every time you touch it). I periodically use the DNG converter to check that the files are still readable.

You'll be able to update the files as you work on them

Updating typically consists of manipulating either the image or the metadata. For instance, as future versions of Photoshop are introduced,

Figure 4-4. "Live and local" isn't only about music—it's also the best way to store your digital files.
Keywords: Music, Musician, Hands, Piano, Guitar, Instruments, Local Events

You Might Be Wondering...
Can't I Just Burn These Old Jobs to DVD and Erase Them from My Hard Drive?

Of course you can, but I don't recommend doing so. As mentioned in the previous chapter, one argument against deleting images from your hard drive is that it's very difficult to accurately calculate the market or personal value of your images long into the future.

Once you start dividing your archive between files that are live and local and ones that have been burned to DVD and erased, you introduce a significant level of complexity into your archive management. This will really become apparent when you need to upgrade your file format, storage medium, or operating system. At that point, you will need to determine which of those files need to be reloaded and migrated. This can be a frustrating, time-consuming, and error-prone process.

Furthermore, the cost of hard drive storage is now so low that erasing images from your drives really won't save you much money. It is good practice, however, to thin outtakes periodically. In Chapter 9, I will show you how my editing method will let you quickly identify images that can be culled, while keeping the best of the take.

better RAW conversions will be possible. You might want to reconvert important image files, or perhaps convert your images for the first time. You will want to store these new Camera Raw settings along with the files in the master archive, either as XMP sidecar files or (preferably) embedded in DNG conversion files.

Additionally, as you perform organizational work on the images (rating, grouping, and keywording), you will want to write much of that metadata back into the XMP or DNG files. Think of the hassle of reburning CDs or DVDs each time you made a better conversion or after every keywording session—or the even greater nightmare of keeping track of which selected images have been updated, and which have not.

Unnecessary duplication and version drift will be easier to avoid
Because there is only one place for files to reside, you can easily find the original (which you'll know is the most current version) and determine whether it has been properly backed up. Back in the day, when hard drives were very expensive, I used to archive on CDs. This became very confusing, as I struggled to keep track of which images had been burned to CD, which copies of a file were the most recent, and which were the most versatile. In order to determine this, it was necessary to load the CD and open and compare files. Sometimes the differences were slight, and it took quite a bit of time to determine which was the best file.

This live and local strategy provides an orderly framework for your archive, with only one each of the master original file and the master derivative file. It is an accessible, confirmable, migratable, and updatable system.

Balancing Cost and Performance

If you *knew* film was going to drop to half its current price in 12 months, how much film would you keep in stock? While this is unlikely to happen to film, this is the rate at which digital storage costs have dropped over the last decade. Thus, one thing that should immediately be clear is that you shouldn't buy storage capacity that you don't intend to use in the next six months.

The storage medium for your photographs will be one of the fastest-changing components of your digital photography archive. When I first started working with digital images in the early nineties, hard drive storage cost $2,000 per gigabyte. Today, it can be purchased for $.20 per gigabyte—a one million percent increase in purchasing power. Storage solutions will continue to get cheaper, faster, physically smaller, more reliable, and higher in capacity in the future. Keep this in mind as you decide how to store your images now, and how to configure future storage systems.

In addition to deciding what quantity of storage to buy, you must also decide on quality. Don't expect any part of your storage system to still be in use in 10 years; most of it will be entirely replaced in fewer than 5. Looked at in

this way, paying a lot extra for 300-year archival CDs doesn't make much sense.

I would also suggest—at the time of this writing, at least—that buying expensive RAID (Redundant Array of Independent Disks) setups for archive files doesn't make a lot of sense for most photographers, either. All of this stuff will be cheaper, better, and faster in the very near term. As my network administrator friend Skip always says, buy the computer you need now, not what you will need in 18 months. I have found this to be very solid advice, ever since he gave it to me more than 15 years ago.

Establishing a File Server

Most basically, a *server* (Figure 4-5) is a computer that makes files available over a network. A server can be *dedicated* (i.e., exist only to make files available to other computers), or it can do other jobs as well. For example, your main Photoshop workstation could make files available to other machines, qualifying it as a file server, even as it performs other tasks. A *client* computer is one that makes use of files or applications that reside on another computer.

Figure 4-5. Servers can be big or small. **Keywords**: NOC, Network Operations Center, Control Room, Server, Computer

Photographers switch to client/server networks for several reasons, including the following:

- They need to be able to access the files from multiple computers.

- The size of the drive enclosures outgrows the physical space in the desk area, or they get too noisy.

- They want to lock up the files in a more secure and/or temperature-controlled location.

Prepare for Failure

All hard drives will eventually fail. They are precision machines, spinning at thousands of RPMs, with moving heads that skim very close to the data platter. Bearings, controller hardware, and head crash are the most common types of failure. In my 15 years of computing, I have had 4 drives die a sudden death with no warning (of the roughly 60 drives I have owned).

The successful archive strategy includes backing up your drives and rotating them out of critical service *before* they fail, probably expecting no more than three to five years from any drive. Statistically, drives are more likely to fail within the first couple of months, or after many years of service. Be sure to run drive utilities (such as TechTool Pro or Disk Warrior on the Mac, or Norton Utilities on the PC) on your new drives to check their general health, and to keep everything backed up.

SIDEBAR

Self-Contained Servers

Techno-weenie alert! This section is for those who like to take computers apart (and can generally get them back together correctly).

The G4 Macintosh that I use as my file server has been configured in two ways: first with internal drives, and later attached to a big drive box. Here's a quick rundown of my original configuration, and why I changed it. (All of this will be covered in greater detail in the next few pages.)

Many tower computers have extra internal drive bays. In the case of this computer, there are five in total (six if you take out the CD burner). I eventually filled them all, before I went to another configuration. Figure 4-6 shows what this computer looks like when opened up.

In order for the computer to connect to so many drives, it was necessary to install two additional ATA133 PCI expansion cards (about $70 each). These cards do three things:

- They provide extra ATA connections for additional drives.

- They provide a faster transfer rate than the built-in ATA 66 or ATA 100 bus.

- They provide support for drives larger than 137 GB. (Most older ATA buses only support drives smaller than 137 GB.)

 (If I were setting up this system today, I would use a Serial ATA (SATA) PCI card instead, because it is a faster connection.)

Eventually, however, I decided to move the drives over to a big drive box, external to the computer. I did this for several reasons:

- I was concerned about the heat buildup in the computer, which can reduce the lifespan of the internal components.

- I was concerned that I was overtaxing the power supply in the computer.

- I found that I had to open the computer frequently to upgrade the drives, and it was easier to have the drives contained in removable sleds.

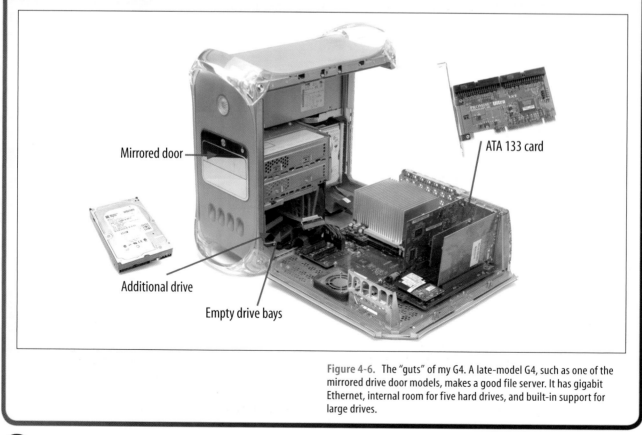

Figure 4-6. The "guts" of my G4. A late-model G4, such as one of the mirrored drive door models, makes a good file server. It has gigabit Ethernet, internal room for five hard drives, and built-in support for large drives.

One economical way to set up a modest server is to take a stable, used computer and add some internal or external drives. This is a good use for a proven-reliable computer that you've replaced with a newer, faster one. Because processor speed is less important for the server than for your Photoshop workstation, an older computer can have a long "second life" as a server. The most desirable qualities for the server are, in order: proven stability, quality manufacturing, gigabit Ethernet, and expansion options (multiple drive bays, FireWire/USB2 ports, or open PCI slots).

At the other end of the server spectrum are rack-mounted machines such as the Apple Xserve or Dell PowerEdge, with a hardware-controlled big RAID setup. These computers are the kinds of machines that large corporate networks run on: they're well made and reliable, with modular, redundant parts for quick swap-out. At the moment, rack-mounted RAID servers are very expensive.

As your archive grows, an increasingly large percentage of it will be archive files rather than working files; you won't need time-critical access to most of it, most of the time. A mission-critical, expensive server like this would be overkill for most photographers' complete archives, especially as the archives grow in size over the years.

I expect that the falling price of hard drive storage, coupled with the demand for lots of media storage space, will spur the development of many new Small Office, Home Office (SOHO) servers with lots of capacity. Look for these to become available soon, driven by the needs of people who want to store lots of video from their digital video cameras and TiVo-like devices.

— N O T E —

If this stuff is too daunting for you to undertake on your own, and you have too many image files to keep on a single drive (and a single backup drive), you probably need a good computer consultant to set up your system for you.

Drive Configurations: JBOD, RAID, or NAS?

It's alphabet soup time! This may sound very confusing at first, but the concepts are not that difficult. When you install multiple drives on a computer, you can either configure them individually, as *Just a Bunch of Disks* (JBOD), or you can configure them as a *Redundant Array of Inexpensive Disks* (RAID). *Networked Attached Storage* (NAS) is also an option. All three possibilities are shown in Figure 4-7.

What we are essentially talking about here is the configuration of your drives, and how they are known to the computers on your network. They can appear to the computers as the individual drives that they are, or as one giant drive. Alternatively, they can be connected to the network without going through a server. Let's take a closer look at the possibilities.

Figure 4-7. Depending on your needs and budget, you can choose from three different network drive configurations.

JBOD

JBOD is a configuration of multiple disks that retain their identity as individual disks. It is the simplest arrangement, and the easiest to configure, upgrade, and repair.

JBOD is the preferred drive structure for the archive files in the bucket system, for several reasons:

- It's simple to set up and to add to.

- It's the most economical configuration.

- For archive files, RAID doesn't get you a lot of necessary protection in exchange for all the expense and work involved.

- Restoration of the archive can be simpler in the event of a drive failure, since only that particular drive is affected.

- The amounts of energy used and heat generated are reduced, since only drives that are being accessed need to "spin up." Drives housing older material can remain at rest when unneeded.

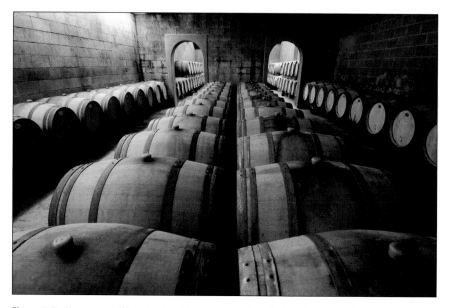

Figure 4-8. Keep your stuff neatly stored in separate buckets (or barrels). **Keywords**: Winery, Cellar, Storage, Barrels

RAID

In a RAID setup, several drives are configured together as though they are one single volume, so the computer sees multiple drives as a single device. This can be desirable for reasons of speed and/or redundancy. Your RAID setup can be controlled by a hardware controller (such as a PCI expansion card), or the drives can be "RAIDed" in software.

A RAID setup can be a good choice for working files in a mission-critical situation, such as a studio where there is lots of deadline pressure. Some possible RAID configurations are outlined below. RAID can be set up as striped RAID, mirrored RAID, or both. RAID 5 is probably the best choice here.

- RAID Level 0, or *striped RAID*, treats several drives as a single drive in order to speed up reading from and writing to the drive. Basically, it breaks up a file into several parts, and writes them simultaneously to multiple drives at once. This is used in applications such as video editing, where great speed is necessary. For most photographers, it is an unnecessary additional level of complexity. Remember, if one of the drives fails, you will have to reconstruct the entire volume from backups.

- RAID Level 1, or *mirrored RAID*, writes the same data to multiple drives to help ensure seamless operation in the event of drive mechanism failure. Mirrored RAID is appropriate for operations that truly need 24/7 functionality, such as large network servers. Mirrored RAID, if used at all by photographers, is most appropriate for working files rather than archive files. Even with mirrored RAID, you still need to have a set of off-site and off-line backups, because mirroring does not protect against some of the most common causes of data loss (theft, virus, and power surge). It also provides no protection against human error, such as accidentally erasing or downsizing a file.

- RAID Level 5, Level 0+1, and Level 10 all provide some combination of striping and mirroring, resulting in both increased redundancy and increased speed. Level 5 is probably the most popular current choice, but like all RAID configurations, it's more expensive and more complicated to set up, administer, troubleshoot, and upgrade than a JBOD configuration.

> **NOTE**
>
> *If you're thinking about setting up a RAID configuration, bear in mind that RAID disks all need to be the same size. Ideally, they should also be the same make and model. One corollary to this is that if you want to increase capacity, you will need to replace all the disks in your RAID array. With a JBOD setup, on the other hand, you can simply add another drive to the bunch or replace a drive with a larger one, without having to upgrade all of your drives at the same time.*

NAS

NAS comes in two flavors: self-contained boxes about the size of a FireWire hard drive; and NAS servers that are effectively small, fully functional servers, with connection ports for monitors, keyboards, and FireWire or USB drives. The self-contained drives are risky, because there is not a transparent operating system—if the disk has a problem, you are dependent on the manufacturer to sort it out for you. The NAS servers are an easy way to add a server for low cost, if you don't already have a computer to turn into a server.

Although I don't recommend using NAS at the present time, it may well become a good storage solution in the future, as the technology matures and as more units come on the market.

System Configurations

So, what will this live and local setup actually look like? It depends on your needs and your budget. As your collection of digital images grows, your storage needs will also grow. Listed below are several configuration strategies, starting with the easiest (and cheapest) to implement, and moving up through the most deluxe (read: expensive):

Starter System: Computer + External Drive + DVD Backup
 The system shown in Figure 4-9 is the cheapest way to get started—simply add a FireWire or USB drive to your existing system and back up your image files onto DVDs (or CDs).

Figure 4-9. This is a very basic starter system.

Better System: Computer + External Drive + External Backup Drive + DVD Backup
 By adding an additional hard drive for backup, as shown in Figure 4-10, you will speed up the backup process, as well as enabling quick saving of incremental changes you make to your image files.

Figure 4-10. This is a slightly better system, with an additional hard drive for backups.

Even Better: Computer with Internal Drives + External Backup Drive + DVD Backup
 If your computer can support additional internal drives, the configuration shown in Figure 4-11 offers increased storage, some improvements in reliability, and a better cost factor per gigabyte of storage.

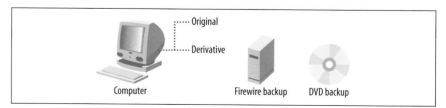

Figure 4-11. An even better system includes additional internal drives.

Client/Server Configuration: Computer + Gigabit Ethernet Switch + Server + External Backup Drive + DVD Backup

The configuration shown in Figure 4-12 adds multi-user access, as well as the ability to lock your server in a remote location in your house or studio. Make sure the server area is vented to avoid overheating.

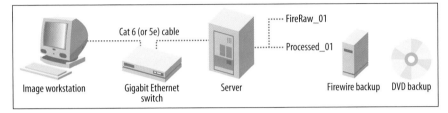

Figure 4-12. A basic client/server setup will provide an extra level of security and allow multiple machines to access your files.

Best Client/Server Setup at a Reasonable Price: Computer + Gigabit Ethernet Switch + Server + JBOD + Backup Drive + DVD Backup

This system, shown in Figure 4-13, offers the best price/performance combination for prolific photographers. You can swap out the drives quickly when necessary, and adding primary or backup drives is easy and inexpensive. This configuration works very well with the bucket system.

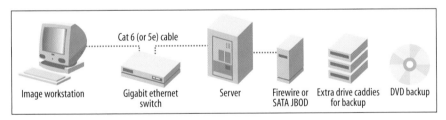

Figure 4-13. Computer + Server + JBOD diagram

Best Setup Without Regard to Cost: Computer + Fibre Channel + Rack-Mounted Server and RAID + External Backup Drive + DVD/Blu-ray/HD-DVD/Tape Backup

The configuration shown in Figure 4-14 provides the fastest access times and redundant storage, for a no-down-time storage solution. It's also really expensive.

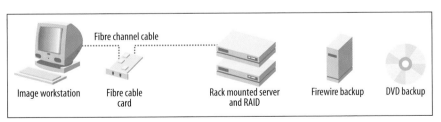

Figure 4-14. If you have a very high budget, this configuration will provide the best results.

Communication Between Computers: Ethernet and Wireless Networks

If you are going to be using a networked server to store all your image files, you will want to set up a fast Ethernet network to transport those files. The three basic speeds are 10 BaseT, 100 BaseT, and gigabit Ethernet. For image files, a network should be at least 100 BaseT, with gigabit preferred. Wireless networks—even the fastest ones—are more in the range of 10 BaseT, and will really slow you down.

In order to get the fastest throughput from your network, you will want to use good cable (Cat 5e or Cat 6) and make sure that it is not routed adjacent to power lines as it runs through the walls. Extra-long runs can slow down throughput, as they introduce more interference to the signal.

Whatever configuration you choose, remember that it will just be a temporary host for your information structure. As your collection grows and your needs evolve, your hardware setup will need to evolve as well.

Choosing Your Hard Drives

Once you've decided to use live and local hard drives to archive your files, you'll still need to make several configuration decisions. For instance, you'll have to decide whether you want to use internal or external drives, and how the drives will be powered and connected. Each hard drive will have a case, a power supply, and an interface, and you'll need to consider the options for each. Let's take a look.

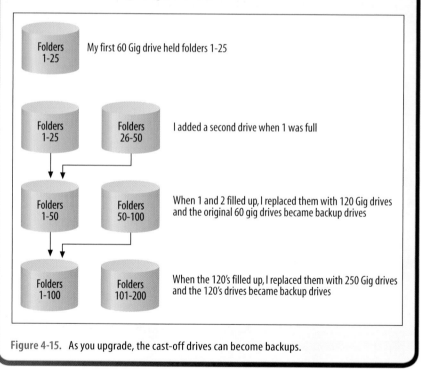

SIDEBAR

Hard Drive Musical Chairs

During the life of my live and local digital archive, I have upgraded drives several times. The original 60-GB drives were replaced by 120s, which were then replaced by 250s. Several have recently been upgraded to 400s, as the 250s have filled up. These cast-off drives then become my backup drives for off-site storage (Figure 4-15).

Folders 1-25 — My first 60 Gig drive held folders 1-25

Folders 1-25 Folders 26-50 — I added a second drive when 1 was full

Folders 1-50 Folders 50-100 — When 1 and 2 filled up, I replaced them with 120 Gig drives and the original 60 gig drives became backup drives

Folders 1-100 Folders 101-200 — When the 120's filled up, I replaced them with 250 Gig drives and the 120's drives became backup drives

Figure 4-15. As you upgrade, the cast-off drives can become backups.

Hard Drive Cases

The case for your hard drive can be the computer itself (for an *internal* drive), a *single-drive external* case, or a *multiple-drive external* case. Figure 4-16 illustrates each of these case types.

Figure 4-16. You can increase your hard drive capacity by adding internal drives, single-drive externals, or multiple-drive externals.

Internal drives

If you are using a tower computer as your file server, it is likely that you have one or more empty drive bays inside the computer that can hold a new drive. The advantages of using internal drives are that they are the cheapest way to add storage and they take up the least amount of room. One drawback is that they aren't as easy to swap out as external drives.

Single-drive externals

If you don't have an empty drive bay, or if installing a new internal drive seems too daunting, it is usually very easy to add external FireWire (IEEE1394) or USB2 drives to your computer. External single-drive cases have the advantages of being easily portable and not increasing the demand on your computer's cooling system. The drawbacks are the higher cost and extra clutter.

Multiple-drive externals

Multiple-drive cases are an excellent solution for a large archive. Although they are larger, there's less wiring clutter than you would get with several single-drive cases. And once you have bought a big drive box, you can fill it with less-expensive internal drives, which you can swap out for bigger drives as additional space is required. This is the arrangement that I currently favor—read on to see how to add one of these for your archive files.

SIDEBAR

Anatomy of a Big Drive Box

Currently, the easiest and most economical way to add a lot of storage space is to connect a big drive box (Figure 4-17) to your computer or server. The components of these drive enclosures are pretty simple:

- Case—The "box" part of the big drive box.
- Power supply—Inside the box, it changes the 120-volt AC house current into the 6- or 12-volt DC that the hard drives need.
- Drive bays—May include drive sleds for easy drive swapping.
- Interface with computer—FireWire, USB, ATA, or SATA—how do you connect this thing? FireWire and USB2 are probably the easiest and most universal; SATA is fastest.
- Fans—Gotta keep it cool. Each drive should have its own fan; some drive sleds also come with individual temperature displays.
- Hard drives—Just another swappable component.

The advantages of the big drive box are:

- It's inexpensive. If you shop around, you can get the box itself for a reasonable price, and you can fill it with the less-expensive internal drives of your choice.
- It's easy to set up. Just put the drive in the bay, connect the cables, and fire it up.
- It's easy to upgrade: you can replace the drives with bigger ones when you want. If you use sleds, this can take only a few minutes.
- Problems are easy to diagnose and repair. It's a pretty simple machine with interchangeable parts, and you can swap out parts to diagnose problems. Power supplies are generally available at any computer store.
- It's user-serviceable. Unlike with a single-drive external case, you don't void the drive warranty by swapping out the drive itself to diagnose problems.
- Power users can mix and match interfaces. You can have several SATA bays for fast transfer, and several FireWire bays for easy drive swapping.
- It can be outfitted with removable hard drive sleds, which makes for easy diagnosis, repairs, and upgrades.

The disadvantages of the big drive box are:

- It can be big and noisy. Every drive bay should have its own fan, and these may make quite a bit of noise when they are all running. Additionally, these drives can generate lots of heat if they are all spinning. As you think about where to put this box, remember these two issues.

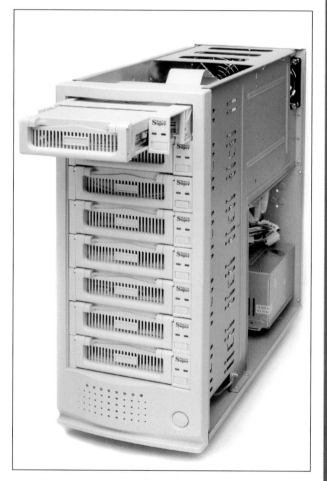

Figure 4-17. Here's what a big drive box looks like with the cover off. The power supply is at the bottom rear. Each of these drive bays can be fitted with a drive sled for easy swapping of disks.

Hard Drive Power Supplies

The power supply the drive will use depends on the case design. An internal drive added to a tower computer will use the computer's power supply. This is tidier, because you don't have power cables running all over the place. It does tax the computer's power supply, however, and that can lead to failure (watch out for an SPF).

The power supply for single-drive external cases is typically a "power brick" that sits outside of the case. If you are going to use these, try to always buy the same brand so that you have "swappable" components to test with if there is a problem.

The power supply for a multiple-drive case is usually inside the case, and is a lot like the power supply inside your computer. If it fails, it can usually be replaced with a generic one from a local computer store.

Hard Drive Interfaces

The third general consideration to make about hard drives is how they are going to connect to the computer. The interface, naturally, will differ for internal and external drives.

Internal hard drive interfaces

If you choose a configuration that uses internal drives, you'll typically use a SCSI, IDE/ATA, or Serial ATA (SATA) interface:

SCSI (Small Computer System Interface)
> SCSI (pronounced Scuzzy) used to be the "gold standard" in hard drives, offering easy connectivity and fast speeds. However, SCSI drives are generally smaller in capacity and more expensive than other options. These days, they are typically used as working drives only when the highest possible speed is important. For example, they might be used as Photoshop "scratch disks" because of their high data throughput.

IDE/ATA (Integrated Drive Electronics/Advanced Technology Attachment)
> IDE or ATA drives (the terms are pretty much interchangeable) are the most common kind of hard drives. They have been the standard internal drive for many years. Each IDE/ATA drive needs to be configured with a "jumper" as either a master or a slave (if two drives are connected to the same cable, the master typically shows up ahead of the slave when the computer's OS lists the available drives). For the last several years, IDE/ATA drives have also come with a "cable select" (CS) option, where the connector cable itself is able to set a drive as either the master or the slave. There is usually a jumper diagram on the drive that can tell you how to set a drive as master, slave, or CS. If it is not marked on the drive, you can usually find the settings listed on the manufacturer's web site. IDE/ATA connections will have a specified top speed. IDE/ATA33

is the slowest you are likely to see, and 133 is the fastest. If you are adding IDE/ATA capacity, go for the faster specification.

SATA (Serial ATA)

SATA is the newest flavor of ATA. It has higher data throughput, so it can read and write faster than regular (parallel) ATA. And because drives don't have to be set as masters or slaves, configuration is slightly easier. SATA is currently the drive of choice for high performance at a good price. Note that the connectors for ATA and SATA are not interchangeable. If you want to add SATA drives to a computer that did not originally come with them, you will need to add a PCI expansion card to provide this connectivity, as well as a power cord adapter.

Figure 4-18. **Keywords:** Stock, Highway, Tunnel, Speed, Blur, Truck

External hard drive interfaces

The most common way to connect external drives is through FireWire (IEEE1394) or USB2. (Stay away from USB1, because the transfer rates are too slow for image files.) Fibre Channel is another up-and-coming high-throughput option, although it's currently prohibitively expensive. If you are hardware-savvy, you can also choose to use external SATA drives, but this will probably require some custom configuration. Here are the options:

FireWire/USB2

FireWire and USB2 interfaces have the advantage of being easily available and generally "plug and play." It's very easy to add drives, and you can "daisy-chain" them (adding one drive onto another, and so on). I find using a big drive box connected by FireWire to be a great way to

add lots of capacity to my server economically. If you are going to be adding a big drive box—or any FireWire or USB2 storage—to your *main* computer (not a remote server), though, here are a few notes of caution:

- As a digital photographer, you will be using the FireWire and/or USB ports for a number of temporary connections, such as your camera, card reader, and backup drives. This will involve a lot of plugging and unplugging during the life of the archive, and mistakes can happen—I found that when I used FireWire drives connected to my workstation, I occasionally unplugged or turned off the wrong drive inadvertently. *This can lead to total data loss on the drive.*

 If you are going to use external drives for your primary archiving, make sure that you configure your computer's physical space so as to minimize the chances of unplugging the wrong drive. I suggest using cables that are different colors from the ones you use for other FireWire/USB2 devices.

- Also, while FireWire is ostensibly "plug and play," manufacturers have different protocols for plugging and playing. Some require drives to be connected before powering up, while others require just the reverse. Make sure to pay attention to the owner's manual on this point. You may want to affix a label to the drive indicating the preferred connection sequence.

Fibre Channel

Fibre Channel is a technology that has migrated from supercomputers down to enterprise-level storage (big companies) and will likely be available for SOHO users eventually. It offers a high throughput and the potential to be used over distances of several hundred feet. It can be used over copper cable as well as optical fiber.

SATA

Most people currently connect SATA drives as internal drives, but an increasing number of specialized vendors are offering ways to add external SATA drives in a big drive box.

> ——— N O T E ———
> *Techno-weenie alert! The following section is only for those of you who like to work on computer hardware.*

These drives have advantages over USB and FireWire in terms of speed, reliability, and interchangeability. SATA drives are on a faster "bus" than anything except the very expensive Fibre Channnel, which means that files can be opened and saved faster.

At the moment, adding external SATA drives means a certain amount of customization. You can't just go down to your local computer store (yet) and buy an external SATA box; you have to make it. This setup will also include adding a PCI SATA card so that you have something to link the external drives to. Check out *http://www.theDAMbook.com* for links to vendors who carry these components.

Backing Up Your Archive: How Safe Is Safe?

There is a saying among IT-geeks that a backup is not a backup until there are at least two copies, one of which is off-site. I use two kinds of backup media for archive files: a set of hard drives stored at a remote location, and a set of DVDs locked up here at the studio. I consider the off-site hard drives to be the primary backup. (I know several photographers who find DVD burning to be too time-consuming, and choose instead to back up to multiple hard drives.)

Figure 4-19. The big safe safe. **Keywords:** Safe, Storage, Security, Vault

Understanding Threats to Your Archive's Well-Being

Just as the new capabilities of digital media bring new solutions, the vulnerabilities of digital media bring a whole new set of challenges to the serious photographer. It's up to photographers to determine for themselves how much risk they can tolerate, and to balance that against the cost of

redundancy. Let's take a look at some of the dangers to your archive's well-being, and some of the solutions.

Device failure

Device failure encompasses the entire range of hardware malfunctions that can befall your storage media. For hard-drive-based systems, this includes failure of the internal components themselves, such as the read heads or the data platters. It can also include failure of the drive controller (the circuit board on the bottom of the hard drive). For any of these problems, your only real recourse, should you need to get the data off the drive, is to send it to an expensive data-recovery service.

For FireWire and USB external drives, you can also have failures of the power supply, the controller board in the case, and the cables. However, you may be able to fix these problems yourself by changing the cables, putting the drive into another enclosure, or getting a different power supply.

Device failure for CDs, DVDs, and digital tape means the loss of readability of the media. This can be caused by breakage, damage from scratches or excessive heat, or from the media simply degenerating over time. You can sometimes repair scratches on CDs and DVDs by treating the surface with a scratch-repairing compound, available at music or computer stores. If the foil itself (the reflective stuff inside the plastic of a CD or DVD) is damaged, though, the disc is probably a total loss.

The life expectancy of all digital media is essentially unknown, and even media "expected" to last for many years can be subject to sudden failure. The solution that offers the most protection against device failure is to use multiple media formats, to keep redundant copies, and to check the integrity of your backups periodically.

Viruses

Viruses are destructive programs that propagate from computer to computer and can wipe out all data stored on rewritable media such as a hard drives. Because we depend on computers so heavily, it's important to have good virus-protection software, and to update the virus definitions regularly. (Viruses are much more common on PCs than on Macs, but Macs do occasionally get hit.)

If you ever experience unexplained data loss (the drive is inexplicably empty, can't be read, etc.), it's *very important* to ascertain that a virus is not the cause, *before* you open your backup copies and try to restore the data. If you open your backup on an infected machine, you may destroy it too.

Using write-once media such as CDs or DVDs can help protect against viruses more thoroughly than hard drive backups alone, because viruses can't infect your data once it has been burned.

Encoding/decoding glitches

Sometimes the way that information is stored on a hard drive can get corrupted. This can happen for many reasons, and it can often be repaired with a disk utility. These problems can also arise—and be more serious—with RAID setups and NAS systems. In these cases, disk-repair utilities will often be of no use, and you will be forced to contact the manufacturer for help.

You should own a disk-repair utility and learn how to use it to protect and restore your disks. Good choices currently include Disk Warrior for the Mac and Norton Utilities for the PC.

Lightning strike/voltage surge

Excess voltage from a lightning strike (Figure 4-20) or a blown power company transformer can fry your computer in a heartbeat. A *surge protector* is a device that can protect your computer from damage caused by this excess voltage. Keep in mind that while a surge protector will protect against many power fluctuations, it may not protect from a direct lightning strike to your property. It's also possible that while your computer might cease to function because of a surge, the hard drive itself may still be fine. You can try to swap it into a working computer to see if it still functions.

Figure 4-20. Lightning: beautiful in photographs, but potentially deadly to digital files. Make sure to protect against voltage surges with a good surge protector and an uninterruptible power supply. **Keywords:** Lightening, Storm, Road

An *uninterruptible power supply* (UPS) is a battery-powered device that can provide from a few minutes to an hour or more of emergency power if the electricity goes out. This can give you time to save open files and shut down your computer. All computers and peripherals should have surge

protection, at a minimum; all mission-critical computers and peripherals should have a UPS.

For real protection against voltage spikes, one copy of your backups must be off-line (disconnected from the computer and from house current). You should be particularly attentive to this if, say, you are forced to work during a severe thunderstorm.

Theft

While photographers have always been exposed to theft, that hazard rarely extended to our images themselves. Since our pictures are now stored on expensive devices, though, they are at risk. The ways to protect against theft include security measures such as alarms, as well as a complete off-site backup strategy. A secure safe could also offer protection here.

Fire/water damage

Like our film archives, digital images can be destroyed by fire or water damage. But unlike with a film archive, it's possible to make a complete, lossless, off-site duplicate of your digital archive for very little money, and thus to be fully protected.

If it is impractical for you to have an off-site backup, a fireproof safe could be an answer. Safes come with ratings for the kind of media inside, and for the severity of the fire. Make a careful evaluation of your real risk as you choose a fireproof safe, taking into account the kind of structure you live/work in, the presence or absence of sprinklers, and the likelihood that other tenants could be the source of the fires.

> **NOTE**
>
> *Some fireproof safes can get as hot as 350°F inside, and that will melt your DVDs. Fireproof safes now have ratings for media, so make sure you find one that protects your assets properly.*

Human error

One of the most common causes of data loss is simple human error. Files can be accidentally thrown away, or unintentionally modified in some undesirable way (such as being downsampled). Protection here is a little more complex, particularly for working files (archive files should be protected by the off-line backup). If you are using a RAID system, damage from human error will most likely destroy that backup immediately. I keep a "temporary backup" (updated nightly) on a drive accessible over the network for all working files.

The bottom line is that the best way to protect against all of these hazards is to keep comprehensive, regularly updated, off-site (or at least off-line) backups. Let's take a look at some good backup strategies.

Backup Strategies

Different types of files require different backup strategies, because each kind of file has a different value and rate of change. I divide my backups into three categories:

- *Working files* (images and text files) need off-line backups and daily incremental backups.

- *Archive files* need off-site/off-line backups, preferably on two different media types. One set should be on "write-once" media such as DVDs.

- *Boot drives* should be backed up to a bootable volume so that all your software configurations can be saved in the event of drive failure.

Digital files are susceptible to sudden catastrophic loss in ways that film images never were. While fire and water damage can ruin both film images and digital files, electronic files have added theft, virus, human error, and device failure to the list of vulnerabilities. It's unlikely that anyone is going to break into my studio and cart off my filing cabinets full of shot film, but that G5 sitting on my desk is another story. And device failure, whether due to power surges, viruses, or internal component failure, can happen at any time.

Fortunately, you can protect yourself from the various hazards pretty well, pretty cheaply. If someone had come to me in 1985 and said that they would be able to make reproduction-quality dupes from my last 75,000 images, and that they could do it in a few hours for under $500, it would have seemed like magic. Well, that kind of protection is available now by simply copying your digital originals.

Working, or incremental, file backup

Backups for working files should be very easy to do (preferably automated), and multiple copies should exist on-site. My working files backup is done to a drive in the Server JBOD accessible via Ethernet. As illustrated in Figure 4-22, I copy working files to this networked drive at the end of each day to

Backup Role-Playing Game

Imagine that you have gone away for a long weekend. Upon your return, you find that all your computer equipment has been stolen (it happened to a friend of mine). Try to imagine what you would be thinking, and how much you would be willing to pay to get all your photographs back.

Or imagine this: you work all morning at your three-month-old computer, and then get up for lunch. When you sit back down, your hard drive is making an unusual clicking sound and has just died a sudden and inexplicable death. (This one happened to me.) Data recovery starts at $600 just for evaluation.

Now, go run your backups.

Figure 4-21. Maddy says, "Run your backups." **Keywords:** Maddy, Scold, Nag, Nagging

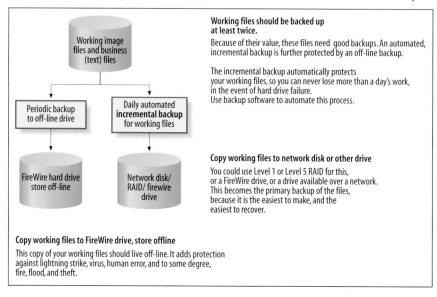

Figure 4-22. Working files should be backed up daily by some kind of automatic means so that you don't lose your important current work.

protect against drive failure and, to a certain degree (because the server is locked in a secure place), theft. This backup procedure can be done manually, or it can be automated by a program such as Chronosync or Retrospect on the Mac and Retrospect or Norton Ghost on the PC.

This daily backup offers protection against some hazards, but it does not protect against viruses, lightning strike, or human error. Consequently, the online backup of working files should be augmented with an off-line backup (also illustrated in Figure 4-23). By "off-line," I mean that:

- It should not be powered-up, so that it is not susceptible to virus attacks, accidental erasure, or voltage spikes.

- It should not reside in the same computer as the primary version and should be kept in a secure location, so that it is not exposed to theft.

A good solution for this off-line backup is a FireWire drive (or a drive in a removable sled that can be plugged into the JBOD) that is disconnected and stored somewhere in your house or studio. Doing an off-line backup is standard practice for me when I come back from a shoot and download my files. The oldest files on this temporary backup drive get erased as I need more room for new files. By the time I delete them, they have already been backed up to the archive backup, as well as written to DVD.

> NOTE
>
> *In addition to the backup of my image files, I use this system to back up my business files (client contacts, billing, email, etc.).*

Archive backup

The procedure for an archive backup (for both original and derivative files) is somewhat less rigorous than the one for working files. Because the files change less frequently, they can be backed up on a weekly basis, rather than daily. Also, because they are used less often and generally don't need to be accessed at a moment's notice, the principle (hard drive) backups can live off-site.

Your hard drive backup (the primary backup) should also be augmented by a backup on write-once media such as DVDs, as shown in Figure 4-23. Because these media are not susceptible to viruses or accidental erasure, they add a different kind of protection than that provided by rewritable media such as hard drives. A second set of hard drive backups can also provide significant protection, but is more exposed to loss due to virus, human error, or device failure.

The bucket system provides a very handy way of making backups, and of making sure that you have included everything. By correlating the buckets on the primary storage drive with the hard drive backup buckets and the DVD buckets, you can easily confirm that everything has been copied.

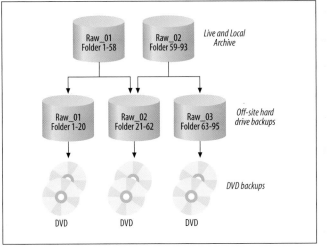

Figure 4-23. Your live and local archive should be backed up twice: in an off-site hard drive backup and on write-once media such as CDs or DVDs.

NOTE

Because the bucket sequences are discrete individual chunks, you can use backup drives of sizes that are different from the primary storage drives. This enables you to use drives that you have outgrown for primary storage as backup drives.

Boot drive backup

Make sure that you back up your boot drive, as well as your other files. If you are using one drive hold your OS and your applications and another drive to store your working files, it may not seem essential at first to thoroughly back up your boot drive. If you've ever had a boot drive crash, though, you know that's not the case.

The reinstallation of software and the reconfiguration of all your presets and passwords can take quite some time. If you lose your boot drive during some mission-critical task, such as short-deadline delivery or a multi-day location shoot, this can lead to a financial loss as well.

The best strategy is to make an exact mirror of your boot drive and store it off-line somewhere safe. Most newer computer offer the ability to boot from an external drive. If you create your backup as a bootable volume, it can actually provide a no-down-time solution in the event of boot drive failure. For the Macintosh, Carbon Copy Cloner is a shareware program that can turn any FireWire drive into a bootable backup boot drive. For the PC, use Norton Ghost. I suggest trying to boot from this copy *before you actually need to*, so that you can troubleshoot any problems that might arise.

If you have several computers that you want to make backup boot drives for, you may be able to partition the external drive so that there are multiple bootable volumes on a single drive. I have one drive that has boot drive backups for five of the computers in my studio. Each of the five partitions has a bootable copy of the drive from a different computer.

Additionally, whenever I go on the road, I back up my entire laptop drive to two bootable FireWire drives. One comes with me, and one stays back at the studio for safekeeping. Traveling with a computer exposes it to significantly greater risk (of theft or mishandling, particularly) and should trigger extra protection.

Backup Review

Figure 4-24 illustrates how you should back up your working files and your boot drive.

Here are some key thoughts to keep in mind when planning your backup strategy:

- You'll need to back up both your working files and your boot drive. If you keep your working files together in a particular folder in the directory, automated backups of these important, ever-changing files is a pretty simple task. You should make frequent backups of files that change often, such as email records, invoices, your address book, etc. on your business computer, and working image files on your Photoshop workstation. Working image files should be backed up after each shoot or extended Photoshop session.

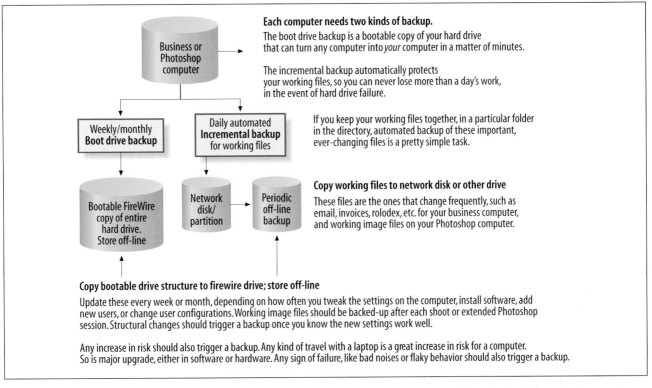

Each computer needs two kinds of backup.
The boot drive backup is a bootable copy of your hard drive
that can turn any computer into *your* computer in a matter of minutes.

The incremental backup automatically protects
your working files, so you can never lose more than a day's work,
in the event of hard drive failure.

If you keep your working files together, in a particular folder
in the directory, automated backup of these important,
ever-changing files is a pretty simple task.

Copy working files to network disk or other drive
These files are the ones that change frequently, such as
email, invoices, rolodex, etc. for your business computer,
and working image files on your Photoshop computer.

Copy bootable drive structure to firewire drive; store off-line
Update these every week or month, depending on how often you tweak the settings on the computer, install software, add
new users, or change user configurations. Working image files should be backed-up after each shoot or extended Photoshop
session. Structural changes should trigger a backup once you know the new settings work well.

Any increase in risk should also trigger a backup. Any kind of travel with a laptop is a great increase in risk for a computer.
So is major upgrade, either in software or hardware. Any sign of failure, like bad noises or flaky behavior should also trigger a backup.

Figure 4-24. Be sure to back up your boot
drive in addition to your working files drive.
Losing your software configurations can be a
major pain.

- To protect against losing all of your computer settings, make periodic boot drive backups. The boot drive backup is a bootable copy of your hard drive that can turn any computer into your computer in a matter of minutes. Copy your bootable drive structure to a FireWire drive, and store it off-line. Update your boot drive backup every week or month, depending on how often you tweak the settings on your computer, install software, add new users, or change user configurations.

- Structural changes should trigger a backup, once you know the settings work well. Any increase in risk should also trigger a backup. Traveling with a laptop greatly increases the risk of something going wrong, as does a major upgrade (either software or hardware). Any sign of failure, such as unusual noises or flaky behavior, should also trigger a backup.

Choosing Backup Media

There are several options for backup media, as outlined below. All of these can serve as off-site storage. For maximum security, you should combine two backup formats, so that the backups do not share susceptibilities. For instance, write-once media are not vulnerable to viruses in the way that hard drives are. This nicely compliments the hard drive's greater speed and updatability.

The current options are:

External hard drive

> This is the fastest, and therefore most convenient, backup medium. Currently, hard drive storage ranges from $.20 to $1.50 per gigabyte. Its drawbacks are that it is susceptible to data corruption or loss by virus, impact damage, and human error, as well loss of function due to prolonged lack of use or poor storage conditions.

CD

> Because of their small storage capacity, CDs only make sense for photographers who shoot JPEGs rather than RAW files. CDs should not be marked with anything other than a CD-safe marker. Data loss can be caused by manufacturing defects (cheap ones are generally not as reliable as name brands) as well as poor storage conditions (excessive heat, non-archival sleeves or pages, pressure, sunlight). Current costs range from $.10 to $1 per gigabyte.

DVD

> DVD is a very good option for backups at the present time (Figure 4-25). DVD-R and DVD+R (stay away from DVD-RWs as a backup medium) are relatively stable, hold large amounts of data, and should be readable for some time to come. Data loss can be caused by manufacturing defects (cheap ones are not as reliable as name brands) as well as poor storage conditions (excessive heat, non-archival sleeves or pages, pressure, sunlight). Current costs range from $.10 to $.40 per gigabyte.

Figure 4-25. Because each bucket can fit on a DVD, correlating the master bucket file to the backups is very easy to confirm.

Blu-ray/HD-DVD

A new format to replace DVD, on discs of the same physical size, is coming down the pike quickly. At the moment, Blu-ray seems to be the front-runner, with storage capacities of about 25 GB for a single-layer disc and 50 GB for a dual-layer disc. HD-DVD currently offers storage capacities of 15 GB (single-layer) or 30 GB (double-layer), and triple-layer (45 GB) discs are in development. Once one of these becomes the clear standard and the price drops, it should make an excellent format for backups using the bucket system. Current costs are high, but they're sure to fall rapidly.

Digital tape

This is probably still the backup medium of choice for large network systems, because of the way it works with backup software. If you intend to install an automated backup system that can protect your data nightly, digital tape is an option, but I don't recommend it. Like any of these other media, it can degrade when not stored properly (i.e., if exposed to heat, sunlight, moisture, etc.), and a single unreadable section in a tape can render the entire backup useless. It is also very slow to recover from. Current costs for digital tape are $.30 to $1 per gigabyte.

Mirrored RAID system

Mirrored RAID provides the easiest backup and restoration against *drive mechanism failure*, and it can be a good choice as an on-site backup for working files. Because it's a hard drive sitting in the same box as the computer, however, it shares many of the vulnerabilities you are trying to protect against (such as susceptibility to theft, voltage spikes, viruses, and human error). For this reason, it should only be used alongside a rigorous off-line strategy.

Now that we've got the archive set up, the next chapter will discuss the "control center" for this new system, Adobe Bridge.

Labeling CDs and DVDs

Although you may want to label CDs and DVDs with permanent marker or ink-jet printing for short-term uses (such as client delivery, where the useful life is a year or two), you should stay away from these for archive discs. According to the National Institute of Standards and Technology, printing with inks containing volatile organic compounds can lead to disc degradation and data loss in long-term storage. I also recommend against ever using stick-on labels, as they can affect the balance of a rapidly spinning disk and may even peel off, ruining the drive.

For maximum longevity, label your discs with a CD-safe marker and write only in the center area (Figure 4-26). I label the disc with only the DVD number, and the date it was burned.

Figure 4-26. For my archive DVDs, I use only a CD-safe marker and write only on the inside label area.

Setting Up Bridge

5

When you first start working in Photoshop CS2, one of the first things that you might ask yourself is, "Where the heck did the File Browser go?" Well, the little File Browser has grown up to be its own application, now named *Bridge*. Bridge offers much more integrated functionality with all of the Creative Suite applications. As a matter of fact, it works as a bridge between *all* of those programs, so that they can work together more closely than ever before. (You could also think of it as Command Central, a place where the captain of a spaceship might sit and have access to control over all the different systems of his vessel... Yes, I'm talking about Star Trek.)

"But I miss the File Browser," you say. Although I sympathize, I think that you will find the capabilities of Bridge to be far superior, especially with regard to the tasks that we will be performing with it.

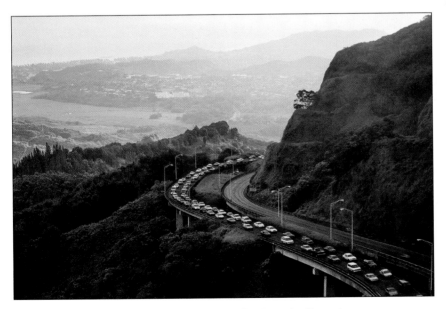

Figure 5-1. Keywords: Honolulu, Highway, Bridge, Traffic, Mountains, Frustration

Figure 5-2 shows the Bridge window. There's lots of information surrounding your images, as well as a number of tools. Take a look and see if you know what each group of tools does.

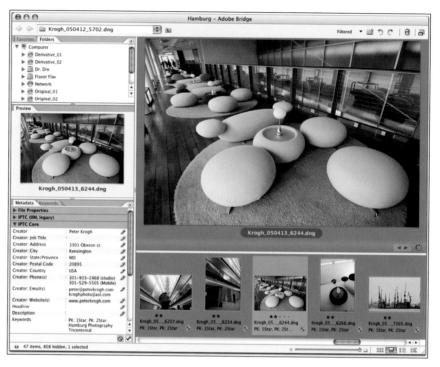

Figure 5-2. The Bridge window.

In this chapter, I discuss the tools and the setup of Bridge as they relate to digital asset management. I assume that you are familiar with both Photoshop and general file browsing, and that you can figure out many of the basic controls. What I cover here are the less-intuitive controls, and the controls that you can use in a particular way to enhance the DAM capabilities of Bridge.

What Exactly Is Bridge?

First, let's get straight what Bridge is *not*. It's not a comprehensive DAM solution, at least for digital photographers. It's a browser, not a cataloging application. While it lets you do some management tasks, and while there is a database of sorts under the hood, it does not perform the cataloging functions outlined in Chapter 1.

Bridge will not let you browse off-line images (such as those on DVDs or unmounted server volumes), nor will it let you create virtual collections. And if you have a large collection of photographs, it will not provide the speed that you need to efficiently work with image files scattered throughout your archive. Bridge *is* good, however, for many of the tasks that you will need to do when you first transfer your images (particularly RAW images) into your computer.

Bridge Is an Excellent First Tool for Image Preparation

There are a handful of important things that you will want to do to any images as you prepare them for inclusion in your permanent collection. In most cases, you will want to do some kind of readjustment to the way the images look, you will want to apply bulk metadata and ratings, and you will want to convert the files to DNG for an integrated DAM workflow. Bridge is a very effective tool for all of this work.

Bridge Is a Scriptable Application

Another cool thing about Bridge that's not immediately obvious is that it has been built to be a scriptable frontend to the Creative Suite applications. A number of the features that you'll see in Bridge are actually JavaScript *applets* (small programs) that integrate seamlessly. I'll show you later in this chapter how you can "trick up" your Bridge by adding new scripts.

Setting Up Bridge's Preferences

Let's take a look at how to set up Bridge to maximize its usefulness for photographers' digital asset management. The first order of business when you install any software should be to examine the preferences. This will tell you quite a bit about the program's capabilities, and will let you get a head start on making it do its work efficiently. Let's take a look at Bridge's Preferences panel (which you can open via the Bridge menu on a Mac or the Edit menu on a PC) and go over some of the more critical items you'll need to know about for implementing your DAM system.

Setting General Preferences

The first thing you will notice on the General tab (Figure 5-3) is that you have the option to change the background tone from black to white, or anywhere in between. This is a nice customization that the File Browser did not offer. Set it to your liking.

NOTE

Because Bridge is designed to work with all the CS2 applications, it has a number of functions that are of less importance to digital photographers than to art directors and graphic designers. As we go through Bridge's preferences and abilities, I will focus here on the capabilities that relate to the management of your digital photography archive.

Figure 5-3. Use this tab to set general display preferences and to configure the Favorites pane.

The "Show Tooltips" checkbox turns on and off the balloon messages that pop up when you hover your mouse over items on the screen, to help you figure out what all those new buttons are. As you get more familiar with the interface, or if you find that the balloons get in the way of your work in Bridge, you may want to switch off this option (I have).

Next, you'll be given the option of setting your metadata display. Bridge always displays the name underneath the image thumbnail. You also have the option to add up to three additional fields of information, selectable from a pull-down list. While I don't find these additional fields particularly useful for *browsing* the files, they can be useful if you would like to confirm that you have entered information in certain important metadata fields. By checking at least one box, you make it easy to see that metadata has been applied to all of your images. Since Copyright, Keywords, and Author are the most important of these fields for me, I have set them as defaults.

You can use the checkboxes in the Favorite Items section to specify which items you wish to display in the Bridge window's Favorites pane (which you can use to navigate quickly through your files). Because I don't use the Home, Documents, or Pictures folders, I uncheck them; I only display Computer, Collections, and Desktop. (The Adobe Stock Photos and Version Cue features are beyond the scope of this book, so I won't discuss them here.)

Finally, at the bottom of the screen are two buttons. The Reveal button will lead you right to the place to put JavaScripts, which will become important later in this chapter. The Reset Warnings button lets you undo the "ignore warnings" checkboxes you might have clicked in the past.

Setting Metadata Preferences

The Metadata preferences tab is where you can customize which of the many metadata fields you wish to display in the Bridge window's Metadata pane. Note that this only toggles the display of the fields on and off; it does not actually deactivate the fields themselves. You will simplify your metadata workflow if you uncheck the fields that you generally don't use.

Figure 5-4 shows how I have my metadata display configured. To see the subcategories of a particular metadata category (as shown in Figure 5-5), click on the arrow indicator to the left of the category name.

If you want to view a field that is unchecked, you will have to either select the photo and choose File Info from the File menu, or go back to the Metadata preferences panel and choose to display that hidden field.

I suggest that you keep the "Hide Empty Fields" box unchecked so that you can still have access to blank fields as you fill out metadata. This will also serve as a reminder of which fields might need further information entered in them.

Figure 5-4. Use the Metadata tab of the Preferences window to choose which kinds of metadata to display in Bridge's Metadata pane.

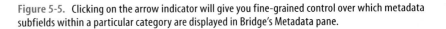

Figure 5-5. Clicking on the arrow indicator will give you fine-grained control over which metadata subfields within a particular category are displayed in Bridge's Metadata pane.

Setting Label Preferences

Labels are one of the handiest improvements in the Bridge workflow. The label function lets you apply a word, a term, or some other designation to one or more image files with a single keystroke. You can see in Figure 5-6 how I have my labels set. In Chapter 6, I'll show you how I make use of these designations. Note that only the first four labels get a keyboard shortcut.

Figure 5-6. Set your label preferences in the Labels tab of the Preferences window.

YOU MIGHT BE WONDERING...

Where Does This Label Information Go?

When you use a keystroke to apply a label to a file, what exactly is being written to the file? The value of the label that you have set in the preferences is written to a custom XMP field created just for that purpose. Figure 5-7 shows this custom XMP field, as well as the Media Management field that holds the preserved filename information (see the discussion of the Batch Rename dialog later in this chapter).

Because this XMP field is not currently read by any other applications, this information is invisible to most other software. If you want to make your labels visible, you will need to copy this information to someplace more accessible, such as in the Keywords field. (More on that in Chapter 6.)

Figure 5-7. The label information and the saved filename, which are stored deep in the XMP data, are visible in the Advanced Metadata panel in the File Info dialog.

I also uncheck the "Require the Command Key to Apply Labels and Ratings" box, because I find that using the Command key (Ctrl on a PC) is a pretty uncomfortable hand position for me. If you keep this unchecked, you'll only need to press the number key—not the Command key plus the number key—to assign a label or rating.

Setting Advanced Preferences

The final Preferences tab we're going to cover here, the Advanced tab shown in Figure 5-8, gives you a few more options. First, you can tell Bridge to use the embedded preview for very large files (instead of generating a "live" preview), by specifying a value in the "Do not process files larger than" field. This can speed up the browsing of folders with large files. You can also set the number of recently visited folders to be visible in the pop-up menu in the main Bridge window.

The other options in the Advanced tab relate to Camera Raw hosting and the cache.

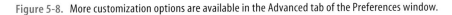

Figure 5-8. More customization options are available in the Advanced tab of the Preferences window.

Determining Camera Raw hosting

The "Double-click edits Camera Raw settings in Bridge" checkbox lets you set a preference for how Camera Raw is *hosted*. Camera Raw is essentially a separate program from Photoshop and Bridge, and either one of these can host Camera Raw. How does this affect the workflow?

In my workflow, *all* RAW files go through Camera Raw and get converted to DNG files. They may get an automatic adjustment, a manual adjustment, or no adjustment. For most images, this is the only place they will ever be adjusted, because the work you can do in Camera Raw is all that most images will ever need. Only a small percentage of these files will get opened up in Photoshop for further enhancements (layers, retouching, custom color corrections, etc.).

Because of this, I prefer to host Camera Raw with Bridge—this means I can do most of my work on images without even opening Photoshop. By checking the "Double-click edits Camera Raw settings in Bridge" box, I streamline the workflow of bringing images into and out of Camera Raw: double-clicking on an image brings up the Camera Raw interface directly, as shown in Figure 5-9.

Figure 5-9 Choosing to host Camera Raw from Bridge means you don't have to open Photoshop to make Camera Raw adjustments.

If you leave this preference box unchecked, whenever you launch Camera Raw Photoshop will start up. The default behavior will be to open the images into Photoshop, rather than to returning you to Bridge when you've finished working on your images.

Cache preferences

The cache can be a little confusing at first. Just like the File Browser in Photoshop CS, Bridge extracts lots of information to display and tag your files. This can be in the form of the previews it generates (those large and accurate displays that you see in Bridge when you click on an image), or in

the form of metadata (all the information Bridge harvests and creates about your images).

The cache enables Bridge to find and work with that information quickly. It would be very slow indeed if Bridge had to regenerate previews each time you opened a folder of images, so instead of creating new previews every time, it creates them once and stores them in its cache.

Cached information can be stored in one of two places. If you select the "Use a Centralized Cache File" option, it will be stored in the location specified in the "Centralized Cache Location" setting. If you select "Use Distributed Cache Files When Possible," information about an image will also be written back to the folder where that image is stored.

I suggest that you opt to use a distributed cache, for a couple of reasons. First, it makes the cache portable. If you do some work on your images on a laptop and then transfer those files to another computer, the distributed cache comes along for the ride. This will speed up the display of the images when you open the files on the second computer.

Additionally, distributing the cache enables you to back it up. With one big, centralized cache that can't easily be backed up, you run the risk of corruption, and therefore losing this time-saving information.

There is one drawback to using a distributed cache, though: Bridge writes the two cache documents—the *.bc* and *.bct* files—into every folder that it opens (Figure 5-10). This can mean that you have *lots* of these files lying around on your computer.

Figure 5-10. The Bridge cache documents. If you use a distributed cache, you will find these documents in every folder that Bridge opens.

Since Bridge places the cache files in any folder that you point it to, you can reduce the number of Bridge cache files by bringing your images through in the same folders. You can also delete these cache files at any time with no risk of losing any of your work (you're only throwing away something Bridge created to make its life easier and quicker), or even hide them. On Windows, this is pretty easy: just right-click and set the attributes as hidden. Note that you will have to do this to each Adobe Bridge cache document, though—it's not a global preference. On a Mac, it's a little tougher. At this point, you need to either use a third-party tool such as ResEdit, or go into the *.plist* files. I think this is more trouble than it's worth.

Setting Camera Raw Preferences

While we're on the subject of preferences, let's check our Camera Raw preferences as well. On both the Mac and the PC, the option to open the Camera Raw Preferences dialog is located just above the option to open Bridge's main Preferences dialog, on the Bridge menu and the Edit menu, respectively. (You can also access Camera Raw preferences inside Camera Raw by using the flyout menu.) Figure 5-11 shows just a few options. If your screen does not look like this, you may not have updated your Camera Raw from the original version that came with CS2. You should always have the latest version—check *http://www.theDAMbook.com* for a link to the most recent download.

Figure 5-11. The Camera Raw 3.1 Preferences dialog.

Sidecar files

In order to make all the work done to RAW files on one computer portable to another, you will want to save your settings in sidecar XMP files. A small XMP document will then be created for every adjusted image in a

folder (Figure 5-12). These sidecar files hold the settings you make in Camera Raw, as well as any metadata you enter for the images.

Sharpening

There is no universal consensus about the use of Camera Raw sharpening, but I recommend that you use it. The sharpening algorithms that Camera Raw uses are not as simple as the single slider suggests. Thomas Knoll has made a special formula for each supported camera, and he doesn't just apply simple unsharp masking. The sharpening in Camera Raw works mostly on the luminance data, rather than the color data, which is the preferred method for Photoshop power users.

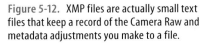

Figure 5-12. XMP files are actually small text files that keep a record of the Camera Raw and metadata adjustments you make to a file.

Remember that what you are generally doing with Camera Raw is capture sharpening, not output sharpening. Essentially, this means that you are going about halfway to where you ultimately want to be. When you convert your images to derivative files—whether by batch processing or by custom conversion—you will need to add more sharpening. (We'll discuss this further in Chapter 8.)

Cache

You may have noticed the nifty filmstrip mode inside Camera Raw. You can now load multiple images in Camera Raw and run through them together, making all your adjustments at once. This, in fact, may be the best productivity feature for photographers in all of Creative Suite 2. The Camera Raw cache is where Camera Raw stashes the previews it uses to display images (in Camera Raw only).

The Preferences dialog gives you the option to set the size of this cache, and to clear it entirely. If you are pressed for disk space, you might want to make the cache smaller; if you have lots of unused space on your boot disk, a larger cache might work better for you. You may want to play with the cache size as you fine-tune your workflow. On my desktop computer the cache size is set to 10 GB, and on my laptop it's set to 1 GB.

Clicking the Purge Cache button can help you gain disk space, and maybe some speed, particularly if it is full of images that are no longer on the computer. However, if you purge the cache and then bring previously cached

You Might Be Wondering...
Why Do We Need to Make All These Sidecar Files?

As I explained in Chapter 1, Adobe has chosen to hold RAW file modifications in sidecar files, or in a central database, rather than writing them back to the files themselves. Because it can safely contain information about the modifications that have been made, the DNG format does away with the need to use sidecar files.

Until you have made your DNG files, however, I suggest that you continue using sidecar files with your RAW files. This will enable you to back up the work and transfer it between computers.

images back through Camera Raw, you will take a speed hit because it will have to generate the previews all over again.

DNG handling

In Figure 5-13 you can see some of the new options that Camera Raw 3.1 added for dealing with DNGs. The "Ignore sidecar '.xmp' files" checkbox is there for the instance where a sidecar file and a DNG are in the same folder. This lets the user choose whether to respect the settings in the DNG file or to use the settings in the sidecar file.

Figure 5-13. DNG handling preferences from the Camera Raw Preferences dialog box.

There are two instances where you'll generally see sidecar files in a folder with DNG files. The first is if you keep RAW and DNG files in the same folder. Any adjustments you make to the RAW files will be stored in sidecar files. In this case, I would suggest that you ignore the sidecar files and work directly on the DNG file once it has been created. (I would suggest, furthermore, that it is simply bad practice to store DNG files in a folder with RAW and XMP files.)

The other time that you'll see sidecar files in the same folder as DNG files is when the DNGs have been readjusted in CS1. Since CS1 will not remake the DNGs—it creates a sidecar file instead of embedding the new settings back into the DNG file—you might find yourself with DNGs *and* sidecar files that you want to use. In this case, you should uncheck the "Ignore..." checkbox.

The "Update embedded JPEG previews" option is much more important. If you readjust a DNG file in Camera Raw, you need to have this box checked, *or the DNG will still contain the old preview.* Why is this such a big deal?

As DNG becomes more universally supported, these embedded previews will become ever more useful. If the embedded preview is always accurate,

You Might Be Wondering...
What's the Downside of Always Updating the Preview?

In a word, speed. When you update the preview of a DNG file, you will lock Bridge out of doing anything else. Unlike when you first make a DNG (when Bridge is able to multi-task), when you *remake* a DNG, Bridge must stop everything else it's doing. If you have a large folder of images to update, this can take quite a while.

(Incidentally, the delay incurred when remaking DNG files is the reason that I do not advocate creating DNG files immediately.)

Despite this, I believe that you will be amply rewarded for always keeping the DNG preview accurate. As you create an archive full of DNG files with accurate previews, you will see significant speed gains in the creation of derivative files.

it can be used for most of the output that you will have to make from the file. This includes web galleries, proof prints, email copies, slideshows, and more.

The embedded preview is a JPEG sitting inside the DNG wrapper. As such, it's much quicker to use than the underlying RAW data. I strongly suggest that you build your archive DNGs with accurate previews. I also suggest that you choose to embed the largest preview. This will be very useful over the life of the image file.

If you don't have the "Always update..." box checked, there is still a way to update the previews of your DNG files: you can use the Export Settings command in Camera Raw's flyout Settings menu, as shown in Figure 5-14. This will tell Camera Raw to build new previews for the selected files.

Figure 5-14. You can update selected DNG previews from Camera Raw, even if you don't have the preference set to always update.

The Bridge Menus

Now that the preferences are set, let's take a look at the important menu options that are available in Bridge—often, it turns out that the functionality or command that you are looking for is hidden in plain sight. As stated earlier, I won't go into every menu option; I am only going to address the functions of Bridge that relate directly to DAM workflow. With that in mind, let's take a look.

The File Menu

The first menu in Bridge is the File menu. In Figure 5-15, you can see that this menu provides commands for such things as opening, closing, and deleting files.

Here are some of the commands you will find useful:

Open

When used on a folder, opens that folder in the current Bridge window. When used on a select-ed image, opens that image in Photoshop (or whatever appli-cation is selected in the File Type Associations pane of the Preferences window to open that type of file). Using the Open command is much like simply double-clicking on a file or folder.

Figure 5-15. The File menu in Bridge.

Open with Camera Raw

Enables you to adjust images in Camera Raw without opening them in Photoshop, if you have your Advanced preferences set as I've suggested. In this case, using this com-mand will be the same as double-clicking.

Return to Adobe Photoshop CS2

Takes you back to Photoshop without performing any action.

File Info

Brings up the same File Info panels you get in Photoshop. This enables you to enter metadata for the selected file, and it is the place to create metadata templates (discussed below).

Making metadata templates

Generally, there are a number of pieces of information that you will want to apply to entire sets of images (for instance, your copyright and contact information). These can best be applied with a *universal metadata template* —a saved set of metadata entries. To make a metadata template, first create a blank image from scratch in Photoshop, and open up the File Info dialog box from the File menu.

Go through all the screens, entering your copyright and contact informa-tion (as shown in Figure 5-16). Take care to fill out only the fields that will apply to every image you shoot. (In the next step, we will see how to make a template that works for more targeted sets of images.)

Figure 5-16. Save your basic contact info as a metadata template.

Once you have filled in all the universal information, click the flyout menu at the top right of the File Info window (Figure 5-17). You will see a set of options that includes "Save Metadata Template." Choose this option, and

Figure 5-17. Use the flyout menu in the File Info window to save and access metadata templates.

you will be prompted to give your template a name. Choose something like "Copyright Basic."

Once you have saved this main template, you can save others that you will commonly want to use. Since the division between personal and work-related photography is important to me, I have saved several templates for my most common categories of images. I also often save templates for ongoing jobs, since I will need to apply the same information to images produced over the course of several weeks. The flyout menu in Figure 5-17 shows some of my metadata templates, which range from the very general (Copyright Basic), to the more specific (Copyright Jobs), to the very specific (Copyright GLC Brochure).

The Edit Menu

As you can see in Figure 5-18, most of Bridge's Edit menu is very familiar from other applications, or is self-explanatory. Let's take a look at the DAM-specific menu items.

Find

The *Find* command is a useful way to perform a limited search through a known collection, although because of how Bridge conducts searches (and its limited ability to save search results), you will be better off doing most of your searching in your cataloging application rather than Bridge. Figure 5-19 shows the Find dialog box.

> **NOTE**
>
> Alternates *are commands that are used with Version Cue. Because I don't think Version Cue is the right tool for digital photographers, I don't cover it in this book.*

Figure 5-18. The Edit menu in Bridge.

Figure 5-19. The Find dialog box.

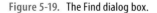

The options that I usually use to search are "Include All Subfolders," "If all criteria are met," and "Show find results in a new browser window." If you want Bridge to look in more than one folder, you must have it search the *parent* folder—that is, the folder that contains all the subfolders you want to look in. If you are trying to find images that are in two different "buckets," Bridge must search the entire volume that the buckets are in, which can take a long time.

One of the frustrations I hear from Bridge users is that they want to be able to see all the images in subfolders. That is, they want to point Bridge at a folder, and see all the images that are in any subfolder within that larger folder. Well, there is a way to do it, but it is not very obvious.

If you use the "Find" command, and check "Include All Subfolders" and "Find All Files", then Bridge will show you every image inside that folder, no matter how many subfolders it might be buried inside. While this is merely a convenience much of the time, it becomes a necessity in certain renaming situations, outlined in the next chapter.

If you select "Show find results in a new browser window," Bridge will display the results in a new window labeled "Find Results," as shown in Figure 5-20. You will notice that this window has a different appearance than other Bridge windows. The search criteria are shown at the top of the window, along with a "Save As Collection" button.

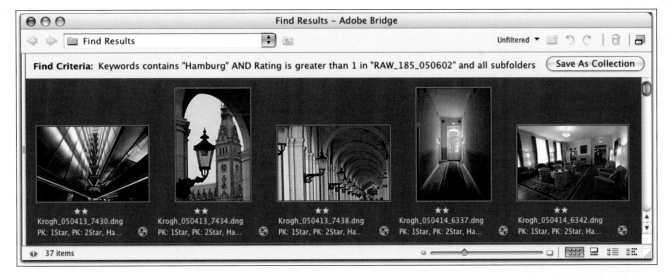

Figure 5-20. In the Find Results window, the search parameters are shown along with the results, and you can opt to save those parameters.

If you click on Save As Collection, you'll see the screen in Figure 5-21. It's important to understand what is being saved here: it is not the *search results*, it is the *search parameters*. So, if you do something to change how the results are returned—such as removing a keyword or moving a file—when you return to the same collection, you will not get exactly the same results (nor will you be given any indication that the results differ from the first time you conducted the search).

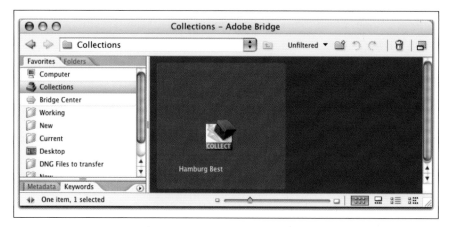

Figure 5-21. By opening this collection, you will perform the search again.

This behavior—known as *dynamic collections*—may be useful for some file-handling tasks, but it is not well suited for long-term digital asset management. A good cataloging application will let you save a collection of actual image files, in addition to a set of search commands. By saving the collection of images, you ensure that the collection includes what you want it to, and you can use this information to help you actually *manage* the files.

Apply Camera Raw Settings

Probably the most useful item on the Edit menu is *Apply Camera Raw Settings*, which brings up the submenu shown in Figure 5-22. This option enables you to select multiple images and make adjustments to the entire

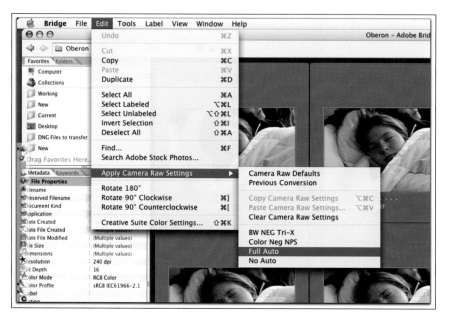

Figure 5-22. The Apply Camera Raw Settings command is one of the most powerful features of Bridge.

group, with settings you save in Camera Raw (I'll show you how to save the settings below). By saving various groups of settings, you can quickly adjust many images at once.

The top options on the submenu, Camera Raw Defaults and Previous Conversion, work as expected, letting you reset images to the defaults or apply the same custom setting that you just used on another image. The Camera Raw Defaults command is a surprisingly necessary command, as I will outline in the next chapter.

The next three commands let you copy and paste Camera Raw settings from one image to another.

The last group shown in Figure 5-22 are settings that I made and saved from inside Camera Raw. For example, I have made a custom setting that uses all the automatic exposure corrections, and one that uses none. Saving these settings makes them available to me while I am in Bridge, in case I need to make a rapid, basic correction to many image files. Bracketed images, or ones with lots of white in the frame, get the No Auto setting. I might use the Full Auto setting for a set of images that were shot in rapidly changing lighting conditions. (The two other settings—BW NEG Tri-X and Color Neg NPS—are used when I make camera scans, covered in Chapter 9.)

To save groups of Camera Raw settings, all you have to do is make the settings and then use the Camera Raw flyout menu, pictured in Figure 5-23, to save them. These settings will then be available via Bridge's Edit menu.

Figure 5-23. Use the Save Settings command in Camera Raw to make presets that are available in Bridge.

The Tools Menu

The Tools menu in Bridge gives you access to some of the same functions that are available in Photoshop's Automate menu, as well as some new ones. It's also the place where you will be able to access add-on scripts.

Figure 5-24 shows my Tools menu—I say *my* menu because it probably looks different from yours. Both Dr. Brown's Services and Import from Camera are free scripts you can use to extend the functionality of Bridge. You can find these in the links section of *http://www.theDAMbook.com*. (You will only see the Illustrator and InDesign tools if you bought the entire Creative Suite.)

Let's take a look at some of the things that are available on the Tools menu.

Figure 5-24. My Tools menu includes a few add-on scripts.

Photoshop

You will notice that you get the familiar Photoshop automation tools in the Photoshop submenu. The newest one for many of you might be the Image Processor. This is based on Dr. Brown's Image Processor, and it is useful for converting many image files in a batch. I'll go over this script in detail in Chapter 8.

For now, the important thing to note is that while you can invoke many of these tools in either Photoshop or Bridge, generally, if you do it in Photoshop you will have the option to work on entire folders or on *open* images only, while if you choose a script from within Bridge, you generally get the option of running it on an entire folder or on *selected* images in Bridge. For this reason, I find that it's generally preferable to run the tools from within Bridge.

YOU MIGHT BE WONDERING...

What Is a Script?

Scripts are actually freestanding programs—Bridge uses JavaScript—that call on a program to perform some kind of action. One of the great features of Bridge is the extent to which it is scriptable, and the extent to which those scripts can control all the CS2 applications.

To run a script, you need to put it in the correct folder and then invoke it from the application. To load a script in Bridge, first you must find the proper place to put it. Fortunately, the Adobe engineers have made this pretty easy. Open Bridge's Preferences window and select the General tab, shown in Figure 5-24. Clicking on the Reveal button at the bottom of the window will open the folder that Bridge scripts live in. Place the script in that folder, and relaunch Bridge. Your newly installed script will be accessible in Bridge's Tools menu.

Figure 5-25. Clicking on the Reveal button at the bottom of the General preferences tab will open the folder that contains the Bridge scripts.

Import from Camera

One of the best parts of Bridge did not even come with the original version —it's the *Import from Camera* (IFC) script, a handy utility created by Bob Stucky of Adobe that lets you perform a number of functions on a set of images all at once. You can find a link to download this script at *http://www.theDAMboook.com*. IFC can accomplish the following tasks:

- Rename images, including the ability to extract any metadata and use it to rename the files.

- Rename RAW + JPEG files as a linked set.

- Combine images from several folders into one folder.

- Build the cache for the new folder.

- Write the old and new filenames to metadata.

- Apply a metadata template.

- Back up images to another folder or disk.

Let's look at the interface shown in Figure 5-26, and see how to use it.

Figure 5-26. The Import from Camera Download Camera Images dialog box. IFC is a very capable script for the ingestion of multiple images.

In the Download Camera Images dialog, you'll see the following sections:

Sources

> In the Sources box, you can specify which files you want the script to work on. As I said before, I typically download the data from my media cards manually, but you can tell the script to do this for you. Note that the settings here are "sticky," meaning that the script will come back to this same place the next time you open it.

> You can use the Configure button to save favorite places to download from, and give each of these places a name.

Options

> In the Options section, you control what will be done to the files. If you have structured your downloads like mine, in folders named for the image numbers they contain (as described in the next chapter), checking the "Flatten Directory Structure" box will move the renamed files into a single folder. If you would like to keep your folder structure (for instance, if you have divided each shooting situation into its own folder), keep this box unchecked.

> I also suggest that you have IFC build your cache for you (i.e., check the "Build Folder Caches" box). This will greatly speed the browsing of these image files the first time you look at them.

You Might Be Wondering...

Do I Have to Have My Camera Connected to Use IFC?

As a matter of fact, you don't actually have to import images from the camera—IFC can work on any folder of images. I download all my images using the Finder, so that I can make sure that everything goes as expected. Once all the images from a shoot have been downloaded, I can run IFC on the whole group at once.

Rename on Import

When you use IFC to rename images, you get a very powerful set of options to choose from. There's one drawback: the renaming instructions are coded in scripting language, not in plain English. At first this will probably look completely unintelligible, but it's really not that bad. I'll show you how it works.

To open the renaming dialog (shown in Figure 5-27), click the Rename Options button.

Figure 5-27. The Rename Options dialog in the Import from Camera script.

The "Rename using Template" option is the easiest way to configure the script, once you have created a template. Be careful as you save these templates, as you cannot easily erase them once they've been saved.

The Add Element drop-down, shown in Figure 5-28, is a way to specify particular information to put into the filename. You can choose an element from the pull-down menu, and then click Add to have it included in the naming scheme. The After box in the Preview section below will

Figure 5-28. The Add Element drop-down menu contains available fields that you can use to automatically rename your photos.

show you an example of the new name. If you decide that you don't like the addition to the name, just highlight and delete the element.

Here are some of the options available in the Add Element section of the Rename Options dialog:

Adding a text string

To add a text string to the filename, just start typing in the naming window. In the example in Figure 5-29, I added "Krogh_" to the start of the filename.

Figure 5-29. The IFC rename options. This configuration yields the result pictured in the After box in the Preview section.

Adding a date string

If you choose "Modification Date" from the pull-down, for instance (this field works best for my Nikon cameras to indicate the date shot), it will place the text *<var mdate[YYMMDD>* in the naming window. Note that if this option does not work for your camera, you might need to try a different one (possibly "Creation Date").

Here are the elements of this text: *< var* tells the script to pull a variable out of the file, *mdate* indicates that the variable will come from the modification date in the EXIF data, *[YYMMDD* tells the script to use a six-digit number to represent the date (starting with the year, then the month, then the date), and the closing*>* tells the script that that's the end of the item.

Adding a unique identifier

There are several ways to add a unique identifier to a filename with this script. I will show you two. The first will snip the identifier out of the original filename, and the second will let you specify a sequence number to use.

To snip out a chunk of the original filename, you need to first select "Filename – Substring" from the Add Element drop-down, as shown in Figure 5-30. The phrase *<var filename[4,8] >* tells the script to add

a chunk of the original filename to the new name. The *[4,8]* tells it to use the 4th through 8th characters of the original name in the new name, and to ignore those characters that come both before and after the chosen data.

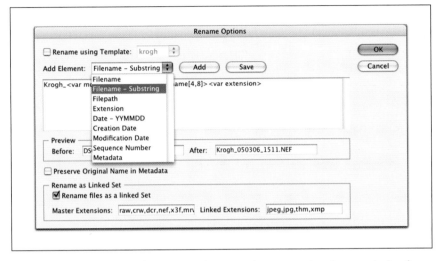

Figure 5-30. This pull-down menu item lets you keep a portion of the original filename in the new filename.

Notice that I typed in an underscore between the date and the four-digit identifier. The script sees this as text. It is used to make an easy visual division between the date and the sequence number, as you can see in the After preview box.

Adding a sequence number

If you would like to add a sequence number to your filenames instead of using the original unique identifier number, you set part of it in the Rename Options dialog and part of it in the main dialog. Select "Sequence Number" from the Add Element drop-down, shown in Figure 5-31. You will see that it shows up in the After preview box as 000. (You can change the number of digits by replacing the *[3]* in the naming window with the number of your choosing.)

Figure 5-31. The Add Element drop-down includes an option that allows you to add a sequence number to your filenames.

Once you are back in the main dialog, you will see that there is a place to enter a starting sequence number. Type in the number you wish to start your sequence from.

Adding other metadata

Experiment with the naming variations until you find one you like. This humble script can actually pull out metadata you didn't even know existed and use it to rename files.

If you want to add metadata that is not included in the list of choices, you can choose "Metadata" from the Add Element drop-down. This will bring up the dialog pictured in Figure 5-32. There, you will get a choice of just about any piece of metadata you can think of (and lots you probably never even knew existed).

─ **N O T E** ─

If you have both RAW and JPEG files in a folder, but they were not shot as RAW + JPEG, IFC will skip these JPEG files, and they will not be transferred to the new folder. This could lead to accidental erasure of the skipped files, if you don't realize the omission. Make sure you have this box checked appropriately.

Figure 5-32. The metadata options available to IFC. You can extract nearly any piece of metadata from the image and use it to rename the file.

Once you get the name looking the way you want, save the configuration as a template.

"Preserve Original Name in Metadata" is a feature of the Rename Options dialog that can be very useful. It writes both the old and new filenames into the XMP Media Management field. This can be quite valuable if you need to trace a renamed file back to its original version. If you purchase the Rank and File script (available at *http://www. DAMuseful.com*) that is covered in the next chapter, you can get even more functionality out of this feature.

The "Rename files as a linked Set" function is a welcome feature if you shoot RAW + JPEG. By selecting this box, you will ensure that the same renaming is applied to both the RAW and JPEG files.

Well that was a lot to digest. Now let's go back to the main IFC window (the Download Camera Images dialog) and finish out our settings.

Apply Metadata on Import

In the "Apply Metadata on Import" section (Figure 5-33), you can choose an existing metadata template from the pull-down menu to apply to all the images. If you would like to apply a template that has job-specific information, you will have to create it in Photoshop or Bridge (as described earlier in this chapter), prior to launching the IFC script.

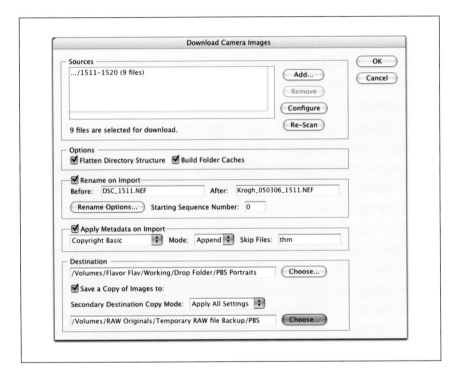

Figure 5-33. Metadata options for the IFC script.

The Mode pull-down menu gives you the choice of either appending or replacing metadata. "Append" adds to what's there, and "Replace" removes the existing entries (if there are any) and replaces them with the ones from the template.

Destination

The final step in the setup is to determine where the new files will end up. In the Destination section shown at the bottom of the window in Figure 5-26, you can see that my preferred place to save the files to is a drop folder on my Desktop. I also save a copy of the files to an additional temporary backup folder on another drive. This temporary backup

NOTE

A note about the Import from Camera Script. Even now, several months after CS2 shipped, the Import from Camera script is still being tweaked and improved. Take a look at http://www.the DAMbook.com to see if there are any more developments with the script, or new versions that you should be aware of.

folder is useful until the fully annotated, Camera-Raw-corrected DNG files are ready for permanent archiving and backing up.

Cache

Another item on the Tools menu is the Cache submenu. As I wrote earlier in this chapter, Bridge caches image previews and metadata so that it can work with images more quickly. The cache commands, shown in Figure 5-34, may not be needed often, but they can be valuable in certain instances.

— NOTE —

I'd like to take a minute to point out the Rank and File *script, which I developed with Tom Nolan. This utility greatly extends the functionality of Bridge's ratings and labels, particularly in conjunction with other DAM applications (or any software that can read IPTC data). It is available for purchase at http://www.DAMuseful.com.*

Figure 5-34. The Cache submenu.

Here are the options on the Cache submenu:

Build Cache for Subfolders
>This command tells Bridge to make sure to go through all documents—including folders inside folders—and cache each of them. If you use Import from Camera to rename your files, you will rarely need to use Build Cache for Subfolders.
>
>Unlike in CS1, Build Cache for Subfolders does not lock you out of doing other work in Bridge, and it gives you a progress window.

Purge Cache for This Folder and Purge Central Cache
>Generally speaking, you should only need to purge the cache when you are having some kind of problem (i.e., if images or metadata are not showing up correctly). If you browse a folder of images from a camera that is unsupported by Camera Raw, for instance, Bridge will only show an icon of the file, not an image. If you later upgrade Camera Raw to a

Digital Asset Management

version that does support that camera, Bridge will still show the plain icon. You will need to purge the cache in order to tell Bridge to rebuild the previews of these images.

Export Cache

> If you have chosen to use a distributed cache, you will generally not need to use this command. The only time I find I need it is when I am working on files across a network. By default, Bridge will not write the cache files across a network. If you would like to export the cache to a folder on a network server, use the Export Cache command to do so.
>
> If you have chosen to use a centralized cache (if, for instance, you only have one computer that you ever use to store, browse, or work with image files), you might choose to export the cache if you are shipping off some image files to someone else.

The Label Menu

I find this menu, shown in Figure 5-35, to be one of the most useful tools in Bridge. We will go over the specific use of labels and ratings in the next chapter. For now, take note that Bridge offers you two different ways to tag image files: with a rating and with a label. Note that these two tools are separate, so an image file can have both a rating and a label (although I don't generally do that myself). I have assigned permanent values to some of the labels and kept others free for temporary assignment. These can be used to tag image files for a particular usage, such as indicating a client's preferred images.

The View Menu

Most of the View menu should be self-explanatory, but I will offer one tip: if you find that your panel options are grayed-out (as in Figure 5-36), this is because you have dragged the window divider all the way to the left and hidden these panels. To get the panel options to reappear, all you need to do is drag the divider back to the right.

Figure 5-35. The Label menu in Bridge, as it appears on my computers.

I also want to point out a cool new feature in Bridge that's accessible from this menu: the Slideshow feature. This is a great way to really look at images, and a wonderful way to show them to clients. Remember that the

H key will always bring up the Help menu in the slideshow, where you can see the entire range of keyboard commands that are available.

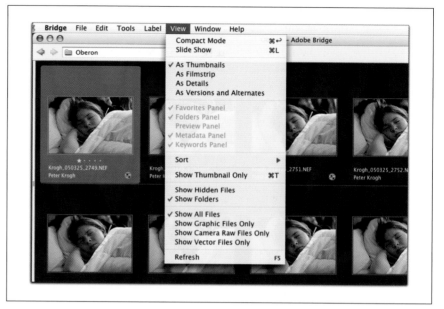

Figure 5-36. The View menu in Bridge, with panel options grayed-out.

The Window Menu

The Window menu is a fairly standard menu for navigation between and around open windows, but out of the box Bridge's Window menu is missing a few important capabilities. Fortunately, you can customize the Window menu (as shown in Figure 5-37) with two handy scripts: *BridgeNav.jsx* and *Window Popper.*

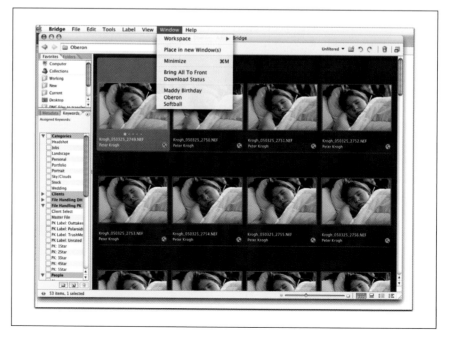

Figure 5-37. The Window menu as I have it configured. I use two scripts to customize how my Window menu operates: BridgeNav and Window Popper.

The BridgeNav script enables Bridge to show you the names of each open window, as you can see at the bottom of the Window menu in Figure 5-37. You can download this free script from *http://www.DAMuseful.com*. To cycle through all open windows in Bridge, press Command-~.

The "Place in new Window(s)" command is provided by the Window Popper script. It enables you to create a new window for every image currently selected in Bridge. This is very handy at the end of an edit, when you want to review your selections, or if you would like to show a client several images by themselves. If you want to add this functionality to your Bridge, you can purchase the script from *http://www.DAMuseful.com*.

Workspaces

Workspaces are saved configurations of the Bridge windows. They let you quickly switch between views that are good for different functions. Bridge comes with five presets, and gives you the ability to make many more. Seven of your custom workspaces can have keyboard shortcuts attached; the rest can be invoked only by menu commands.

I have several favorite workspaces, as you can see in Figure 5-36. For example, I have one for general image browsing on my laptop, pictured in Figure 5-38, and one that I use when I plug the laptop into a large monitor, pictured in Figure 5-39.

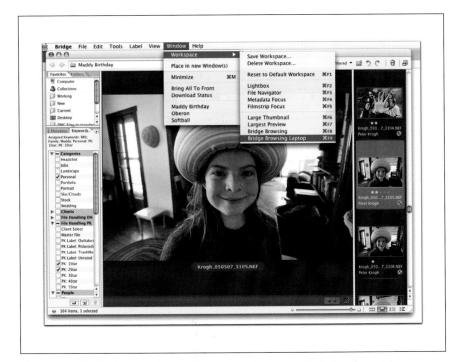

Figure 5-38. The Workspaces submenu. My custom workspaces are the bottom four entries.

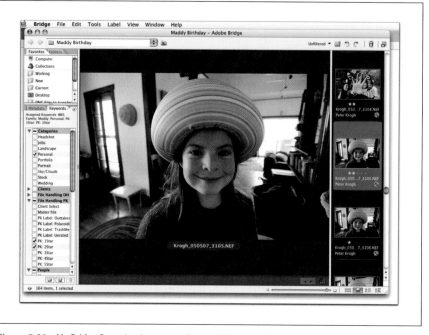

Figure 5-39. My Bridge Browsing Laptop workspace. I have sized these windows to be optimum for browsing a folder of images at a screen resolution of 1024x768.

I have also created two custom workspaces that let me get a better look at an image in Bridge. Figure 5-40 shows my Largest Preview workspace, and Figure 5-41 shows my Large Thumbnail workspace.

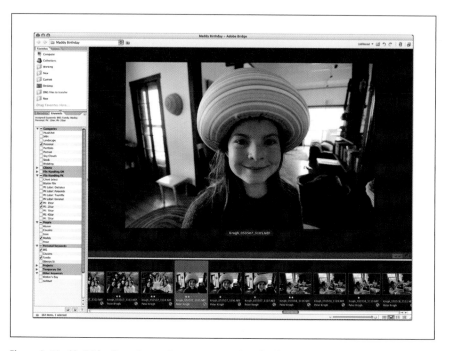

Figure 5-40. My Bridge Browsing workspace, on a monitor that has a resolution of 1600x1200 pixels.

Figure 5-41. My Largest Preview workspace displays an image as large as Bridge can. I find it useful to display selected images in this workspace at the end of an edit, to review my choices.

Setting Up Keywords in Bridge

The Keywords pane on the Bridge window can be a great place to apply some bulk or higher metadata to your images. Figure 5-42 shows how my keywords are set up today. Some of these sets, such as File Handling and Personal Keywords, stay relatively static. Other sets, such as Clients and Projects, are fluid, and entries are added and cleaned out periodically.

I suggest that, in general, you do your bulk metadata entry with templates. As discussed earlier in this chapter, you can accomplish this with the Import from Camera script, with the File Info window, or with the flyout Metadata menu in the Bridge window (as shown in Figure 5-43).

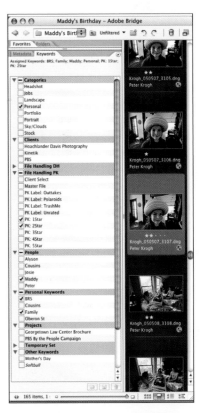

Figure 5-42. My keyword setup in Bridge.

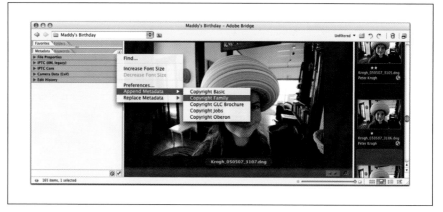

Figure 5-43. You can apply a metadata template from the flyout menu. Note that you have to have the Metadata pane on top for the flyout to be available.

How the Keyword Sets Work

You will notice that Bridge comes with both *keywords* and *keyword sets*. The first thing to understand is that the sets are just a handy way to organize many keywords, and they have nothing to do with how the keywords are actually written to the file. In other words, the same keyword—Cousins, for instance—is written to the file in exactly the same way whether it's in the Personal Keywords set or the People set (Figure 5-42).

Keyword sets are also useful for something else. If you want to apply several keywords to a large group of images, you may want to drag them into the Temporary Set, so that you can apply them with a single mouse click.

YOU MIGHT BE WONDERING...

What About That Spinning Radar Thing?

The Bridge activity indicator (Figure 5-44) lets you know that Bridge is working and what it is doing. While the indicator is spinning, you should assume that Bridge has not yet finished harvesting all the metadata from the displayed files. This can be critical if you are filtering by rating, or doing some kind of search. Until it fully indexes everything, it will return incomplete results.

While the activity indicator is spinning, you can perform some tasks, such as looking through images and applying ratings, but you should not do any tasks that involve all of the files.

Figure 5-44. The Bridge activity indicator lets you know that Bridge is working, and even gives you some information about what it is doing.

This will greatly speed up the keyword application process. When you're finished, you can drag the keywords back to their normal sets.

How Keywords Get Added to the Panel

The first set of keywords—the famous Julius and Michael—comes prein-stalled. Of course, you can also add keywords, by either clicking on the Keyword flyout, clicking on the New Keyword button in the Keywords pane, or right-clicking on any keyword or set. Keywords that Bridge does not know also get added whenever Bridge indexes an image.

Using Bridge's Contextual Menus

As a last note about menus, I should say a few words about the contextual menus (those menus that appear when you right-click on something or, if you are using a one-button mouse, when you Option-click on something).

Windows users will be very familiar with these, but Mac users may be unaware that they exist. With any application, I find it helpful to do some right-click exploration. Oftentimes, the function that you want will be close at hand through the contextual menu.

Figure 5-45 shows the contextual menu Bridge displays when you right/Option-click with one or more items selected. You will notice that it combines some of the most useful features from several of the Bridge menus. As you work through Bridge, make sure to check the options offered by the contextual menus.

Figure 5-45. The contextual menu that is invoked when you select one or more images and right-click. For one-button-mouse Mac users, this may be something of a surprise.

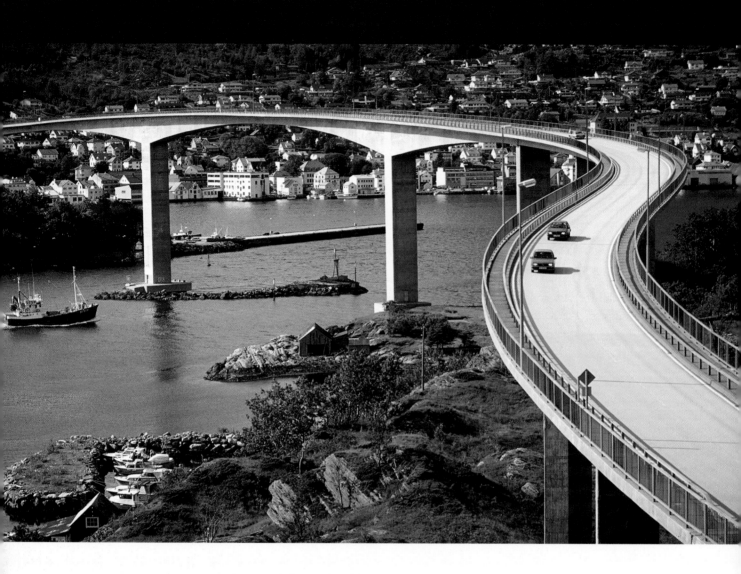

The Workflow Checklist

The Editing Workflow 6

Bridge is a powerful tool for image preparation as part of an integrated digital asset management system. Using Bridge, in about the same amount of time it took to adjust your Camera Raw settings in Photoshop CS, you can rename and back up your images, apply bulk metadata, rate the images, apply custom Camera Raw settings, and convert the RAW files to archival DNG files. Bridge lets you do all of this important work in one application, with a streamlined workflow. After you have finished these tasks, the images will be ready for your cataloging software.

Let's take a look at the exact image preparation workflow in Bridge. I've structured this chapter by first showing how to do each step manually. After going through bulk metadata application, I'll take a brief detour to show how you the Import from Camera script can help you accomplish some tasks automatically. We'll then continue on with the application of higher metadata, Camera Raw adjustments, and creation of DNG files. Before we get started, however, I want to introduce a very old-fashioned tool that should be part of your workflow: the Workflow Checklist.

Figure 6-1. **Keywords:** Crew, Sunrise, Bridge

The Workflow Checklist

The Workflow Checklist is a wonderful tool that my Digital Producer (and Associate Photographer) Darren Higgins came up with for work in the field. As we downloaded and erased cards, Darren wanted to keep a permanent record of what had been done, and of any anomalies that might have occurred. The Workflow Checklist addressed both of these issues, and it has been an essential part of our digital workflow ever since.

The Workflow Checklist is helpful in four ways:

- It keeps a record of what has been done to files, so that you can know that everything has been processed.

- It keeps a record of anomalies so that you can identify bad cards or bad image-handling protocols.

- It gives you a flowchart to follow as you go through the processing workflow, helping you to systematize your work order.

- Lastly, it aids you when you want to alter your workflow in some way. By printing a new checklist—with the new step added—you can more easily remember the new work order.

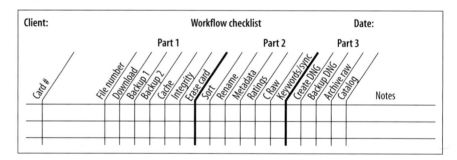

Figure 6-2. This is the checklist that I use to confirm my workflow from card through final archive.

As we move through this chapter, we'll discuss each of these steps and how you can use Bridge most effectively to accomplish them. This checklist is available for free download in either PDF or InDesign format at *http://www.theDAMbook.com*.

In general, here's my suggested work order:

- Download to computer

- Download to "digital wallet" (in the field)

- Back up to temporary hard drive

- Build cache

- Confirm file integrity in Bridge

- Erase cards

- Sort (if multi-camera shoot)

- Rename

- Apply metadata

- Apply ratings

- Adjust in Camera Raw

- Apply more keywords and/or sync ratings and labels

- Create DNGs

- Back up DNGs

- Archive RAW files (if desired)

- Catalog images

Let's take a look at each of these steps in detail, and see how we can best accomplish them.

You Might Be Wondering...

What if I Only Shoot JPEGS?

Although this workflow has been crafted with RAW shooters in mind, it also works well for those of you who only shoot JPEGs. You can skip the steps that are applicable to RAW only—such a Camera Raw adjustment and DNG conversion—but use the rest of them to prepare your image files for archiving.

YOU MIGHT BE WONDERING...

What if I Don't Have Time to Do All This Work Before I Need to Deliver Proofs?

You can work through the steps outlined here very quickly once you get used to the workflow. As a matter of fact, I find that the speed improvements in Bridge let me considerably shorten my production time, even though I am doing much more work to the files.

If you are shooting on tight deadline, however, you might need to adapt this workflow a bit. There are two different approaches you can use to do this. The easiest change that would save you some time would be to make proofing files after metadata, ranking, and Camera Raw adjustment, but before DNG conversion.

You could also decide to shoot RAW + JPEG, do a quick processing cycle on the JPEGs, and send them out. While this will save a bit of time in the near term, it will cost you later. Either you will have to manually transfer the rating and metadata work from the JPEG files to the RAW files, or you will have to find some way of automating this transfer.

iView MediaPro does offer a script that can transfer ratings from a JPEG to a similarly named RAW file, but it's an extra level of complexity to introduce into the workflow. I'll show you how this works in the next chapter.

If you are often on a *very* tight deadline, you might also consider using PhotoMechanic for your ingestion software. Because it browses image files by showing the embedded previews, it can bring up image files faster the first time around than Bridge can.

Phase 1: Acquiring Images

In this phase, we will be getting our images safely from the media card in the camera to the computer's hard drive and backing them up. Although this is generally a simple process, it is also a place where simple errors can lead to catastrophic failure. The process I outline will address the hazards of initial file handling in an orderly and systematized way.

Media-Card Handling

Although this is not a part of the Bridge workflow specifically, proper handling of media cards is an integral part of asset management from camera to computer. I start with a simple system to indicate whether a card is full or empty by how it is placed in the card wallet. If the card is placed with the front outward, I know its contents have been downloaded, backed up, and confirmed and it's ready to use. If it is upside-down, it is full and is ready to be downloaded (Figure 6-3).

Figure 6-3. A card keeper with four Compact Flash cards. I keep the unshot ones right side up and the ones ready for download upside-down.

It is considered good practice to avoid deleting images in-camera if possible. There is a widely held belief among professional photographers that in-camera deletion can cause problems with the memory card's directory. (I have seen this myself.) Of course, if you find yourself in a situation where you need to delete a few images or you'll miss the shot, you can go ahead—the risks are relatively low. In these cases, you should wait for the camera to stop writing the original files before you delete.

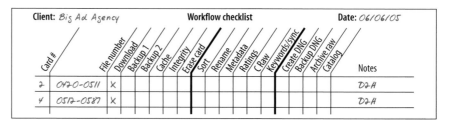

Card #	File number	Download	Backup 1	Backup 2	Cache	Integrity	Erase card	Sort	Rename	Metadata	Ratings	C Raw	Keywords/sync	Create DNG	Backup DNG	Archive raw	Catalog	Notes
2	0420-0511	X																D2H
4	0512-0587	X																D2H

Client: Big Ad Agency — **Workflow checklist** — *Date: 06/06/05*

Figure 6-4. The first step is downloading the card to your computer.

Downloading Images to Your Computer

The real production work starts as you download the card contents to your computer. Since this is a vulnerable time in the life of a digital image—there

is only one copy—I like the download process to be as transparent as possible, so I manually download the images to the working folder in my computer.

I keep a record of what media cards have been used in the first column of the Workflow Checklist. This has helped us to identify a problem card in the past. Since the problem was intermittent, it was not clear if the card or the workflow was the problem. By looking at a series of old checklists, we determined that a particular card was always the one causing problems. Upon very close examination, I could see damage to one of the internal contacts.

After I have downloaded a folder of images, I like to rename the folder for the sequence numbers of the first and last images included. (The sequence number is generally a four-digit number just prior to the extension.) For example, if the first file on the card is named *DSC_0420.NEF* and the last file on the card is named *DSC_0511.NEF*, the folder will be named *0420-0511*. If everything is done properly, the next folder of downloaded images will pick up where the last one left off (*0512-0587*, in this case.) Naming folders in this way makes it easy to see that you have downloaded all the images and have not skipped a card (Figure 6-5).

Figure 6-5. If you name your folders for the images contained, you can easily see that all cards have been downloaded and none has been skipped.

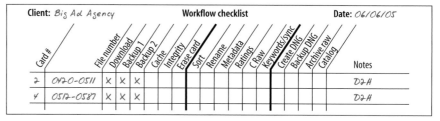

Figure 6-6. After download, the first thing you'll want to do is back up your files.

You Might Be Wondering...
Why Do You Make So Many Backups?

My images are very important to me, and I make a lot of backups because I know that drives can fail at any time. (As a matter of fact, I had a laptop drive die suddenly while I was writing this book—the third such drive that has died while still under warranty.) I believe that there should be at least three permanent copies of each file in existence at any given time. And because my typical shoots pass through three computers (laptop, workstation, and server) before they get to their final home, several temporary backups are also made along the way.

As you plan your workflow, make sure that you know which backups are temporary, and which ones are more permanent. Either dedicate entire drives to the task, or use large folders to contain the temporary backups. Make sure that it is immediately obvious to you which files are the primary versions and which are to be used only in case of a problem. I like to use the designation "Temp" on a folder to indicate that I generally don't have to worry about trashing its contents later.

Of course, until they're erased, the original media cards also contain copies of the image files. In this workflow, I am primarily addressing location shoots where I need to either erase and reuse cards, or get onsite confirmation that the images have come out properly. If neither of these needs is present, I go back to the studio and download the cards directly to my workstation.

Backing Up

Once you've downloaded the files, the first thing you should do is back them up. Hard drives—particularly laptop drives—can fail suddenly and with no warning. For jobs and important personal work, I typically back up to a digital wallet, and to an additional hard drive. The digital wallet is self-contained device that can download and store image files directly off a media card (Figure 6-7). These are temporary backups, which will be erased once the new DNG files have been archived and backed up permanently.

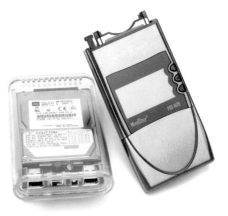

Figure 6-7. A "bus-powered" FireWire drive (it gets its power from the FireWire port, rather than from an external power supply) and a digital wallet.

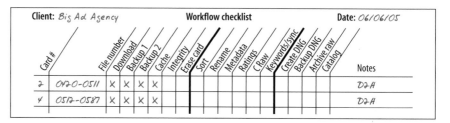

Figure 6-8. Once you've backed up the files, build the cache in Bridge so you can view the image previews.

Building the Cache

Building the cache in Bridge is an essential part of the Phase 1 tasks, because it lets us know that the files have been transferred properly and that we are free to reformat the card. Since Bridge builds the previews directly from the image data, it will show you *proper* previews only for images that it can open and work with. It is only once we see that previews Bridge builds that we know there have been no errors along the way. If you have downloaded each card into a separate folder, as I suggest, you might want to combine all these images together in one folder before building the cache. To build

the cache, you then simply open the folder of images in Bridge. Alternately, you can open each folder simultaneously and have Bridge build the cache all at once.

If you have a large number of images in the folder, it can take quite a while for the cache to be built. During this time, you can see the activity indicator spinning in the bottom-left corner of the Bridge window. You can speed the process of building the cache by using the Build Cache for Subfolders command in the Tools menu.

As you'll see later in this chapter, the Import from Camera script can also build the cache automatically as part of its rename/backup/metadata assignment process.

If you find that files are corrupted or missing in Bridge, you may want to put the offending card aside and work on it later. If the images aren't right, it's easy to get freaked out and start making mistakes. Troubleshooting file corruption problems is hard to do correctly when you're working on location under pressure.

That said, there are times when you will want to know if the images really are lost while you're still on location ("Can I get the Bride and Groom back up on the altar, please?"). There are several good utilities for image recovery, and you should have at least one on your laptop. You should also familiarize yourself with it *before* you need it on location. I have successfully used Photorescue, which can work on either a Mac or a PC.

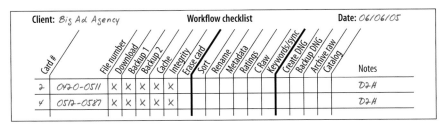

Figure 6-9. Assure the integrity of your image files before erasing the card.

Confirming File Integrity

Unfortunately, the digital photography process is not without a glitch every now and then. Problems can be caused by the camera, the storage medium, the transfer process, the operating system, or operator error (this means you). Before you erase the images from the storage card, you should ascertain that no severe file creation or transfer errors have occurred, and that all images have full integrity.

The first images that show up when you browse a folder in Bridge are the thumbnail images that the camera writes into the files. You should be aware that these images may be fine, even if the underlying RAW data is corrupted. To confirm file integrity, I suggest you wait for Bridge to finish

Differences Between the CS and CS2 Cache

When Adobe designed CS2, they fixed a design flaw that was present in the cache behavior of CS1. In CS1, the flagging and ranking information was stored *only* in the cache. This was problematic in two ways: it made this information invisible to other applications, and it meant that if you cleared the cache, moved files to another machine, or fully reinstalled Photoshop, you lost this information.

If you use sidecar XMP files with CS2, information is never stored only in the cache, unless the images are on locked media (such as CDs or DVDs). This is an important improvement for the long-term handling of image files.

The second difference between the two applications is that using the Build Cache for Subfolders command no longer locks up the machine, as it did in CS1. Because Bridge multitasks well, you can tell it to build the cache and immediately start to edit the images.

building the cache, switch to the Lightbox workspace (Command-F2), and quickly look through the files to ensure that the images are displaying as expected.

If Bridge cannot open a file, two things can happen. If the file is entirely corrupted, Bridge will display a generic icon for the RAW file. If the underlying data is corrupted but the preview built into the RAW file is fine, in theory, Bridge could display the embedded preview. This image should look different enough from the rest of the files to clue you in to the fact that there is something wrong with the image.

There is another way to confirm file integrity, but it adds overhead to the process: you could have the free DNG Converter (available for download at *http://www.theDAMbook.com*) convert the RAW image files to DNG. If it runs into a file it cannot parse, it will generate an error report. If you choose to do this—for a very important shoot, for instance—I suggest that you delete these DNG files after conversion, for reasons I will go over later in this chapter. You can speed up this process by telling the DNG converter not to embed a preview.

Once you have confirmed the integrity of your image files (and made your two backups), you can erase your media card with confidence that the files have been captured and transferred properly.

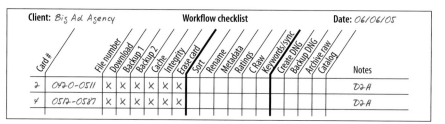

Figure 6-10. Habitually formatting your media cards for reuse after confirming the integrity of the transferred files can help you avoid erasing images that have not been downloaded.

Formatting the Media Card

After file integrity has been confirmed, you are free to format your media cards in preparation for reuse. By habitually formatting cards once the images have been backed up and confirmed, you reduce the possibility of one kind of error: accidental erasure of cards that have *not* been download-ed. Any time you insert a card and see that it is not empty, you will know to double-check that its contents have indeed been downloaded.

Of course, you may choose to format your cards later, only when you absolutely need to. By waiting, you keep yet another backup of the files. I suggest, however, that you make card formatting a part of the workflow once the integrity of the files has been confirmed and the backups have been made.

Always Format Cards in the Camera

Cards should always be formatted in the camera, rather than on the computer. This will greatly reduce the chance of errors when writing to the cards. Breaking any of the following rules will not always lead to a problem, but it will increase the probability:

- Always format the card in-camera, prior to use.
- Never format the card in the computer.
- If possible, never erase images from cards one at a time—this leaves fragmented space on the memory card.

Some people also suggest that you should leave a little extra room on the card, rather than filling it to capacity.

Phase 2: Preparing Images in Bridge

We finished up the Phase 1 work by safely transferring the images from the card to the computer. We're already in Bridge, but now the real magic begins, as we rename the files, apply metadata, rate and adjust them, and make DNGs. Let's take a look at this phase of the workflow.

Feel free to start working on the rating of individual files as the cache is building, but do not try to perform any functions on *all* of the files, such as batch-renaming or searching through metadata, because they won't all be accessible until the caching is complete. (In most cases you won't want to be searching yet anyway, since this is the part of the process where we are *assigning* metadata.)

Building the Cache, and Applying Camera Raw Settings

When Bridge first opens a folder of RAW images, it displays the images with Camera Raw settings that were most recently saved as Camera Raw defaults. Note that there is a different default for each model of camera supported in Camera Raw—so, for example, if you make a custom default for your Canon D30 that does not use Auto, the default for your 1DS MarkII camera will remain unchanged. I suggest that you make a custom default for each camera you use (unless you are happy with the way the defaults already work). I have made a default for each of my cameras that do not use the autoexposure options.

Note that if you never actively apply a Camera Raw default, Bridge will use the current defaults when it opens the files. This means that if you open files on your computer (where, for instance, you have Auto turned off) and create DNGs of the files, and the files are then opened on a machine that has a different Camera Raw default setting (with Auto turned on, say), the second computer's default settings will be applied.

YOU MIGHT BE WONDERING...

To Auto or Not to Auto?

The settings that will be applied to image files as the cache is being built are the current camera defaults that Camera Raw is set to. For most people, the biggest decision is whether to use the autoexposure options or not.

Adobe has done a good job of creating Auto settings to apply in Camera Raw, but they are not optimum for all images. As you work with CS2, you may find that you want to turn off Auto settings as the default, and apply them only in certain circumstances.

There are several situations where Auto will definitely work against you. For example, if you are shooting against a white background, and you intend that background to go to pure blown-out white, you will find that the Auto settings will not work well. In general, Auto will try to prevent the highlights and shadows from being clipped in this manner. The Auto settings are also not recommended for images that have been exposure-bracketed. Auto will largely remove the differences between these frames, making it difficult to determine which is the best exposure.

If you want a particular custom Camera Raw default to stick with these files, you need to select the files and choose Edit→Apply Camera Raw Settings→Camera Raw Defaults, as shown in Figure 6-11.

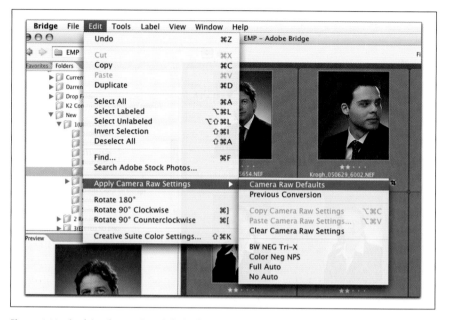

Figure 6-11. Applying Camera Raw defaults from Bridge. If no settings get applied to photos, they will use the current defaults for the computer on which they are opened.

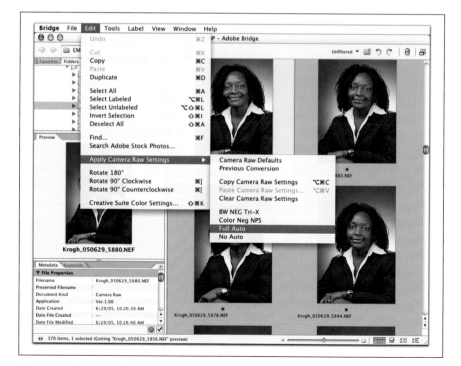

Figure 6-12. You can apply saved Camera Raw settings to images in Bridge. The Full Auto and No Auto settings are some of the ones I've made, as discussed in the previous chapter.

If you generally use Auto and want to disable it for a set of images, it's help-ful to have a No Auto Camera Raw preset to apply from Bridge. (Figure 6-12 shows how you can access these presets from within Bridge.) Select all the files for which Auto is not beneficial, go to Edit→Apply Camera Raw Settings, and choose the No Auto preset.

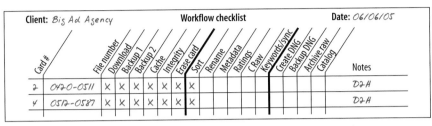

Card #	File number	Download	Backup 1	Backup 2	Cache	Integrity	Erase card	Sort	Rename	Metadata	Ratings	C Raw	Keywords/sync	Create DNG	Backup DNG	Archive raw	Catalog	Notes
2	0470-0511	X	X	X	X	X	X	X										D2H
4	0512-0587	X	X	X	X	X	X	X										D2H

Client: Big Ad Agency **Workflow checklist** **Date:** 06/06/05

Figure 6-13. Sorting is only necessary if you are using more than one camera on a shoot.

Sorting Image Files

This particular step is required only if you are renaming images from mul-tiple cameras that were used for the same shoot. In these cases, it is very handy to sort the images by the Date Created field (which goes down to the second). This ensures that all images line up in the exact order they were made, regardless of how many cameras were used.

The first step in sorting with Bridge is to combine all the images into one folder, since Bridge can display only one folder at a time. (You may have already done this to build the cache.) Note that the cache must be com-pletely built before Bridge can sort the images properly, since Bridge will be sorting with EXIF data that it extracts from the files. After the caching has finished, go to View→ Sort→By Date Created (Figure 6-14). Once the images have been sorted, they can be renamed in the current sequence.

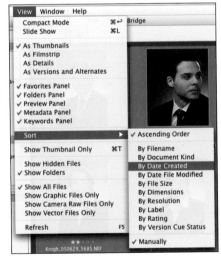

Figure 6-14. You can sort the file order by multiple criteria.

Be careful as you combine images that you do not overwrite images with the same name. If your cameras are using the same naming method, and the sequence numbers overlap (say, both cameras record image 5001 during the shoot), you could run into big problems as you combine these images into one folder—the image *DSC_5001* from Camera 1 might overwrite *DSC_5001* from Camera 2, erasing it forever.

> **NOTE**
>
> *For the images to sort chrono-logically, all the cameras must be synchronized. As you prepare for the shoot, make sure that you compare the internal clocks of the cameras so that they read the same.*

If you want to rename images from multiple cameras in chronological order, and they may have duplicate filenames out of the camera, you can use the Find function to make this a quick process.

1. Collect all the folders of images into one large folder, and open that folder in Bridge.

2. Go to Edit→Find, and check "Include all Subfolders" and "Find all Files." This will show every file contained in the entire folder structure, as though they were all in the same folder.

3. Go to View→Sort→By Date Created. This will make them line up in chronological order.

4. Batch Rename with the settings in shown in the next section.

How Do the Destination Folder Settings Work?

Bridge's Batch Rename function has three options for the destination folder. You'll want to be sure you know what each one does:

- "Rename in same folder" renames the images and keeps them where they are.

- "Move to other folder" renames the files, copies them to another location, and erases the originals.

- "Copy to other folder" copies the images to another folder and renames them, leaving the originals untouched.

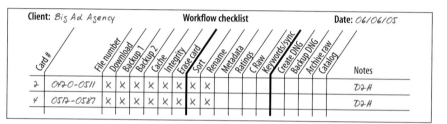

Figure 6-15. Choose a file naming convention, and stick to it.

Renaming the Files

The Batch Rename function in Bridge offers a number of different naming options. You can include the original filename, pieces of text, sequence numbers, and information pulled from the metadata of the files themselves. I presented several naming strategies in Chapter 3, which you might want to review if you have not yet settled on a final naming convention.

In general, the most important principles of naming are:

- Give the file its final name as soon as possible.

- Use a consistent naming structure for all of your files.

- If you put a database-style date near the front of the name, all your images will line up in chronological order.

- Don't use more than 31 characters (plus the extension), and don't include spaces, or any punctuation other than underscores or dashes and a single period before the file extension.

From the Tools menu, select Batch Rename to display the dialog box shown in Figure 6-16. The first option, Destination Folder, allows you to choose where to put the renamed files. I keep this set to "Rename in same folder," but I suggest you don't use this option until you are confident that you have all your settings correct (this setting will actually rename the files, instead of

copying them and renaming the copies). The first few times you try it, select only a small number of images and select "Copy to other folder." This way, if you mess up the renaming, you have not altered the original files. Once you're comfortable with the functionality, you'll want to rename the original files rather than renaming a set copied to a different folder.

You can see how the New Filenames function works by checking the preview at the bottom of the dialog box. You can enter text, or you can have Bridge extract information from the file's metadata. As of version 1.0.2, Bridge has some very robust renaming capabilities regarding date. Most importantly, you can have Bridge automatically extract the date the image was shot, and incorporate it as part of the filename (Figure 6-16). This lets you batch rename images shot over several days at the same time.

Figure 6-16. These are the settings I use to batch-rename files from a multi-camera shoot.

There is a "Preserve current filename in XMP Metadata" option available here, but in my opinion it preserves the wrong name. The name I want to preserve is the new, permanent name, not the original one given by the camera. I leave this option unchecked.

The Compatibility settings keep you from using a naming scheme that does not work with other formats. If you are experimenting with naming strategies, it can be helpful to check these options so that you don't inadvertently use a naming protocol that is incompatible with another operating system. The naming systems I suggest are universal, so you shouldn't actually *need* these.

The final item in the Batch Rename dialog box, Preview, shows you how the name currently appears and how it will appear after it's renamed. It also indicates how many files will be renamed.

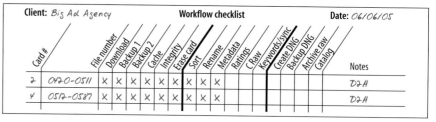

Figure 6-17. Assign your bulk metadata fairly early in the process.

Appending Copyright Info and Bulk Metadata

Because bulk metadata assignment is one of the most valuable things you can do to your files, I suggest that you do it very early in the process. I know many photographers will have to get back to shooting, or even doing unrelated tasks, but at a minimum I suggest that you apply your copyright and contact information to the files at this point in the workflow.

We covered how to make a basic metadata template in the last chapter. If you have an extra minute, I suggest that you customize your basic metadata template so that it's specific to the set of photographs that you're currently working with. This will save you time in the long run.

There are three ways you can apply a metadata template to a set of images. One is through the flyout menu in Bridge's Metadata pane, which gives you the options either to append the metadata in one of the saved templates to the existing metadata or to replace any existing metadata with the metadata in the saved template (Figure 6-18). You can access these same options via the Tools menu.

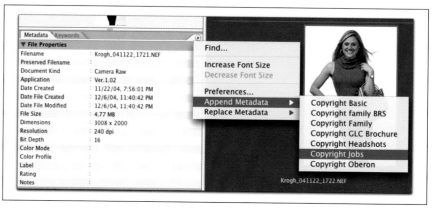

Figure 6-18. You can access previously saved metadata templates via the flyout menu in the Metadata pane (or via the Tools menu).

The third option is to use the flyout menu in the File Info dialog box, accessible from the File menu—the same menu that lets you save templates also lets you apply templates (Figure 6-19). Note that the only option available here is "Replace Metadata," which means that when you apply the new template, the existing metadata will be overwritten (although you will be

Digital Asset Management

asked to click Okay to confirm that you want the changes to be applied to the selected file or files).

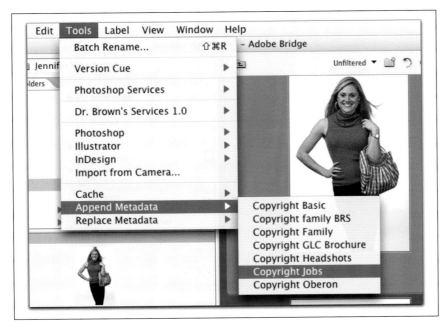

Figure 6-19. You can also apply a metadata template from within the File Info dialog box.

If you would like to apply a metadata template with some notations specific to this particular set of images, you should use the File Info command in the File menu to apply the metadata. This will give you access to each of the metadata fields, so that you can make custom entries (Figure 6-20).

N O T E

If you find yourself applying the same job-specific template many times over the course of a job, you might want to tweak the work order a bit. Remember, one of our rules is "Do it once." If you are downloading images and applying metadata templates several times in a shoot, you may want to wait until you've downloaded the entire shoot before you apply bulk metadata.

If you have downloaded the morning's work and were planning on doing some metadata application at lunch, for instance, it might be a better use of time to do some rating work at lunch, and hold off on bulk metadata application until the day's work is complete.

Figure 6-20. Going via the File Info dialog to apply your metadata template has the advantage of enabling you to add information specific to only the images you are working on currently.

Adding job-specific information to the template will enable you to do more complete and efficient bulk metadata entry. Here are the steps you'll want to follow:

1. Select all images from a particular shoot.

2. Open the File Info dialog, click the flyout menu at the top right, and select a universal metadata template.

3. Fill in the blank fields that apply to all the selected images. These settings will primarily be part of the IPTC Content, IPTC Image, and IPTC Status panels.

4. If you will be applying this same metadata to other images that have not yet been downloaded, you may wish to save this as an additional template for later use.

5. Click Okay once you have filled out all the appropriate fields.

After you have applied a metadata template to your images, you might want to take the opportunity to add a few more keywords. I find that it is generally faster and easier to add keywords to images in Cataloging software, with one exception. Any keywords that you can add easily to all the files, or to large subsets of the files, should be done early in the process. This ensures that the work will get done, and it will help you when you revisit the images in your catalog.

You'll notice that Bridge can take a while to finish writing the keywords to the file (you can see the "Radar" spinning while it updates each selected file). If you are writing several keywords to a lot of different files, it can mean a lot of waiting. For this reason, I like to group keywords that I want to apply together as a Temporary Set, so that I can be more efficient.

When to Rename Manually: Organizing Multiple Cameras

The Import from Camera script is a great way to rename image files and get them ready for rating and Camera Raw adjustments. There is one situation in particular where you shouldn't use this script, however. If you use more than one camera in a shoot, and you would like to rename all the files in chronological order, you will have to rename them in Bridge (as previously outlined), or possibly another DAM application.

Figure 6-21. The Workflow Checklist looks somewhat different if you're using the Import from Camera Script.

Using the Import from Camera Script

We're going to take a brief detour here to look at an alternative version of the Workflow Checklist (Figure 6-21), which is what you'll use if you make use of the Import from Camera (IFC) script introduced in the previous chapter. IFC is an automation tool that Adobe created to provide added

functionality to Bridge. Because the script can perform several functions in one hit that must otherwise be done manually, the checklist above looks a bit different from the original one. As you can see, several of the tasks are encompassed by the "Run Script" entry, and you will do some of the remaining tasks (checking file integrity and erasing your memory cards) in a different order.

Despite its name, IFC is useful for much more than just importing images. It can work on a folder full of images (or on a folder full of folders full of images), and it provides a one-button solution to accomplish many of the common tasks that need to be done to multiple files. These include:

- Renaming

- Moving images from multiple folders to a single folder

- Building the cache

- Writing both the old and new filenames to XMP metadata

- Applying the Camera Raw Default to the images

- Applying a metadata template

- Backing up the files to a separate location

- Doing all of the above work to a "linked set" of RAW + JPEG files shot simultaneously

— N O T E —

In order to use the Import from Camera script, you need to download and install it in your startup scripts folder. Instructions for this are in Chapter 5 and at http://www.theDAMbook.com.

Once you've downloaded and installed it, you can access the IFC script via Bridge's Tools menu. In the previous chapter, I went through all the logic behind the script's controls. If you are interested in using IFC, review that chapter before trying it. For the purposes of this chapter, I'll just show you how I have the controls set (see Figure 6-22).

That said, let's move on to the next item that appears on both checklists: ratings.

Figure 6-22. These are the settings I use with the Import from Camera script, discussed in the previous chapter.

Card #		File number	Download	Backup 1	Backup 2	Cache	Integrity	Erase card	Sort	Rename	Metadata	Ratings	C Raw	Keywords/sync	Create DNG	Backup DNG	Archive raw	Catalog	Notes
2	0470-0511	X	X	X	X	X	X	X	X	X	X	X							D2H
4	0512-0587	X	X	X	X	X	X	X	X	X	X	X							D2H

Figure 6-23. Once you've applied bulk metadata, you can move on to higher metadata and apply your ratings.

Applying Ratings (Positive and Negative)

The next part of the work order deals with some higher metadata: the ratings. Ratings are discussed thoroughly in Chapter 2. If you have skipped to this chapter, I suggest that you go back and take a look at the principles outlined in the section "Tagging Images for Quality: The Ratings Pyramid." It's important to decide on the meaning of your ratings before you start applying them, particularly if they are to be of use collection-wide. I will be referencing the principles discussed in Chapter 2 here, but I won't go over them again entirely.

Figure 6-24 shows the layout I prefer for rating images. When I am on a laptop, and space is at a premium, I configure the thumbnails to run vertically. On my larger desktop monitor, I have the thumbnails run horizontally across the bottom of the screen.

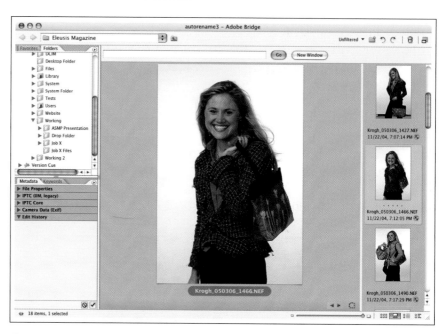

Figure 6-24. My preferred layout for rating images.

I find that the most useful workspace for ratings in Bridge is the Filmstrip. I have created a custom workspace that shows the Folders, Favorites, and Metadata panes, as well as the Filmstrip, for doing this work. If you have set up your Bridge preferences in the way I suggest in Chapter 5, you will find this to be a very convenient way to evaluate the relative quality of your images and to give them corresponding ratings.

You may also want to make a workspace that does not include the navigation and metadata displays on the left side of the page, but since doing that does not get me any additional image size, I prefer to leave those panes showing.

Editing sequence

Bridge lets us see thumbnails in the Filmstrip, and a nice high-resolution preview in the big window. Because we can see the sequence of images, we can determine how big the set of similar frames is, so that we can more effectively rate them comparatively. If we are looking at exposure brackets, for instance, we can browse the entire set and pretty easily determine which one is best. If we are looking at a sports action sequence, we can run through it from start to finish to get an idea of which are the best frames as we determine the ratings.

Assigning ratings and labels with the keyboard

To apply ratings, I use the arrow keys and the number keys. I keep my right hand on the arrows to move through the images (Up and Right move forward, and Down and Left move back), and I keep my left hand on the number keys to assign a label or a rating for the selected image. (You can also use the mouse, but I find this slows things down.)

I often use the arrow keys to quickly run through each set of similars, then go back to the start of the set to apply the ratings. Once I've quickly evaluated the set that I am choosing from, it becomes easier to make the relative quality decisions that are at the heart of the rating process.

In general, I suggest that you use the number keys as much as you can to assign labels and ratings. You can change a star rating at any time by pressing the key corresponding to the new desired rating. Unlike with labels, though, pressing a star rating key twice will not undo the rating (if you press 6 to assign a label, pressing 6 again will remove it).

Positive ratings

For images that I want to show to the client, I apply a single star, using the 1 key. (You could also use Command-Period, but I find that is an uncomfortable hand position.) For images that I want to *recommend* to the client, I add an extra star, generally by pressing the 2 key. (I may assign three stars to some images, but only very rarely at this point. This rating is generally

saved for images that are the best of my collection, or that are client selects. I use four stars only for portfolio images.)

Negative ratings

As I see images that have problems, I can assign negative ratings as well. For pictures that I will want to throw away immediately, I assign the label that I have called "TrashMe." For images that I will throw away once the job has been fully delivered and paid for but that may prove useful in the meantime, I assign the label "Outtakes."

Reviewing the ratings

Once you have gone through the images once, you can step back and revisit the ratings as a whole. The most critical evaluation is to make sure that you will not be throwing away anything that you ought to keep. For example, you might find that you were unhappy with every image from a particular situation, and have labeled them all as trash. At this second evaluation opportunity, you may decide to relabel one of the images as Outtakes or neutral, so that you are keeping at least something from that situation. You might also want to increase or decrease the star rating of an image in light of further evaluation of the rest of the images.

Figure 6-25 shows an image that could have been accidentally thrown away, because it was a blink. A second evaluation revealed a picture well worth keeping.

Figure 6-25. One of the advantages of using labels to tag images to throw away is that you can avoid accidentally deleting pictures you should keep. A quick edit might tag all blinks for deletion, while a second evaluation might reveal a great picture.

Viewing "filtered" images

Once you have gone through the images once, you may wish to take advantage of the Filter command (Figure 6-26) to help you refine your edit further. Choose "Show 1 or More Stars," and only those images that you have positively rated will be displayed. This is helpful in a number of ways:

Figure 6-26. Bridge gives you numerous options for filtering the displayed items.

- It hides images that are not up to snuff, so that you can concentrate better on the highest-quality photographs.

- It shows only those images that will be presented to the client, so that you can confirm that you have made a big enough selection to fulfill the assignment.

- By filtering for "Show 2 or More Stars," you can further narrow down the display to only those images with your recommendation.

- The Filter command lets you easily answer the following questions: Have I chosen too many files? Have I chosen too few? Does it tell the entire story? Are there enough images to say that I have completed the job?

Note that when you elect to filter by both stars *and* labels, the only items displayed will be those that have both a label designation and a rating designation. If you would like to find images with either a label *or* a rating, you will have to use the Find command, as shown in Figure 6-27.

> **NOTE**
>
> *I'll show you a little later how you can use keywords to get other applications to mimic Bridge's ratings filtering behavior.*

Figure 6-27. The Find command can be used to show images that have a particular label value (in this case, Client Select) and any rating value.

Using the Unrated designation

There is one category of evaluation that the main Bridge window is not particularly well suited to: judgments where critical image quality is the issue. If you need to judge critical focus, or if shadow detail will be the determining factor, you will probably want to make those judgments in Camera Raw, rather than in the Bridge window. For these images, it can be helpful to tag the set of pictures with the "Unrated" label (Figure 6-28), so that you know they are unstarred because they have not yet been evaluated, rather than because they are not very good (i.e., have a neutral rating). We will see how to rate in Camera Raw in the next section.

Figure 6-28. I use the label "Unrated" to mark image files that I need to evaluate further once I take them into Camera Raw. These files need closer examination for focus and fine detail.

You may also want to use the Unrated label for another important reason: because you did not have time to complete the rating process before stopping. Again, it's important to know that an image has no positive or negative rating because it has not yet been rated, rather than because it does not deserve a rating.

SIDEBAR

Using the Slideshow

The slideshow (View→Slide Show) is a great new feature in Bridge. You may find that you like to use the slideshow as a viewer to rate your images. The advantage is that you get a full-screen image, which can be particularly helpful on a laptop. The disadvantage, compared with Filmstrip mode, is that you don't get to see what's coming and what's gone by in the strip window. It's easier in the Filmstrip mode, for example, to see that there are eight images in this particular situation and that you have rated three as 1Star and one as 2Star. In the slideshow mode, you can only see one image at a time, so you don't get an overview of the whole set.

The slideshow has many options, all of which display the first time you launch it. You should remember at least three keyboard shortcuts when you first start using the slideshow: the spacebar pauses and restarts the show,

the "H" key displays the list of other keyboard shortcuts (Figure 6-29), and the escape key brings you back to the main Bridge window (as an added bonus, the tilde key— that funny squiggle to the left of the number one—also displays the menu).

Essentially, navigation in the slideshow is the same as in the Filmstrip, once you have paused the auto-advance (by pressing the spacebar). You can move through the images with the arrow keys, and you can rate the images with the number keys.

The slideshow can be a good place to rate images, but it's an even better place to use for display, either for your client or for any other display purpose where you want images to be presented nicely (as long as they don't have to sync up with music).

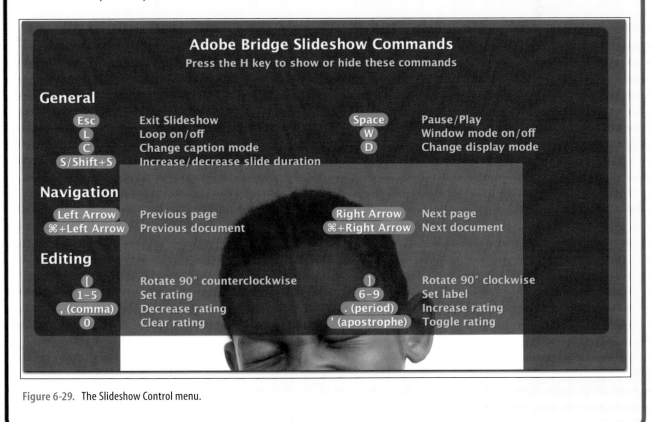

Figure 6-29. The Slideshow Control menu.

This section will not be applicable if you only shoot JPEGs. If you do not shoot RAW files, you will not have access to Camera Raw and the adjustments you can make there. You can skip ahead to the section "Applying Keywords and Synchronizing Ratings," where we will outline the processes of keywording and ratings syncing in preparing your images for archiving.

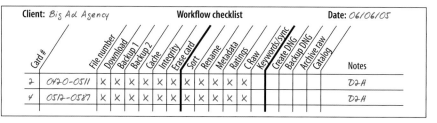

Card #		File number	Download	Backup 1	Backup 2	Cache	Integrity	Erase card	Sort	Rename	Metadata	Ratings	Raw	Keywords/sync	Create DNG	Backup DNG	Archive raw	Catalog	Notes
	2	0420-0511	X	X	X	X	X	X	X	X	X	X	X						D2H
	Y	0512-0587	X	X	X	X	X	X	X	X	X	X	X						D2H

Client: Big Ad Agency **Workflow checklist** **Date:** 06/06/05

Figure 6-30. Once you've rated your images, it's time for Camera Raw adjustments.

Making Prints Versus Virtual Printing

When we photographers went into the darkroom to make prints, we were doing two different tasks simultaneously. We were making a physical object—the print—but we were also deciding how we wanted that image to appear. We made decisions on density and contrast, whether to burn or dodge, how to crop, and so on.

In the virtual world, these two tasks are often separated. As we bring images through Camera Raw, we are doing the second part of the work outlined above: making "virtual" prints. We are deciding how we want the images to appear, and making the appropriate settings.

With the advent of DNG, and its ability to store a "pretty good print" within the file, I suggest that you consider that you are "printing" as you bring your images through Camera Raw. Although the output of the image files may come later (or never), and the output medium could be virtual or physical, I consider this to be the truly artful part of printing the digital image.

Adjusting Camera Raw Settings

Probably the single best productivity improvement provided by CS2 is the enhanced Camera Raw workflow. By bringing multiple images simultaneously through Camera Raw, you can very quickly make adjustments that enable them to appear the way you want them to. And by saving your images as DNG files, you can enable other applications to see the adjustments you have made.

To get started, we need to select a group of images in a folder, and open them in Camera Raw. We can do this by double-clicking (if you have set your preferences as I suggested in the previous chapter), or using the keyboard shortcut Command-R. If you have selected a large number of images, it may take a moment for all of the previews to be generated. You will notice

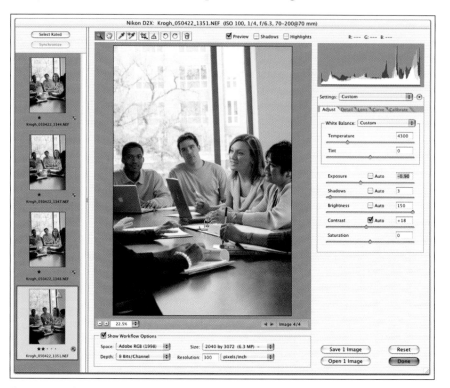

Figure 6-31. The yellow triangle in either the Filmstrip preview or the main Camera Raw preview window indicates that the preview is updating. Don't make any critical decisions until this caution symbol has disappeared.

that a yellow triangle warning appears when images first come into Camera Raw (Figure 6-31). This indicates that the previews are still being generated. You don't want to make any decisions on how to adjust a file until this caution sign goes away.

You can now begin to adjust the settings for your files. I'll give you an overview of the controls that Camera Raw provides below, but first let's take a look at some strategies.

Camera Raw work order

As you go through your images making custom settings, you can see the importance of having ratings attached to the photos. Because Camera Raw offers so many adjustment options, you can spend quite a bit of time getting your settings perfect. If your images have already been rated, you can spend the bulk of your time and effort working on the best images.

You first need to think about how much time you want to spend correcting images of different ratings. At either end of the spectrum, the decision is simple: the higher the star ratings, the more you want the settings to be ideal; you can spend less time on neutral images, and for images labeled as Outtakes it probably makes no sense to spend time adjusting settings. In fact, you may decide to only adjust images that have a positive rating, and not even bring the neutral or negatively rated images into Camera Raw.

> **NOTE**
>
> *For a more complete exploration of Camera Raw capabilities, check out Bruce Fraser's* Real World Camera Raw *(Peach Pit, 2005) or Mikkel Aaland's* Photoshop RAW *(O'Reilly, 2005).*

> **NOTE**
>
> *You will notice that Camera Raw holds the magnification for an image, even if you click on another image. If you are judging focus in one particular part of an image and want to compare it to similar frames, you can enlarge and zoom them to the same settings, and make your evaluations more quickly. Here's how:*
>
> - *Select multiple images.*
> - *Zoom to the desired percentage.*
> - *Move the image until the area of interest is visible in the Preview window.*
> - *Now you can arrow through the images, comparing fine detail in the same area of each picture.*

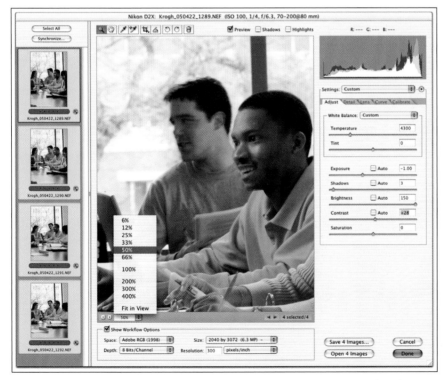

Figure 6-32. You can select multiple images and zoom them to match each other. Note how the Unrated label easily indicates to me that I need to evaluate these images in Camera Raw for critical focus issues.

Because of the different functionality of Camera Raw, the Bridge preference for applying ratings by pressing only the number key does not work here. To apply a rating to an image in Camera Raw, you need to press Command-(number).

If you were saving some images to rate—those images where you need to judge critical focus, for instance—now is the time, and Camera Raw is the place. You can get a full-resolution preview of the image, so this is the best time to make critical focus evaluations.

Applying settings to multiple similar images

A handy feature that Camera Raw offers is the ability to make a set of adjustments to one image, and then reapply them to other images, using the Synchronize function. Typically, for a set of images that share exposure values, I first select the highest-rated image. Once I am happy with the way I have adjusted it, I select the similar neighbors (Shift-click highlights all images in between, and Command-click lets you select images one by one). After selecting those neighbors, I click the Synchronize button at the top of the strip. This brings up a dialog box, shown in Figure 6-33, that enables me to choose which settings to apply to the set. For images that are exactly alike in color and exposure, choose "Everything." If the images need a similar color adjustment but have different exposure needs, you may only wish to transfer the white balance corrections, and so on. Note in Figure 6-33 that I have first made adjustments to the two-star image, and I am then transferring them to the lesser-rated photographs. Also note how the Synchronize dialog box lets you choose preset groups of settings to apply. The image with the blue frame around the thumbnail is the one whose settings will be copied.

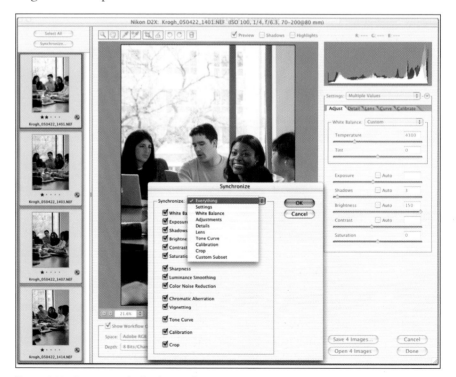

Figure 6-33. You can use the Synchronize function in Camera Raw to apply the same set of adjustments to multiple images.

Once you see how the settings affect the other images, you may want to further refine them for some of the photos. As before, pay the most attention to the files that have the highest rating, and pay little or no attention to neutral or negatively rated images.

Now that we have established the logic behind our adjusting work, let's see the work order for a particular image. Remember, this workflow is outlining what we do for a large set of images for proofing, not what we would do when making a master file. There are settings we will skip entirely at this time, but that we would expect to return to once we, or the client, have made final selections.

The following sections walk you through the various settings available on the Adjust, Detail, Lens, Curve, and Calibrate tabs in Camera Raw.

The Adjust tab

The Adjust tab is the place where you will do the most work for your general Camera Raw adjustments. This is where you control the color and brightness of the images. It's also a great place to turn images from color into black and white. You can access the following on the Adjust tab:

White Balance settings

You can adjust the overall color of your images in Camera Raw in several ways: you can choose a preset color balance, or you can create a custom color balance with either the Dropper tool, the White Balance sliders, or a combination of both. The presets mimic the behavior of the white balance controls of the camera, giving you a good, quick adjustment for any particular kind of light. Figure 6-34 shows how you access these presets from the White Balance drop-down menu.

If the presets don't get you exactly what you want, or if there is something in the frame that is supposed to be a neutral white or grey, the white balance

Figure 6-34. You have access to your camera's preset white balances from Camera Raw.

Dropper tool (available at the top left of the Camera Raw window) can be a quick way of getting a pretty good color balance. Select the Dropper tool, click on the area, and see what happens. If you don't like the result, hit Command-Z to undo it.

Use the Option/Alt Key to Select Only Positively Rated Images in Camera Raw

If you are in a hurry and only want to adjust images with a positive rating, there is a handy shortcut built into Camera Raw. When you press the Option key, the Select All button at the top left of the window changes from "Select All" to "Select Rated," and automatically selects only images with star ratings. This can also be a useful tool if you want to browse through your best images to confirm that they have had a good-enough adjustment before you leave Camera Raw.

Be careful when you are doing this, however. Since you *have selected* all the positively rated images, any changes you make to one image will be applied to all of them. Make sure you *deselect* the entire group before you readjust a single image that needs a further tweak.

Figure 6-35 shows the White Balance sliders in action. As soon as you begin to move them, the setting in the pull-down menu changes from a pre-set to "Custom." You can use the Temperature and Tint sliders to adjust the color of your image. The Temperature slider controls the blue/yellow balance of the image, and the Tint slider controls the red/green balance. Since I like a warmer look, I often click in the image with the Dropper tool and then adjust the Temperature and Tint sliders slightly to the right.

You will notice that if the Auto checkboxes are checked in the exposure controls, the Exposure sliders will start to move when you adjust the white balance. This is because Camera Raw is constantly updating the Auto settings based on how the brightness data is distributed. As you change the color balance, you are changing the brightness distribution of individual color channels, and therefore the autoexposure settings are recalculated. This is one reason why I adjust white balance first.

Figure 6-35. Use the White Balance sliders to adjust the color of your image.

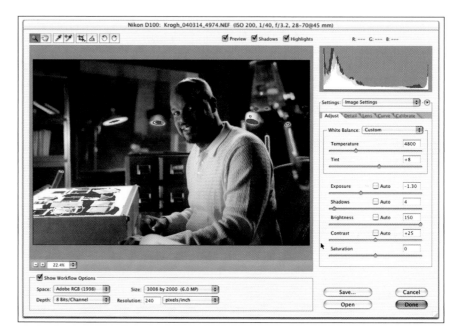

Figure 6-36. The Camera Raw window with red and blue clipping indicators appearing to show where highlight and shadow problems lurk.

Figure 6-36 shows the Camera Raw window with the clipping indicators checked. This shows areas where the highlight detail is being lost with blocks of red, and areas where shadow detail is blocking up with bright blue. The histogram in Camera Raw now shows each of the colors, so you can get a better idea of exactly what detail is being lost. This image should have both the Exposure and Shadows sliders backed off a bit to preserve detail. The red and blue clipping indicators in the Camera Raw window indicate highlight and shadow problems.

Exposure settings

The four settings below White Balance—Exposure, Shadows, Brightness, and Contrast—set the lightness and darkness of the image. Using these in conjunction with the Clipping and Histogram tools, you can make very good adjustments very quickly to your images. The available settings are:

Exposure

The first setting I adjust after white balance is the Exposure slider. This control works mostly on the highlights of an image. I like to set the highlight while watching the highlight clipping indicator in the Preview window. This enables me to make decisions about where I can sacrifice detail—in a light bulb, for instance—and where I definitely don't want to lose detail—skin tones, for example.

Shadows

The second lightness adjustment I make is to the Shadows slider, which of course works primarily on the darkest pixels in the image. Again, the histogram and the clipping indicators are very helpful in determining exactly where to set this control. For most images, I adjust the Shadows slider up to the point where the histogram is starting to show some clipping on the low end. I have also started using the Auto setting on Shadows even as I adjust the others manually.

Brightness

The Brightness slider lets you adjust the midtones of an image. You use this to move the data in the middle of the histogram one way or another. Of course, it will also make some changes at either the highlight or the shadow end, so you might want to readjust those sliders after you have run through it once.

Contrast

The Contrast slider pushes data out from the midline of the histogram as you move it right (lights get lighter, darks get darker), or does exactly the opposite as you move it left. I don't use this control as much, but I find that it can be helpful if I have an image where I can't hold highlights and shadows and get the midtones to look right.

You Might Be Wondering...
What Are Clipping and Histograms?

Clipping is a term that refers to RGB values that are at either end of the brightness scale: either down to 0 or up to 255. Generally, this indicates an area where there is no detail in either the highlights or the shadows. This gets slightly more complicated for color photos, because individual channels can be clipped while others are not. For instance, the Red channel in Figure 6-36 is clipped, while the Blue and Green channels are not. (The red indicator is not an indication that Red is the clipped channel; it's the color Camera Raw uses to indicate all highlight clipping. We can tell that it's the Red channel by looking at the histogram.)

A *histogram* is a graph of the distribution of the brightness information. The dark pixels are represented by the lefthand side of the graph, and the bright pixels are represented by the right. You can see that the clipped areas make for a "spike" at either end of the histogram.

Before I leave Camera Raw, I typically run through all positively rated images to confirm that there is no unwanted clipping of either highlight or shadow detail.

— N O T E —

After you have finished tweaking the exposure, you may want to readjust the white balance slightly.

Converting to Black and White in Camera Raw

For those of us who really like shooting in black and white, Camera Raw is a godsend. It gives you great control over the final look of the image. Because it desaturates the file after the color information has been pushed around, you have the same kind of control over your images that you can get by using colored filters and black-and-white film.

As a matter of fact, I find the creative control over black and white conversions that's available in Camera Raw to be more thorough and intuitive than in any other place in Photoshop.

If you want to make truly stunning black and white conversions, there's a link on my web site (*http:// www.theDAMbook.com*) to a set of powerful presets that Russell Brown has made available. Check them out.

Saturation

The Saturation slider can be useful for tweaking the amount of color in an image file. In general, these moves should be pretty small, unless you are going for some kind of exaggerated effect. Saturation is also a wonderful tool for the conversion of color digital images to black and white (Figure 6-37). You can move the Saturation slider all the way to the left, and then—by using the White Balance tools along with the Exposure/Shadows/Brightness/Contrast sliders—you can control how the color tones are mapped to the black and white.

Figure 6-37. You can make great black and white conversions in Camera Raw.

The Detail tab

Most of the work I do to proofs (this first round of corrections we are doing now) is done in the Adjust and Curve tabs, but I will do some adjustment in the Detail tab (Figure 6-38) if the images have an objectionable amount of noise for a proof. Generally, this is appropriate for images that were either shot at high speed or were underexposed. These images will get some Color Noise Reduction and possibly some Luminance Smoothing.

Figure 6-38. The Detail tab in Camera Raw.

You can make three types of adjustments on the Detail tab:

Sharpness

As I stated in Chapter 5, the Sharpness tool in Camera Raw is more sophisticated than the simple slider suggests. Thomas Knoll has configured the sharpening for each camera model, and he uses a combination of the various sharpening methods available to Photoshop. You should think of this as "capture sharpening" rather than "output sharpening." Capture sharpening is a small amount of sharpening that will make the image look better in Photoshop—and get you closer to a final product—without oversharpening. Output sharpening is additional sharpening you do to a final file, appropriate to the size and output device used.

Figure 6-39. Image with accentuated color noise (it's a high-ISO photo, with contrast boosted in Camera Raw to emphasize the noise).

Luminance Smoothing

The Luminance Smoothing slider will correct for luminance noise: the appearance of some pixels as inappropriately bright in shadow areas. In doing this noise reduction, you will also be reducing detail, so you will want to look at the image enlarged to 100% in order to judge if the tradeoff is worth it.

Color Noise Reduction

I use Color Noise Reduction quite a bit. This evens out the multi-color appearance of shadow detail in high-ISO or under-exposed images. Again, you will want to look at images at 100% magnification in order to determine how much of this correction you need. Figures 6-39 and 6-40 show the same image before and after Color Noise Reduction was applied.

Figure 6-40. The same image with Color Noise Reduction applied. The offensive red speckles have been removed with almost no loss of detail.

Figure 6-41. The Lens tab in Camera Raw.

The Lens tab

The Lens tab (Figure 6-41) provides corrections for lens imperfections. I don't generally adjust the Chromatic Aberration settings for proofing, but the Vignetting tool can be useful at this stage.

Two options are available on the Lens tab:

Chromatic Aberration

The Chromatic Aberration settings in Camera Raw are one of the features that make it a great tool for RAW file conversion. However, it's probably overkill to do too much with it as you prepare images for the proofing stage, as we are doing now.

Chromatic Aberration (CA) refers to the inability of a lens to focus all the colors of light exactly the same. It shows up as a colored fringe on an image, typically red/magenta on one side and blue/green on the other. As digital cameras capture higher-resolution images, the imperfections of the lenses get more noticeable. The CA sliders in Camera Raw let you adjust the individual channels in order to reduce the appearance of the fringing (Figure 6-42).

Figure 6-42. An example of Chromatic Aberration.

There are two reasons why I don't do too much with the CA controls at this point. This first reason is because you generally don't see the CA in a proof: the image is too small, and the CA is slight. The other reason is because adjusting it perfectly can be a very time-consuming process. There are slight differences in CA for different lenses, different apertures, and different focusing distances. It really doesn't pay to do a custom adjust of CA, except to the highest-value images.

Vignetting

Vignetting, on the other hand, is a control that I make use of a bit more often when making proofs. Sliding the Amount control to the

left darkens the edges of the frame, and sliding to the right lightens the outer edges. You can use the Midpoint control to widen the circle of the unaffected area, which makes the difference between the affected and unaffected parts of the image seem greater.

The Vignetting tool can be used for creative effect—for example, darkening edges to direct the eye to the center of the photograph. It can also be used as a correction tool—for instance, to compensate for light falloff at the edges of a wide-angle lens.

The Curve tab

Figure 6-43 shows the Curve tab. You can choose from the presets, or make a custom curve. This is one of the tools that makes Camera Raw adjustment able to produce a "pretty good print." For general proofing, using the Strong Contrast preset often gives your images some "snap."

The Curve control can be very helpful for proofing. By applying a custom curve on top of the Adjust settings, you can get very close to a final image straight out of Camera Raw. In Photoshop CS, I often had to put a curve on a file after Camera Raw was done with it, which added an extra step—a real inefficiency in the workflow. Now that you can apply the curve inside Camera Raw, many images can be converted straight out of Camera Raw and look very good with no further adjustment.

Figure 6-43. Some useful presets are available on the Curve tab.

> **NOTE**
>
> *You can use the arrow keys to move the individual anchors on a curve either up and down or side to side. The Delete key deletes the selected curve anchor.*

The Calibrate tab

Calibrate enables you to correct for the bias of your camera. If a camera typically shoots images too cool, you can warm it up in Calibrate and save that correction as a new camera default for that particular camera model. You can also use the Calibrate tab to exercise creative control over your black and white conversions. The process of building a custom calibration is beyond the scope of this book. If you would like more information on this subject, check out *http://www.theDAMbook* for links to other resources.

The Crop tool

Figure 6-44 shows Camera Raw's Crop tool in action. You can specify the proportion of the crop so that your output can match a particular print size, if desired. You can also rotate the crop box to straighten tilted horizons.

Figure 6-44. The Crop tool in Camera Raw.

If your images need cropping, and if you want that cropping to show up in the proof, you should take advantage of Camera Raw's ability to apply a Crop to an outputted image. Note that Camera Raw does not crop the RAW image itself, only the embedded preview and the image that it opens up into Photoshop. You can always go back into Camera Raw and undo the crop, or recrop the image if desired.

Wrapping up

Once you have finished making all your settings and applying them to the appropriate images, simply click Done to move back to the main Bridge window. The buttons at the bottom-right corner of the Camera Raw screen perform the following actions:

Save...
> Takes you to a dialog box that lets you convert the selected image(s) to another format (TIFF, JPEG, PSD, or DNG)

Open
> Opens the selected image(s) in Photoshop

Cancel
> Returns you to Bridge without modifying the images

Done

> Returns you to Bridge and applies the changes you made in Camera Raw to all images

Holding the Option key (Alt on Windows) changes the behavior of two buttons (Figure 6-45):

Save

> Converts the selected images with your last-used settings, without bringing up the dialog box

Reset

> Clears all the changes you made in Camera Raw without returning you to Bridge

| Save... | Cancel | | Save | Reset |
| Open | Done | | Open | Done |

Figure 6-45. The buttons at the lower right of the Camera Raw screen. If you press the Option key (Alt on Windows), the behavior and appearance of the Save... and Cancel buttons will change, as shown on the right.

We're nearly ready to make the DNG conversions, but there's one more step: we need to synchronize some more metadata back into the file to make our rating work universally accessible. (If you have already entered all the necessary metadata into your files, you may choose to make your DNG files now. We'll cover making the DNGs at the end of this chapter.)

Figure 6-46. We're finished adjusting the settings in Camera Raw and it's time to make our DNGs.

Applying Keywords and Synchronizing Ratings

Once we have adjusted Camera Raw settings, we can make our DNG files. If you have time, however, it makes sense at this point to do a little more organizational work: syncing the ratings and possibly adding additional keywords. As I said earlier, Bridge can be a cumbersome place to add keywords if you are working with a large group of images. Since we will be using the Keywords to Sync the ratings and Labels, however, you can keep your eye out for bulk keywords that you might have overlooked earlier.

If the images that you applied bulk metadata to earlier could benefit from being subdivided further, this is a good time to do it. You might want to subdivide by situation, by persons pictured, or by concepts that the photographs could illustrate. Make a keyword for each of these items, and assign it to as many of the images as is practical.

The general principles guiding the work order are these:

1. Work that can be done to the largest subsets the fastest gets high priority.

2. Work that can be done to images that are of the highest quality also gets high priority.

Adding keywords to subsets

How does this shake out in the real world? Using Principle 1, we are applying keywords in a kind of upside-down pyramid: we start by applying keywords to the largest subsets and work through smaller subsets. So, if we are working with pictures from a family vacation, we would write the keyword "Family Vacation" into all the images in the first bulk metadata application (Figure 6-47). After that, we would group the images into subgroups (Grand Canyon, Las Vegas, Uncle Ernie's House, etc.). These groupings can be done very quickly, because they will typically all be contiguous files: that is, they'll line up next to each other, and can therefore be selected quickly.

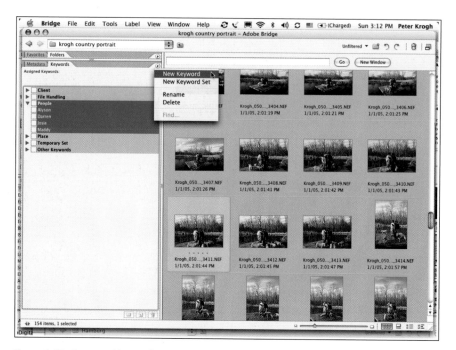

Figure 6-47. You can add a new keyword or a new keyword set.

After we have done the work that can be done to contiguous files, we might want to apply keywords to noncontiguous files. An example of this might be pictures of Josie. Since there are pictures of Josie in each of the groups, but not all the pictures have Josie in them, we need to individually select these images (a more time-consuming process). We will Command-select the images until we have selected all the pictures with Josie in them, and then apply the keyword "Josie."

Our second principle, that the highest-quality images should also get high priority, can come into play here. We can use the ratings pyramid (discussed in Chapter 2) to browse through our images, making sure we assign keywords to the best ones.

If we have 1,000 pictures from that family vacation, we may not have time to look through every one to find each picture of Josie. We might have plenty of time, however, to look through each two- or three-star image to find Josie. This leverages the rating work we did earlier, enabling us to get the most payback for the time spent keywording. You can use the Filter command to show only rated images, and proceed to keyword only those files.

Remember that you can also do this keywording later, either in Bridge or, preferably, in your cataloging application.

> — N O T E —
>
> *A little bit later, I'll show you a handy script,* Rank and File, *that can (among other things) let you use the label function to work more efficiently with noncontiguous files.*

PRO TIP

Using Temporary Sets to Add Keywords

When you add a keyword to a file by clicking on the box next to it, Bridge immediately adds that keyword to all selected files. If you are adding many keywords to many files, this can slow Bridge down a bit.

By making a temporary set of keywords and adding them with a single click, you streamline the process of adding this information. To make the temporary set, add a new keyword set as described previously, and then drag the individual keywords to it. Once you are done assigning this set, you can put the keywords back into the sets they really live in, such as "People" or "Place."

Figure 6-48 shows a temporary set of keywords.

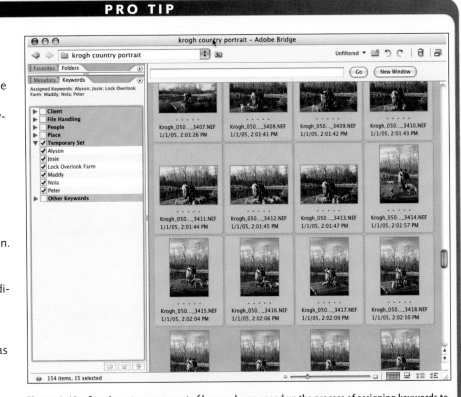

Figure 6-48. Creating a temporary set of keywords can speed up the process of assigning keywords to a group of images.

Synchronizing ratings: Making your ratings visible to other applications

Bridge builds in some wonderful functionality to rate and group your images with labels and stars. There's one drawback, however. Because Bridge writes the ratings stars and label values to XMP data, rather than the more commonly interchangeable IPTC data, no other applications can currently see this valuable work.

If you want your rating work to be visible by other applications, you have to transfer it somehow to IPTC data. The Keywords field is a good place to duplicate this information, because it is one of the most universally accessible IPTC fields—this means that other software is more likely to be able to read it out from the Keywords field than from any other appropriate place.

So, how do we get the rating information into the Keywords field, and what does it look like there? Figure 6-49 shows how keywords can be used to save rating information and make it visible to other applications. I use a "prefix" on the rating or label value ("PK:" for ratings, "Peter's Label" for labels) to make its origin clear, and to make it easier to recover lost rating info.

> **NOTE**
>
> *There's a side benefit to duplicating your ratings to the IPTC Keywords field. You can accidentally change ratings in Bridge if you select multiple images and then hit a rating key. You get no warning as you change these ratings. If you have written the ratings into the Keywords field, however, you can recover your work. Since rating the photos is one of the most valuable sorting tasks you can perform, it makes sense to keep this information in a place where it cannot be so easily lost.*

Figure 6-49. You can use keywords to save rating information.

Fortunately, writing your labels/ratings to the Keywords field is a pretty easy task. First, you need to select all the images that have a particular label or rating. Let's start with the Outtakes. Use the Filter pull-down in the top-right corner of the Bridge window to show only the images labeled as Outtakes. Select all of these images, make sure that the Keywords pane is showing, and click on the keyword Outtakes (or, as I have things set up, Peter's Label:Outtakes). This will apply that keyword to all of the selected images. Repeat this process for all label values.

For images with a positive (star) rating, we can also use the Filter menu to show images to be tagged. Because we want to replicate Bridge's "show all items with this rating and higher" behavior, we will assign a keyword

for each star. So, images with one star get the term 1Star entered into the Keywords field, while images with three stars get three annotations in the Keywords filed: 1Star, 2Star, and 3Star. By annotating images this way, we let any IPTC-aware application behave in the way Bridge does, finding all imge with a particular rating and higher.

Can't I Just Use the Term 3Star for Three-Star Images, and Not Write 1Star and 2Star As Well?

The reason we want to include the lower ratings as keywords in addition to the higher ratings is so that other applications can replicate Bridge's top-down filtering functionality. Bridge lets you look at, for example, all two-star and better images. If we only wrote the term 3Star into the Keywords field for our three-star images, Bridge would not see these when you search on 2Star.

This is the same reasoning behind not using a different term (Select, Best, Portfolio, etc.) for each star rating. When we search on Best, we will typically want to see all Best and Portfolio images, but a search on the term Best will not show images with the keyword Portfolio.

If you want to understand what's going on here, you have to think like a database person, and not the visual thinker you probably really are. In the ratings pyramid, the best images occupy the smallest area, so it looks like they should have the fewest number of ratings keywords: only 5Star. But we want to replicate the behavior of Bridge's top-down rating display. In general, you will want to start your searches in the smallest possible "haystack" (5Star) and then

expand downward (through 4Star, 3Star, etc.) if you don't find what you're looking for. Thus, it's much more useful to show, say, all images with ratings of three stars and above than it is to show all images with ratings of three stars and below, or only three-star images.

In order to replicate this top-down search behavior, we must write the keywords for all the lower sets into a high-set image. Therefore, we end up with a large set of keywords for the best images, and a smaller set for lesser images (as shown in Figure 6-50).

Figure 6-50. Hey, my ratings pyramid is upside-down!

Using the Rank and File script

When I started testing Bridge for Adobe, one of the places where I identified a hole in the workflow was in the transfer of rating and label settings to other applications. My concern was that the information that you create in Bridge be visible in cataloging software. Consequently, I have developed a script (with my friend Tom Nolan, who writes on-board software for spacecraft for NASA) that can assist you in making your rating and labeling work more productive.

The Rank and File script (Figure 6-51) can extract the rating and labeling work that you have done to your files in Bridge and automatically write that information to the image's Keywords field. This provides you with a one-button solution to make this information more permanent and more visible.

Figure 6-51. The Rank and File interface. Note how iView compatibility enables the automatic mapping of ratings to iView labels (via the IPTC Urgency field).

There are a few other tasks that Rank and File can help you with, too. If you want to use your label field for other work besides negative rating, Rank and File can extract the existing labels, write them to the Keywords field, and reset the labels to "no value" so that you can start to use the labels for an entirely different purpose. It can also reset the stars and labels back to saved values if they are changed accidentally, and it can write the filename to the XMP perserved filename field.

You can also use Rank and File to enable the labels function to help you apply annotations to the Description, Headline, or Title fields. In the More Settings dialog box, you can specify where the label gets written.

You can see how these preferences are configured in Figure 6-52.

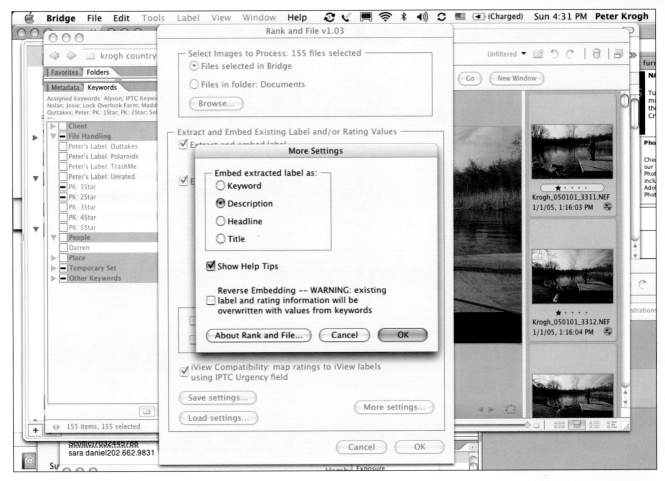

Figure 6-52. You can map the label value to any of four different IPTC fields.

Because Rank and File can automatically enable the use of a "prefix," several users can save their ratings into the keywords, and extract them individually. This could be very useful, say, when a photographer sends rated files to a Picture Editor (PE) who wants to make her own ratings. The PE can run Rank and File on the images, choosing a prefix of "Peter's Ratings" and checking the "Clear rating field after extraction" box so that the images show no stars at all. She can then rate the images as she wishes, having full access to the photographer's original ratings. All ratings by a previous user can easily be restored with one action, by using the "Reverse Embedding" function found in the More Settings dialog (Figure 6-53).

I always run Rank and File on my images prior to conversion to DNG. By making this a part of the process, I know that when I catalog the photos, all the work that I have done rating the images and applying labels will be both permanent and visible.

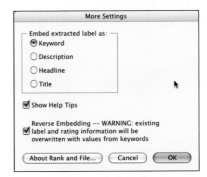

Figure 6-53. The Reverse Embedding command in Rank and File enables several users to embed and then recall their ratings in a set of files. It also enables users to recall ratings and labels that have accidentally been changed or erased.

Phase 3: Creating the DNG Files

Now that we have finished working on our RAW files, we are ready to convert them to DNG. As I said earlier, this should generally not be done until you are happy with your Camera Raw settings. Since reconversion locks you out of Bridge while the DNGs are being remade, it can slow you down considerably.

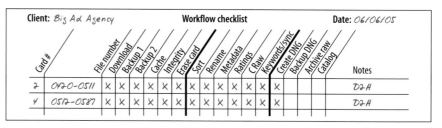

Card #	File number	Download	Backup 1	Backup 2	Cache	Integrity	Erase card	Sort	Rename	Metadata	Ratings	C Raw	Keywords/sync	Create DNG	Backup DNG	Archive raw	Catalog	Notes	
2	0420-0511	X	X	X	X	X	X	X	X	X	X	X	X	X					D2H
4	0512-0587	X	X	X	X	X	X	X	X	X	X	X	X	X					D2H

Client: Big Ad Agency — Workflow checklist — Date: 06/06/05

Figure 6-54. When you've applied all your higher metadata and made your Camera Raw adjustments, it's time to make your DNGs.

Creating the DNGs

Once you've made your annotations and Camera Raw adjustments (and have run Rank and File, if you have it), it's time to make a set of DNG files from the RAW files. (The benefits and limitations of DNG are discussed in Chapter 1; if you have not read it, you should take a look at that chapter before committing to the format. I believe that the benefits of using the DNG format far outweigh the drawbacks, but you should make your own decision.)

There are two ways of making DNG files from RAW files: using Camera Raw, and using the free DNG Converter from Adobe. As of Version 3.2, the DNG Converter can do the same job making DNG files as Camera Raw does (prior versions could not embed a large preview).

Converting images with the DNG Converter

In most cases, it will be simpler and easier to use the DNG Converter to make the files. Using the DNG Converter has two principle advantages. The first is that the DNG Converter can replicate the directory structure of your image files when it makes conversions. If you have split up a shoot into several folders to make it more manageable, the DNG Converter will create folders with the same names and populate them with the appropriate images. The second advantage the DNG Converter offers is that it keeps Bridge free to do other work, with no slowdown.

To invoke the DNG Converter, you can either open the program or simply drop a folder of images onto it. When you open the Converter, you'll see the dialog shown in Figure 6-55. Begin by selecting the folder of images to convert (if you invoked the Converter with the second method mentioned

above, you can skip this step). The "Include images contained within sub-folders" command lets you decide to convert all images contained in a folder and its subfolders, or only those images contained in the parent folder (not its subfolders). I typically choose to convert all images.

Figure 6-55. The DNG Converter.

Next, you'll need to choose where to save the files. I usually save to a "drop folder" at a permanent location on my hard drive. Inside this permanent folder, I place folders labeled with descriptive terms appropriate to the images they contain (this folder naming convention is described in Chapter 3). The "Preserve subfolders" command lets you decide whether to preserve the subfolder structure or transfer all of the images into a single folder.

The next set of options lets you do some file renaming. Because we have already named the files with their permanent names, I generally don't do anything in this section: it simply shows "Document Name" plus the extension. If I am converting a set of images to black and white (while keeping a duplicate set of color DNG files), though, I would append "bw" to the end of the name (e.g., *Krogh_050325_1234bw.DNG*).

In the preferences, I typically choose to use the lossless compression of the DNG format, to not embed the original file (more about this below), and to embed a large (full-sized) preview. This large preview, because it is accurate with respect to Camera Raw settings, will become ever more useful as DNG becomes more of a standard. It will provide a substantial speed gain

for most of your imaging tasks: the DAM previews, web galleries, or proof prints you will want to make will all be more quickly generated by accessing this large preview instead of the underlying RAW data.

The conversion to a linear image defeats the purpose of using DNG, and I suggest that you don't use this setting.

Converting images to DNG with Camera Raw

To make DNG files inside Camera Raw, you need to select all the images and then open them in Camera Raw. In Camera Raw, select all the images again (Command-A) and click on the Save *X* Images button. This will bring up a dialog box that enables the creation of DNG files (Figure 6-56).

Figure 6-56. You can use Camera Raw's Save Options dialog box to create your DNGs. These are the settings I use.

The use of Camera Raw and its settings are nearly identical to the DNG Converter, with the exception of the subfolder commands—Camera Raw does not give you those options.

When you click Save, it appears as though nothing is actually happening. This is one of the best things about using Bridge to make DNG files—since it multitasks so well, work that you might expect to lock up the program merely creates a bit of a slowdown. You can see your progress in the Camera Raw window just above the Save *X* Images button (Figure 6-57), as it counts down the number of images left to save. Feel free to hit Done here, even while the DNGs are being made; the process will go on in the background.

Figure 6-57. The Save Status progress indicator will count down as the DNG files are created.

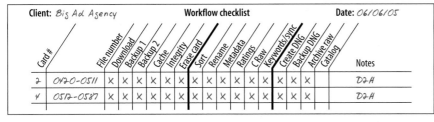

Figure 6-58. With the preparatory work completed, it's now time to archive your files.

Archiving

At this point, you have prepared your files for final archiving. You should back up these images using whatever archive backup protocol you have chosen. All earlier temporary backups of the same files can now be erased. (Some people may choose to archive RAW files also, but I do not believe this is necessary.)

Exporting the cache

Once the image files, in their final form, have been put in their permanent storage place, you may need to export the cache to that folder. If the disk that the image files are on is local, and you have chosen to use a distributed cache, you won't need to do this. However, if you are working across a network, you will probably have to manually export the cache.

By doing this, you will make it faster for Bridge to display and work with the files in the future. This is a pretty simple procedure: before closing the folder of images, simply go to Tools→Cache→Export Cache.

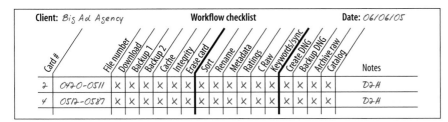

Figure 6-59. The final step on the Workflow Checklist is cataloging.

Cataloging

Now that your images have been edited, ranked, annotated, adjusted with Camera Raw, saved as DNG files, and put to bed, they are ready to be included in your image catalog. We'll take a look at how to choose and set up cataloging software in the next chapter.

Embedding Original RAW Files from Your Best Images into the DNGs

Let me start by saying that I personally think keeping the RAW file in addition to the DNG is unnecessary. However, you may wish to embed a copy of the original RAW file into the DNG for highly rated images. By doing this, you ensure that you can access the manufacturer's software, in case you might want to try a different conversion method than the one Photoshop offers (see the discussion about DNG in Chapter 1). Of course, this also substantially increases the size of each DNG file.

Because embedding the RAW file into the DNG creates such a big file, you'll probably only want to do this for very highly rated images that you are likely to do further work on. Because we have already rated the files, making this split is pretty easy. Let's say that you wanted to embed the original RAW files into all three-star and better images. First, sort all the files by rating. Select all files with two or fewer stars, and do the standard conversion outlined above. After that batch has started (you do not need to wait for it to complete), you can return to Bridge and select the images that have three or more stars and open them in Camera Raw. In this case, after you click on Save X Images you will want to check the "Embed Original Raw File" box at the bottom of the Save Options dialog.

This is a task that is probably easier to do in Camera Raw than in the DNG Converter, because you can select subsets of images.

Using Cataloging Software

7

This chapter is intended to give you an overview of the kinds of advantages that you can get by integrating cataloging software into your workflow. Although I will be using my current cataloging software, iView MediaPro, for the screenshots and examples, this is not meant to be a tutorial on how to use iView.

All of the functions and capabilities that I will outline are part of what I consider to be best practices, and best capabilities. They may be most effectively represented by iView MediaPro today, but some other software company is sure to take these features and leapfrog over what is currently available (perhaps adding a robust multi-user environment, or more effective version-tracking capabilities).

What I am trying to do here is to open you up to the possibilities that are presented by good, capable, intuitive cataloging software. I want you to think about how you can use both public and private metadata to add value to your images, and I want you to see how a transparent management tool can help you prepare your image collection for a long and fruitful life.

We will start by looking at some tips on how to choose cataloging software. Next, we will look at the capabilities of cataloging software, as represented here by iView MediaPro. In the last section, we will look at a few case studies to see how these capabilities can help us to do the kind of collection management that would be hard—if not impossible—to accomplish with a browser.

Evaluating Software

Your choice of cataloging software will often come down to how in sync you are with the people who wrote the software—that is, how well you understand the controls they offer. Under the hood, the cataloging databases may not be all that different. The critical difference may be more subjective: how does the software feel? Do you understand the terminology? Can you find a function when you are looking for it? It will be hard to harness the full power of an application if you can't understand the interface.

How you get on with the software, of course, is quite apart from what the software actually *does*. While most DAM applications offer a similar set of features, as I have researched this book I have been surprised by some of the features that are often left out. Most common is the lack of appreciation of the value and place for private metadata. All browsers, and most cataloging applications, simply do not use it—typically, they only use embedded metadata to organize images (which, as I pointed out in Chapter 3, has a number of important drawbacks).

Figure 7-1. Take your new software for a spin before you buy. **Keywords:** Jobs, Portraits, Annual Report, Farm Equipment, Tractor, Dealer

Things to Keep in Mind

As you think about your choice of cataloging software, keep the following points in mind:

You will probably not use it forever

Make sure that the work you do can be exported. Think of your cataloging software as temporarily hosting the information about your images, in the same way that your hard drives temporarily host the images themselves. One day, you'll need to be able to move everything on.

Make sure the software makes sense to you

Sometimes the problem is wrapping your head around new concepts; sometimes the problem is lousy interface design. Make sure you know the difference.

Test, test, test

Use the evaluation or trial version of the software to ensure that it meets your critical needs.

SIDEBAR

About XMP and DAM

Although embedded XMP data is quite possibly the future of robust, capable, and automatic DAM functionality, the standards of usage have not yet been set. I expect that eventually everything from controlled vocabulary references to automated display and version-tracking functionality will be possible with XMP-based tools. Figure 7-2 shows one of the XMP panels in the Bridge File Info window. Ratings, labels, and preserved filenames are examples of information that is stored in XMP data.

Right now, however, you would be on what we call the "bleeding edge" if you were to commit to any particular proprietary XMP-based solution. You might find yourself with a lot of information that cannot be read by anyone else, and that will take lots of work to convert to a more standard format.

In my observation, few photographers enter even the basics of metadata. For the vast majority of these people, time will be most valuably spent by simply entering the basic ownership, contact, and keyword information into IPTC data.

There's one thing you can expect from any XMP file-management solutions that gain a strong foothold: they will integrate with the legacy IPTC information workflow, so they will be able to leverage all the work you do today to annotate your images.

Keep an eye out for highly functional XMP-based DAM solutions in the future, because they're on their way. You should also keep an eye on operating system search functionality. Apple's Spotlight and Microsoft's Vista both offer the promise of OS-based browsing capability that leverages all your metadata.

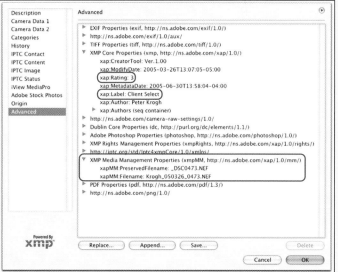

Figure 7-2. The circled items in the Advanced File Info panel are some of the items that live only in XMP data.

Do some homework

There is so much information available at the click of a mouse that you really don't have any excuse for being caught unaware of DAM application deficiencies after purchase. Find out where the users of a particular program gather online, and take a peek at what they are complaining about or praising.

Where to Go for Information

To find out if a piece of cataloging software does what you need it to, I suggest several possible strategies:

Look at the manufacturer's specifications

This can be helpful, but the specs are usually a bit thick to wade through—and don't expect the manufacturers to tell you what their software *won't* do.

Look in books on the subject

Books on the subject may contain useful tips and evaluations, but the landscape of this software is ever-changing. Also, books on this subject are currently few.

Look in the numerous photography forums

Links to some photography forums can be found on *http://www.the DAMbook.com*. Remember that you will have to consider the source of the information you find there, though—on most forums, *anybody* can render an opinion. While this can be helpful, it also means that there will be some information of dubious quality.

Check out the user forums specific to a piece of software

Many manufacturers offer user-to-user support opportunities. These forums are a good place to learn about the problems that people are having with the software, but remember that they are likely to be biased toward the bad user experience. You should also be able to ask questions.

Download and test the software

Most applications offer a 20- or 30-day trial period. This is the best way to find out if the software works for you, but it takes a bit of a time commitment. Try bringing images through, and see if you can understand the interface and if it accomplishes the desired tasks. Make sure you have enough time to really try things out before you start the clock running on your trial period.

My Software Criteria

Here are the main qualities that I am looking for in a piece of DAM software:

- Easy to understand

- Works well with DNG

- Good handling of private metadata

- Ability to easily convert private to embedded metadata, and vice versa

- Functional interchange with Photoshop/Bridge

Here's my wish list for future functionality:

- Multi-user functionality

- Versioning that works

Listed below are the benchmarks that I use in evaluating cataloging software for the serious photographer:

- It can use the full functionality (or nearly) of the DNG format. That includes showing and using the embedded preview, and reading and writing to DNG IPTC metadata.

- It can create nested virtual sets (discussed below). This is like an alternate directory structure, built around the content, rather than the location, of the files. You can have several of these "directory structures" if you wish.

- It can easily move images—both individually and in groups—into Photoshop.

- It can assist me in managing the media aspects of my collection: I can easily move files around, find missing items, check for file integrity, and see folder sizes, media sizes, and the number of selected items.

- It can make the kinds of derivative products that I need to make: web galleries, slideshows, contact sheets, QuickTime movies, and batches of conversion files.

- I understand and feel comfortable with the interface.

- It's affordable.

Integration with Photoshop/Bridge

Of course, one of the most important features of cataloging software is the extent to which it can integrate with Photoshop and Bridge. This integration has three elements: how well it can see and use the work you have done in the Adobe software, how well it can automate your work in Photoshop, and how well it can augment this functionality with capabilities that Adobe does not yet offer. We'll look at the first of these issues now, and work on the other two a little later.

Figure 7-3. Pay attention to your Bridgework. **Keywords:** Stock, Richmond, Landscape, Panorama, Choco Slip, I-95

At the point that I'm writing this, there is actually no desktop cataloging software that offers full information interchange with Bridge—at least, to the point of being able to read and write all the Bridge XMP/XML metadata. (This, of course, includes the rating and label data, but as I pointed out in Chapter 6, this information can be ported over to IPTC data and read that way.) However, some cataloging applications are far ahead of the others.

As I have said several times in this book, DNG is the key to an integrated DAM archive. Because DNG puts the RAW file data in a place that is openly documented—and because it contains a corrected preview and does not need to employ sidecar files—it makes full interchange between Bridge/ Photoshop and cataloging software possible. DNG is the vehicle for carrying Bridge metadata into other applications. In order for cataloging software and Bridge to work well together, the cataloging software needs to be fully functional with DNG.

For the rest of this chapter, I will be showing you how to work with cataloging software by demonstrating work I have done to my own collection. Because I currently use iView MediaPro—which integrates very well with Bridge (ahead of other applications, at the moment)—this will be the source of the screenshots you see. As I stated earlier, most of the functions we'll discuss should be included in any cataloging software you implement.

Integrating labels and ratings with Bridge

Because the keyboard assignment of ratings and labels is a very important part of my workflow, it is important to me that these functions integrate well. In iView, they do. (If you use the processes outlined in Chapter 6.) You can see in Figure 7-4 how I make these applications look and behave like each other.

— N O T E —

To enable these programs to really trade information, I have automated the interchange with the Rank and File *script, discussed in Chapter 6.*

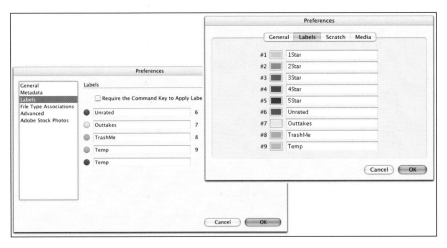

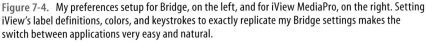

Figure 7-4. My preferences setup for Bridge, on the left, and for iView MediaPro, on the right. Setting iView's label definitions, colors, and keystrokes to exactly replicate my Bridge settings makes the switch between applications very easy and natural.

I have assigned label values in iView that replicate the label behavior in Bridge. The first five iView labels are analogous to the star ratings in Bridge, and the labels from Bridge are also mimicked by the iView settings. For example, in each application—Bridge and iView—the keystroke 3 assigns a value of 3Star to an image, and the keystroke 7 assigns a value of Outtakes. This makes switching between the two applications feel nearly seamless.

— W A R N I N G —

When you enter information into an IPTC field in iView, you are entering it into the catalog data-base only. *You can choose to make this into embedded metadata by choosing to "Sync Annotations." This function will take the information for selected files and write it back into the files. Unless you Sync Annotations, entries you make in iView MediaPro are not embedded into the files.*

YOU MIGHT BE WONDERING...

Where Does My Metadata Live?

Now that we are going to be looking at some metadata and discussing how to use it, let's review the kinds of metadata outlined in Chapter 2:

- Automatically generated metadata is stuff like file size info and EXIF camera data. It is an essential part of the file.
- Embedded metadata is information that lives in the actual file itself, like the IPTC data.
- Private metadata is information that is contained in the catalog only. It is not embedded into the file.

The DAM Interface

The examples here come from one of my real catalogs. In this case, it is a catalog that covers the first half of 2004. I would normally have a catalog cover an entire year, but this particular one started to get sluggish as I filled it up, so I split the year in two. I expect that at some later date 2004 will get rejoined, just as I expect that increasing capacities will one day allow my entire collection to be cataloged with one document.

Using Different Views

One of the most useful features of cataloging software is the ability to view images according to different criteria. Since the catalog collects lots of different kinds of metadata into one place, it offers the ability to quickly view a listing of this metadata, and to see the images that share settings. This ranges from automatically generated information to higher metadata such as ratings, keywords, and groupings.

Figure 7-5 shows the iView MediaPro window. On the top left, you can see several of the categories of metadata that can be used to organize the files.

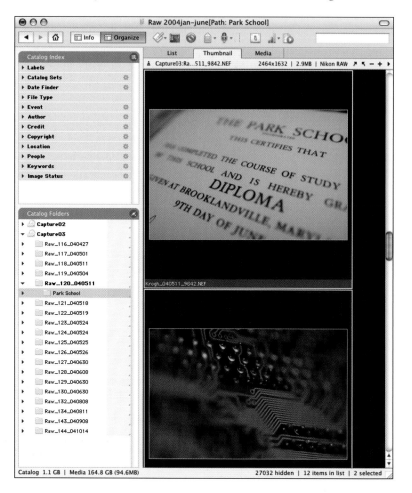

Figure 7-5. The iView window, which shows several categories of metadata and allows you to browse by directory.

Each of these can be opened to reveal an index of that particular field. At the lower left, you can see how the software allows you to browse by directory.

Figure 7-6 shows a close-up of the wealth of information you can see about your images in the bottom of the iView window. On the left, you see the size of the catalog document itself, the size of the media indexed by the catalog (i.e., how much room the photos take up), and the size of the media currently shown in parentheses. On the right, you see the number of image files that are hidden, the number of files that are shown, and the number of files selected.

Catalog 1.1 GB | Media 164.8 GB (94.6MB) 27032 hidden | 12 items in list | 2 selected

Figure 7-6. Information about your images is presented at the bottom of the iView window.

Viewing by Automatically Generated Metadata

I often find it useful to look at an entire collection according to automatically indexed metadata. Some of the automatically generated metadata viewing options are:

- By directory structure, as seen above in Figure 7-5
- By date shot, as shown in Figure 7-7
- By file type, as shown in Figure 7-8

Notice in the latter figures how I can get a count of the images that are represented by a particular trait (this is the number to the right of the classification).

Figure 7-7. The Calendar view in iView includes the number of images shot on a given date.

Figure 7-7 shows the Calendar view of the same catalog. This index is automatically generated by the EXIF metadata. To the right of the date, you can see the number of photographs made on that date. As you can see, there were some days when I shot quite a bit. DAM software made dealing with these files a breeze.

If you open up one of the metadata indexes (Figure 7-8), you can see all the entries for that field in the entire catalog. This can be a helpful way of narrowing down your search quickly, or of finding images that need some attention to their metadata.

In addition to automatically generated metadata, you can also view your collection by user-created metadata (labels, ratings, and so on), which opens up a wide range of organizational options.

Catalog Index	
▶ Labels	
▶ Catalog Sets	✿
▶ Date Finder	✿
▼ File Type	
AVI	2
JPEG	938
Kodak RAW	1223
Nikon RAW	24828
QuickTime Movie	53
▶ Author	✿
▶ Credit	✿
▶ Copyright	✿
▶ Location	✿
▶ People	✿
▶ Keywords	✿
▶ Image Status	✿

Figure 7-8. A metadata index in iView. (Note: Because it's 2004, there are no DNG files.)

Figure 7-9 shows the Labels index. You can see the ratings pyramid (albeit upside-down) in the Labels count. You can also see that images tagged for deletion are all accessible by the click of a button. (Clicking on an entry brings up those images in the Thumbnail window.)

I have several options for dividing my collection. As discussed previously, I can divide it according to some of the bulk metadata that I enter in Bridge. I can also divide the collection by higher metadata, some of which (such as ratings) may have been entered in Bridge, and some of which (such as custom keywords) may have been entered while I was working in iView.

Figure 7-9. The Labels index in iView, where you can see the ratings pyramid (albeit upside-down).

The most valuable tools for me, however, are the nested virtual sets, shown in Figure 7-10. These are created by grouping images together into virtual

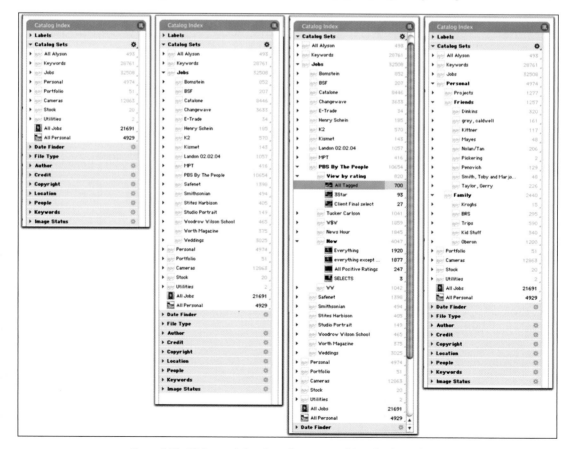

Figure 7-10. With nested virtual sets, I can set up a hierarchy that makes it easy to find what I'm looking for.

folders. I use a combination of several tools to make these sets. I can select images by directory, ratings, keywords, dates, or other metadata, or, most importantly, manually.

These sets work like an alternate directory structure, but they are much more useful than a directory for organizing. Nested virtual sets offer the following important advantages:

- Images can live in more than one place, without having to be duplicated.

- Images from different folders can be grouped together without having to be moved.

Figure 7-10 shows how handy nested virtual sets are. I can set up a hierarchy of image information, so that it's easy to drill down to find exactly what I am looking for. I use a combination of embedded metadata (such as keywords and ratings) as well as media info (directory names, creation dates, file types, and so on) to help me make these sets quickly. As you look from left to right, you can see how the nesting makes it easy to organize this information.

Although you can do a lot of this type of organizing with keywords, it is not ideal. First of all, there is generally no way to make nested sets with keywords; you end up with one giant "flat" list, as shown in Figure 7-11. This list shows some of the keywords that are in this catalog—as you can see, catalog sets are easier to navigate due to the nesting (a feature that you do not get with the keyword list). Secondly, you dilute the value of your important keywords by cluttering up the Keywords field with lots of terms that may be of only temporary usefulness, or may be redundant.

Catalog Index	
▸ File Type	
▸ Author	⚙
▸ Credit	⚙
▸ Copyright	⚙
▸ Location	⚙
▸ People	⚙
▾ Keywords	⚙
02/13/2004	1633
02/18/2004	185
20 year Faculty and Staff	37
Arthur Weiss	185
ASMP Projector	7
Barry Gordon	416
Basketball	29
Bill Crittenberger	53
Bindlestiff Family Cirkus	1004
By the People	7177
Changewave Seminar	187
Changewave Slideshow	19
Client Select	23
Conference	690
Control Room	139
Details	4
Doyle McManus	95
etrade	34
Geoff Colvin	507
Gerry Taylor	226
Gloria Borger	135
Gwen Ifill	1254
Hallway	487
Headshots	143
Henry Schein	185
Jim Lehrer	444
John Harwood	112
Karen Gibbs	721
Karen Gibbs and Geoff Colvin	396
Kismet	143
Landon	662
Laura Farnestrom	65
Make Proof	44
Margaret Warner	542
Middle school	344
MPT	416

Figure 7-11. Organizing with keywords provides one long, flat list that is much more difficult to navigate through than the nested virtual lists.

Using DAM Software to Perform Work on Images

Of course, keeping track of images is only one function that you will want to do with your cataloging software. It makes a lot of sense to also use your cataloging software to initiate batch-processing whenever possible, since you can group your images so much more effectively there. You can sort on multiple criteria, such as keywords and ratings, to find images to select for conversion. You can also easily group images from different folders.

Furthermore, by doing this work within a cataloging application, you get the added bonus of being able to save your groupings as you make them. Any time you are doing manual selection work identifying images, you are probably adding significant value to those images. If you do that work in a cataloging application, you don't have to throw away that time and added value.

Many common tasks are easily automated by iView and other cataloging applications. These functions include:

- Sending images to Photoshop
- Building web galleries
- Making contact sheets
- Making conversion files
- Making slideshows
- Making movies from slideshows

Let's take a look at how this work can be done by iView MediaPro.

Opening Images with Photoshop via iView

iView gives you several ways to open images into Photoshop/Bridge:

- Dragging an image to the Bridge icon in the Dock (or a Desktop shortcut on Windows) will open the entire folder that contains that image in Bridge. (If you drag multiple images—even if they are in the same folder —Bridge will open up a folder for each image.)

- Dragging a single image to the Photoshop icon/shortcut will open it in Camera Raw if it's a RAW image, or straight into Photoshop if it's a standard image.

- If you select multiple images in iView and use the menu command "Open with Photoshop CS2," these images will open in Photoshop. If they are RAW images, they will all open in Camera Raw, just as if you sent them from Bridge (as shown in Figure 7-12).

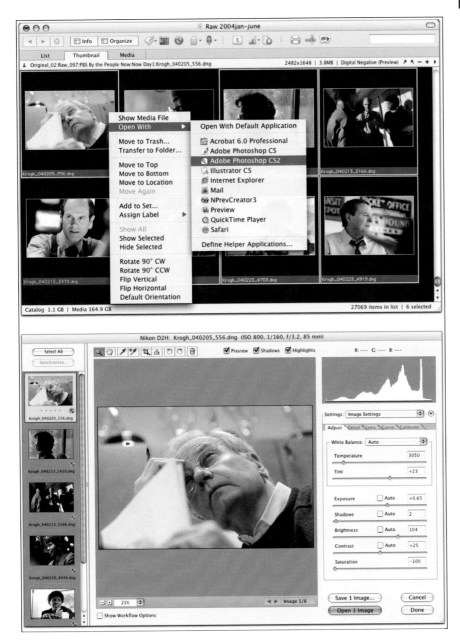

Figure 7-12. Images selected in iView can be opened with CS2 (via the context menu), and they all appear in Camera Raw at the same time, just as if they've been opened from Bridge.

- Sometimes the best way to bring many images into Bridge/Photoshop—particularly if you want to run a script such as Caption Maker (which we'll discuss in the next chapter) on the files—will be to make a copy of every image you want to process in a new temporary folder, process them, and throw the temporary folder away.

- At other times, the best thing may be to tag the images with a keyword, open Bridge, select all files that contain that keyword, and batch-process them within Bridge.

- And for the power user, there is always the Photoshop "droplet" which will add some automation to the process.

Outputting Directly from Cataloging Software

Cataloging software can also do lots of the batch-processing and conversions for you. Particularly for DNG files, or any adjusted non-RAW file, you can typically get a good derivative product. The DNG format is ideal because it contains that "pretty good print" I have been talking about. If your cataloging software can use this preview, it can make a fast and accurate conversion of the image file.

Setting up web galleries

I use iView to make my web galleries for client presentation. I have created a custom template that looks and functions just like the rest of my web site, so that the user experience is seamless (Figure 7-13). When I run the HTML Gallery function, I get a result like Figure 7-14. It's not particularly hard to set up a custom template if you know a bit about HTML page construction. If a web designer handles your web site, I suggest that you have him create a template for you. You can also use one of the several built-in templates, just like you can in Photoshop.

Figure 7-13. My web template—the items such as "(iView:Index)" are " tokens" that will be replaced by images or text from the selected files.

Figure 7-14. This is what my web galleries look like. The page on top is the thumbnail page, and on bottom is the image page.

Making contact sheets

All cataloging software can make contact sheets. Although I have not found any that I particularly like, they do offer some advantages that are not available when making contacts through Photoshop. The principal advantages are that you can draw from images that may be widely scattered over your collection, and that you can save the groupings that you use to make the contacts. Figure 7-15 shows a contact sheet made by iView.

PBS By the People Selects Photographs © Peter Krogh 301-933-2468

Krogh_040205_556.dng	Krogh_040213_2433.dng	Krogh_040213_2439.dng	Krogh_040213_3166.dng
Krogh_040213_3373.dng	Krogh_040220_4049.dng	Krogh_040223_4703.dng	Krogh_040223_4919.dng
Krogh_040223_5316.dng	Krogh_040223_5597.dng	Krogh_040223_5607.dng	Krogh_040223_5868.dng
Krogh_040223_6042.dng	Krogh_040223_6095.dng	Krogh_040504_9458.dng	Krogh_040504_9575.dng
Krogh_040205_884.dng	Krogh_040213_2373.dng	Krogh_040213_2701.dng	Krogh_040220_4371.dng

Figure 7-15. iView MediaPro can make contacts directly from the DNGs so it is both fast and accurate.

Creating conversion files

You may want to make a batch of conversion files from a set of images. Perhaps you want to output a set of 4×6 prints from your vacation, or

perhaps you want to send some files by email for a client to review. Once again, the embedded previews in the DNG files make this process quick and accurate. You can see the options available in Figure 7-16. And once again, by doing your selection work to identify these images in your cataloging software, you leverage the value that you are adding to these files. (The biggest drawback to doing these conversions here is that you don't have an easy way to invoke the Caption Maker script.)

Figure 7-16. iView offers several conversion options for batches of files.

Making slideshows and movies

Bridge has a new slideshow feature built in, and it does a very good job of displaying your images at their best. There are a few problems with it, however. First of all, it can't easily display a slideshow with images from more than one folder. Second, it can't export the saved show as a movie. Third, you may have to recreate the parameters (which images to show, what the order is) each time you come back to Bridge.

Almost all cataloging applications can also do nice slideshows or movies. One of the handy things about doing them in your cataloging application is that you can save the group of images to show as a virtual set, so that it's always at the ready. The Export as Movie feature is also very nice, enabling you to save a slideshow as a QuickTime movie.

Managing the Archive

Let's take a look for a moment at the management part of digital asset management. If you have built your information structure as I suggested in Chapter 2, configured your media as I suggested in Chapter 3, and annotated and saved your files as I suggested in Chapter 6, the management part will not be that hard.

The first part of management—keeping track of everything—is nearly accomplished. You can verify that your data set is complete by checking for the existence of all the sequential buckets, and with the techniques outlined below. You can find and organize your files with the metadata techniques already described, both in this chapter and in previous chapters.

The last step is to examine how cataloging software can help you to ensure that your metadata is entered completely and consistently, and confirm the existence and integrity of the individual files within the archive. We'll also look at how cataloging software helps us recover from a data loss event such as hard drive failure, and how it can help us with the care and pruning of the archive as time passes.

Cleaning Up Metadata

You may well be looking at the well-organized catalog display on the preceding pages and saying, "What kind of a sick person could have things so well organized?" If you knew me you would know that everything is in a pretty constant state of flux around here—and actually, I've found that organizing my photos as digital files is much easier than organizing film and print archives.

Cataloging software lets you get a comprehensive overview of your pictures in a way that is unthinkable with a film and print archive. This capability can be at its most useful when you have a particular project ahead of you, and you need to carefully look back through your pictures. This could be because you want to make a slideshow or portfolio, because you need to do some high-quality printing, or because your child is getting married—any one of a number of reasons.

As you develop a more refined metadata workflow, you will come across older work that needs to be updated or changed. Cataloging software lets you do this quickly.

Writing this book is a perfect example of one of those milestones that has caused me to do a few hours of work cleaning up my catalogs. For instance, as I was poking through my catalog to make these screenshots, I saw that I had used several different ways to list my copyright in 2004 (Figure 7-17). I also saw that I had neglected to enter it at all on 10,703 images (this was work done prior to implementing Bridge). It only took me a few minutes to bring about 15,000 images in line with my current practice.

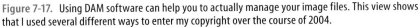

Figure 7-17. Using DAM software can help you to actually manage your image files. This view shows that I used several different ways to enter my copyright over the course of 2004.

Now that I have standardized on one way to do it, I can apply my copyright information to *all* the files in the archive. As I was doing this, I also made sure to pull out the images my wife, Alyson, had made and apply her copyright to them. In the third step, I deleted the older format of copyright entry. This whole process only took a minute or two.

Here are the steps I took to correct this problem:

1. Look at the index of entries, and decide which files have the correct entries.

2. Determine if any images in the catalog do not qualify for this entry. In this case, I identified the images Alyson had created and instead applied her copyright to these.

3. Select all the images that do not have correct copyright info (in this case, mine or Alyson's), and change the copyright annotation in all these files.

4. Delete the entries that are no longer needed.

5. Synchronize the new copyright entries back to the original files.

6. That was fast.

Confirming File Existence and Integrity

Entropy happens. (That's the tendency of matter to go from an organized state to a disorganized state.) Even if you have your archive set up perfectly, and your workflow is solid, you still run the risk of accidentally moving or deleting files. In an archive of tens of thousands of images, how do you check for missing files? Well, you tell iView to "Find Missing Files." It will then search your drives to make sure that every image it thinks ought to be there is in fact present.

This is one of the key capabilities that a browser cannot provide. The browser will simply show you what is there, giving no alert that images are missing from the collection. Because cataloging software stores a record of each image in its catalog database, it can go out and check for the presence of each file.

I consider this capability to be one of the most essential functions in an archive-management tool. In order for this function to be of real value, though, you have to have structured things in a certain way (as outlined in the previous chapters). Also, with regard to your catalogs, you should follow these guidelines:

- Use as few catalogs as you can get by with, so your searching can be both manageable and complete.

- Use clearly defined boundaries for the media included in each catalog. (For me, that is the yearly or half-yearly break point. I know that RAW images for 2003 stop at folder *RAW_096*, so I know that by confirming the integrity of the 2003 catalog and its contents, I am confirming data up through folder *RAW_096*.)

Confirming the integrity of the files is a bit trickier. I don't know of any utilities that will let you do this in a totally automated manner, in the way that "Find Missing Items" finds missing images. However, you *can* use the DNG converter as outlined in Chapter 5 or your cataloging software to offer you a visual confirmation of the integrity of your JPEG and original RAW files. (Check *http://www.theDAMbook.com* for developments on this front.)

By having your cataloging software rebuild your catalog, you are asking it to go through and create a new catalog thumbnail for each file. If a file is corrupted, it will not be able to build a new preview, and either you will get a generic icon in place of the preview, or it will generate an error (Figure 7-18). Thus, by quickly scanning a set of rebuilt previews, you can quickly get confirmation that your image files are sound.

Although this is a tedious process, you'll be glad of the option in the event that you have a problem with your storage media, or if you are doing some kind of major migration.

The most thorough way to confirm integrity of a large number of RAW or DNG files currently available is to run them through the freestanding DNG converter. (Yes, you can run DNG files through a second time.) When the DNG converter processes an image, it parses the image data with a kind of Camera Raw "lite" that is inside the program. If the underlying data is uncorrupted, then it can make a new DNG. If there is a problem with the image data, it will record an error in the error log (Figure 7-18). This makes it a very good tool to confirm the integrity of a large group of images.

----- N O T E -----

If you have your cataloging software set to use the embedded preview, rather than using the underlying image data to generate the preview, the existing preview will confirm the integrity only of the embedded preview, not necessarily of the underlying data.

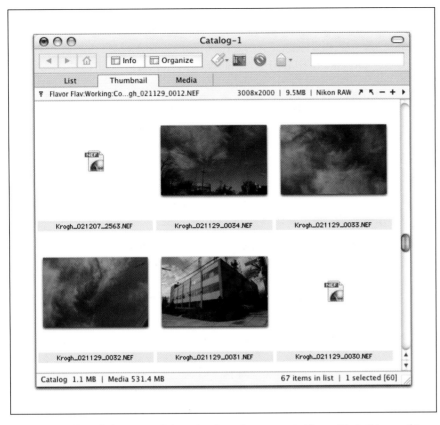

Figure 7-18. iView displays a generic icon when it catalogs a corrupted image file. In this case, this was a DVD that had an error burning.

If you are running the DNG converter as an integrity test, I suggest that you do not generate a preview, as this will make the process faster. Remember to re-set your preferences so that next time you use it, you will generate a preview.

Recovering from Data Loss

You will really thank yourself for comprehensive cataloging if you ever have to recover from drive or other media failure. If your catalog shows all the files that are supposed to be there, and if you have unique filenames, you will have a key to use to make sure that everything has been restored to its proper place in the information structure.

By using the "Find Missing Items" command, you can evaluate the completeness of any drive reconstruction that you do. I have, unfortunately, had to do this before—to a very valuable shoot after drive failure—and it was a great relief to be able to confirm that all the files were recovered.

The Catalog Folders window in iView—the one that shows you a view of the directory structure—can also be very helpful as you are rebuilding your drive. Of course, this whole discussion points out that you should be backing up your catalogs to somewhere safe (including periodically to write-once media such as DVDs) so that you will have access to them in case someone steals your computer or your studio gets hit by lightning.

Care and Pruning of the Archive

As we think about the task of thinning the archive over time, once again we see the payback that comes from good metadata practice and comprehen-

SIDEBAR

Making and Using Utility Sets

When you need to run some kind of sorting or migration process on a bunch of files, you can often make this work more efficient by using what I call *utility sets*. These are temporary groups that collect files together so that you can do some work on them.

For instance, I run through my archive periodically to look for photographs that never got renamed. (Sometimes I download the family point-and-shoot camera to the archive while I am on my way out the door.) I can collect all these files into utility sets called "Needs Rename" and "Needs Keywords," and then do the work to the files (Figure 7-19). I can remove them from the set as the renaming and basic keywording gets done.

I also use utility sets when I reconcile missing items. To find all the missing items in a catalog, the program needs to look through the entire catalog. Once I have done that search once, I save the items identified as "missing" to a set. This way, as I work through the set figuring out why these items are missing (and either pointing them to their files or deleting the items from the catalog), to check my progress I can search again on this limited number of files, rather than having to search the entire catalog again.

Utility sets can be very useful. Once you get used to using them, you will find that they can help speed up all kinds of management-related tasks. For images

that need some kind of work done to them, utility sets provide a good way to keep them together.

Figure 7-19. Utility sets provide a good way to keep together images that need some kind of work done to them.

sive archive management. If we have rated the files for quality, and made basic divisions by keywords, we can easily identify image files that can be deleted.

Of course, the most obvious files to delete are those marked with a designation of "Outtakes." But as time passes, you may decide to delete other files. Unrated images, or even one-star images from some categories, may seem superfluous several years down the road.

Keep an eye out for a ripe time to reexamine these files for their desirability. This could come at an end-of-year review, at a time of media migration, or during a time when you just happen to be looking through your archives because it's fun.

Fun with pictures

This is an important place to point out that one of the best parts of digital photography is the quality time you get to spend with your pictures. Because they are easy to call up and always at the ready, a well-constructed archive makes working with pictures even more fun. I can find, group, print, and share my digital images more quickly and easily than I could have ever imagined with my film and print archive.

So go ahead, let your imagination run wild—put stuff together, and see what works and what doesn't. Playing with your images is rewarding, and it makes you a better photographer.

Other DAM Stuff

Let's take a look at a few other functionalities that you can squeeze out of your cataloging software. (There are actually many more things you can do, once you really get a handle on the way databases work to include, exclude, and cross-reference image files.) Here are a few of the functions that I think you should pay attention to.

Scripting

Oh, no, you say. Not that again. Yes, you can script cataloging software, just like you can script Bridge. And although I am not suggesting that you learn how to write them, I am suggesting that you learn how to find, load, and use scripts. It's really not that hard.

Scripts, for those of you who've forgotten, are mini-programs that can tell a larger program what to do. The programming language used is what makes them scripts, which is a totally irrelevant distinction for most users. You could also think of them as plug-ins, or as upgrades to the software, or as magic dust if you like. (Unfortunately, iView uses different scripting for Windows and Mac—VBScript for Windows and AppleScript for Mac—so not all scripts are available on both platforms.)

You Might Be Wondering...

If I Delete the Image from My Main Drive and My Catalog, Do I Have to Delete It from the Backups?

To some degree, this depends on how meticulous you are. I know some people (Mike) who would be bothered by any misalignment between their master image files and backup image files. My personal attitude is a bit more pragmatic. The worst-case scenario from this situation is that, in the event of drive failure, you might restore some images from the backup that you had already decided to throw away. This is hardly a tragedy.

In the "Case Studies" section of this chapter, I'll present a work order for using your catalog to help you restore a drive that has gone bad, including figuring out how to identify deleted items and how to restore metadata entries.

If a program has been written so that it can accept script commands, people will write scripts for it. Cataloging software is a perfect candidate, because it often has to do many repetitive tasks, and the underlying functionality is essentially a simple database.

iView ships with several scripts and has a support page with lots more. Also, a particularly prolific Frenchman named Daniel Robillard has created many useful AppleScripts that he gives away for free. Let's take a look at a couple of his scripts, called *Duplicate Annotations* and *Field of Sets*. I include the following two sections not because I specifically advocate using these scripts, but rather to get you thinking about the capabilities of your cataloging software and the value of automating some of the work it can do.

Synchronizing RAW + JPEG (or any two file types) with the Duplicate Annotations script

One of the tasks that you might find yourself needing to do is transferring annotations from one file to another version of the same file.

Some photographers, such as those who shoot sports, often shoot RAW + JPEG when they are on a tight deadline. They can quickly sort the JPEG files and send them off to the client, either as proofing files or as the final delivery files. In these instances, a photographer might find himself with a full set of annotations in the JPEGs that he wants to transfer over to the DNGs made from the RAW files. Scripting to the rescue!

The Duplicate Annotations AppleScript takes all the annotations from the first file it sees, and transfers those annotations to another version of the file that has the same name but a different extension. This can make short work of a process that could otherwise be very tedious.

Converting private to embedded metadata with the Field of Sets script

As you create and use private metadata, there will be times when you want to export it back to the original files. Having this kind of control over private metadata is one of the capabilities that I consider absolutely essential for a cataloging application. It closes the loop between public and private metadata, and it gives you an exit strategy for when you want to change software. There are several reasons you may want to synchronize private and embedded metadata, including:

- Because this metadata is valuable as keyword information, and you are submitting the files to a stock agency

- Because you want to use this information to select multiple files in Bridge (for instance, you may have made a set of files that you want to run through Caption Maker to create 4×6 prints)

- Because you are migrating to a new cataloging application, and you want to bring this work with you

WARNING

Before running a script like this, you'll want to test it to make sure it performs as expected. (It does for me, currently.)

The Catalog Sets to Metadata script (the dialog box for which is shown in Figure 7-20) will convert the private metadata contained in catalog sets into embedded metadata in one of several IPTC fields. You can also choose to include the entire folder structure of the sets (the parent containers), if that information is helpful. The last command, Synchronize, exports the annotations from the catalog document into the IPTC fields of the files themselves. The script is available at *http://www.theDAMbook.com*.

Cataloging Software and Other Types of Digital Media Files

As more of the media that you buy, use, and save moves to digital format, you will increasingly face the same problems with these media files that you do with digital photographs. You need to be able to organize and store the files, back them up, check for duplicates, migrate them when necessary, and —oh, yeah—use them.

The same systems that you put in place for your photos can be applied to your PDF files, your InDesign or Quark documents, your fonts, your audio files, your home movie files, and even your collection of commercially produced movies or saved TiVo recordings. Each of these files has a data storage component and a content management component. The bucket system and cataloging software can help you address these challenges.

For instance, I keep my InDesign documents (which I mostly use for portfolio layout) in the same information structure that I use for processed images. This has the advantage of keeping the relative paths constant, so that the InDesign document can see the image files it's linking to. I can catalog these files in iView and work with them seamlessly along with my images.

I also use the same structure and tools to store my home video files, as you can see in Figure 7-21. I typically shoot videos with a small consumer Sony digital camera, so these video files are in the same pipeline as my snapshot photos right from the start. iView can handle these exactly as it does images, which has made my home videos both more secure and more accessible. (Keep in mind that if you use a DV camera, you can generate *lots* of data

Figure 7-20. The dialog box for Daniel Robillard's Catalog Sets to Metadata script, which converts private metadata into embedded metadata.

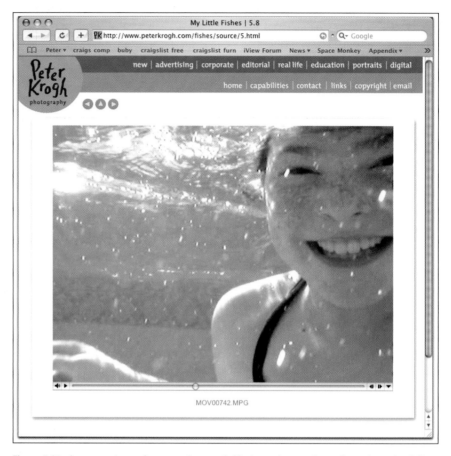

Figure 7-21. I can organize my home movies exactly like I organize my photos; I even have the ability to make web galleries out of them.

very quickly.) iView can even include these video files in a web gallery, just like still images.

With iTunes, many people are now keeping their entire collections of music files on their computers. I started "ripping" my CD collection to the computer years ago, and I now have more than 40 gigabytes of audio files. I have built the same kind of directory structure for these files that I did for my image files. Although I use iTunes to play the files, the management tools that iTunes provides are very limited. Your cataloging software can help you manage the media when you have to do tasks that your listening software does not do well.

Case Studies

Now that we have seen some of the uses that cataloging software can be put to, let's put them together and see how they can help us with some real-world applications. Outlined on the next several pages are three case

studies. I'll present some situations that you might be faced with, and show you how the tools in cataloging software can help you work with your image files.

As you read through these case studies, you should be paying attention to how the tools can function together, rather than simply the "cookbook workflow." I want you to see how the functions of cataloging software (cross-referenced metadata, saved index data, private metadata, nested virtual sets, utility sets) can be leveraged.

Case Study #1: Portfolio Search

In this example, we will see how cataloging software can help us identify and mark photos for consideration as portfolio images. Here's what we'll need:

- Ratings
- Keywords
- Virtual sets
- Utility sets

Goal

Identify the best images from the last several months, and collect them together to evaluate for inclusion in an updated portfolio. We will assume that you have been preparing your images in the manner described in Chapter 6—that is, that you have been rating your files as they go through Bridge, and that you have been assigning at least some bulk metadata to them.

These same techniques can also be used to identify any group of images you want to collect together, such as pictures for a family slideshow or a stock agency submission.

Work order

The first thing you will want to do is to make sure that your catalog is up to date. Browse the directory listing in your cataloging application, and confirm that all the buckets are present and appear to be complete. If you have neglected to catalog everything, do it now.

The next step is to make utility sets. As we sort through the images and winnow them down, it will be helpful to collect them in temporary sets to save our work. I suggest that you create a container called "Portfolio," and inside it create another one called "Portfolio Search (today's date)." Inside that, let's create a set called "Candidates." If we suspect that our searching will take more than a single session, we can make a set called "Search Me" for

images you have not yet gone through. Figure 7-22 shows what this utility set structure might look like.

We will want to be as systematic as possible, as this will enable us to make sure that we identify all possible candidates and to use our searching time as efficiently as possible. Thus, before we get started we'll need to think for a minute or two about what we are going to search and how we are going to search for it.

Here are some general searching strategies:

- Use previous sortings. If you have marked any files as possible portfolio items in the course of your regular workflow, now is the time to round them up. If you have used a virtual set called "Portfolio Possibles," for example, select these and drop them into the "Candidates" set. You may also want to search all images for the keyword "Portfolio," if you think you might have assigned that to some images.

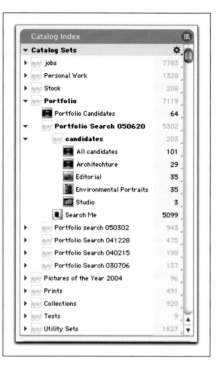

Figure 7-22. You can make saved sets of images to consider for portfolio usage.

- Use ratings and keywords. If you have been rating your files, the easiest way to search is to cross-reference the keywords with the ratings. This should yield a very small set of very likely candidates very quickly. Show all images with the keyword "Jobs," for example, and then show the highest rated of these files. Select any of these that are portfolio contenders, and put them into the Candidates set. If seeing any of these files triggers a memory of other good images in the shoot, you may want to follow that thread to the rest of the shoot. You may also want to expand the search by selecting a lower rating quality to filter by.

- Search everything. If you have not been using ratings consistently, you may want to search all your images. First add every image you want to examine to a "Search Me" set, and then line them up in chronological order by filename or by capture date. As you look through the images, you can add individual images to the Portfolio→Candidates set, and remove them from the Search Me set. When you come back to the search at a later time, only the unsearched items will be left in the Search Me set.

Once you have made a first pass through your collection, delete unneeded utility sets, and start to examine your Candidates set. You may wish to make more targeted sets inside the Portfolio set, such Editorial, Architecture, or Studio. Make as many subgroupings as you need to keep track of the images during the search.

Case Study #2: Large Job Delivery

Next up, let's look at an assignment I had that required shooting lots of pictures and editing them down to a small number. In this case, the assignment was a television spot for PBS featuring several news and issues programs. We did not know how it was going to be cut together, so I had to shoot many different kinds of images, from animation sequences to single "hero" shots. These images needed to be available to the producer so that she could drop them into her offline edit. In all, I shot 7,177 pictures that needed to be cut down to a final 65 (Figure 7-23).

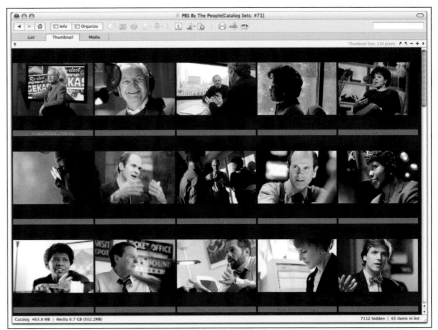

Figure 7-23. **This is what the client's catalog looked like after the results had been narrowed down from 7,177 to 65.**

Here's what I needed for this project:

- Virtual sets
- Ratings and keywords
- Delivery catalogs
- Editing JPEGs

Goal

The end result was to be a series of six spots for the various programs. We needed to be able to edit the 7,177 images down to a manageable number, so that they could be dropped into offline edits of the spots. Images had to be cross-referenced for content so that spots for each of the shows could be created.

Work order

The first part of the work order is to do the procedure outlined in Chapter 6 (rating, keywording, and conversion to DNG). Once that's done, we can

NOTE

I did this assignment prior to the development of CS2, but for the purposes of this exercise we will proceed as though it was being done with CS2 and DNG.

bring the pictures into our cataloging software and really group them. In this case, the producer was on the set and was able to make selections on a laptop while I was still shooting other situations. These went into a set called "Client First Select."

At the end of the shoot, I made additional selections of images that might have been overlooked. These were put in a set called "Peter's Picks." All of the image files were cross-referenced for subject matter, as well as ratings (Figure 7-24).

Once everything was categorized, metadata was synced back to the image files, and conversions were done to make editing JPEGs. To do this, I converted the images to 1,000-pixel JPEGs saved at a quality of 8. These images were put into their own catalog and delivered to the client on CD. I sent these with an installer of iView, so that the client could take advantage of the trial period. I also sent along a copy of the free iView Catalog reader, so that the files could still be browsed after the end of the trial period.

The client was able to use these images to make an "offline" edit. Once the edit was approved, I created master files to be used in the finished piece.

Case Study #3: Recovery from Drive Failure

Let's say that one of your original file drives suddenly dies. What does the recovery process look like, and how can cataloging software help you get back up to speed quickly?

Goal

A hard drive has died, and we want to restore the information to a new drive from the backup. We will need to figure out which files should be on this reconstructed drive, and put them there. Then we will want to identify any images that might have been "thinned out" from the collection between the time we created the backup and the present day, so that we can get rid of these files. We will also want to make sure that any annotations we've made to the image files in the intervening time can be recovered and embedded back into the files. Cataloging software will help us do all of this quickly and with confidence.

Work order

Here's a list of tasks:

1. Find your most recent catalog and duplicate it immediately (you are backing these up, right?). This document will represent your collection at the time that the catalog was last saved (hopefully this is recent). It will include a lot of information you will want to use to help reconstruct the failed drive.

Figure 7-24. These are the virtual sets that were included in the catalog I delivered to my client. She was easily able to find the images that she liked for any of the many situations I shot.

2. Expand the directory listing in the catalog. You can see how your drive was structured, what bucket it started on, and what bucket it ended on. This will help you figure out which files to load back onto the drive. This catalog will also hold a key to any files that you might have deleted because they were no longer needed.

 This catalog will also contain any metadata additions that you have made in your cataloging software. One of the main benefits of using cataloging software to enter metadata is that you keep a separate copy of *all of it* in the catalog itself.

3. Load all your buckets onto a new drive, and make sure that everything is named the same as it was on the failed drive. Use the "Reset Paths" command in your cataloging application to make sure your catalog points to the restored items, if necessary.

4. Make a utility set of all items that are currently in the catalog. Label it something like "Pre-Crash Contents." This set will help you easily identify items that have been deleted, or that were added to the catalog after the catalog you are using was saved.

5. Use your cataloging software to index the *entire* reconstructed drive. This will add any files that you may have intentionally thinned but that were still on the old version of the backup.

6. Use your cataloging software to search for all files that are in the catalog, but are not in the Pre-Crash Contents utility set. This should produce a *found set* of items that you have either deleted or never entered into the catalog. A quick examination of the files should let you pick which files to delete and which to keep.

7. Resync your metadata. If you use your cataloging software to enter metadata, there may be lots of metadata (keywords, for instance) in the catalog that does not exist in the newly recovered files. You can use your cataloging software to "push" this metadata back into the files.

8. Use catalog software to check the integrity of the JPEG files. Use the DNG converter to check the integrity of the RAW and DNG files.

9. Make a new hard drive backup of the restored drive.

Derivative Files 8

In a perfect world, we would only need one version of a file. A file format like the (imaginary) *SuperDNG* could hold original file data and metadata, offer multiple conversion options, include flattened composites representing any adjustments and retouching we have done to the file, and help provide for secure distribution and use of the file.

Unfortunately, we don't live in a perfect world, and there is no one-size-fits-all solution for RAW file archiving, robust master file creation, and ease of delivery. We will want to make use of several different kinds of derivative files, depending on the functionality we are seeking.

Figure 8-1. Is it a derivative, or the real thing? **Keywords:** Castle, Traffic, Copy, Derivative

Each of the file conversions we will do will have several components, which we will look at here. We will start by defining the purposes of the various types of derivative files, and then we'll look at the different formatting and image tools that can help create a derivative file appropriate to the purpose at hand. Last, we will look at the archiving and cataloging issues associated with the inclusion of derivative files in an integrated collection.

What's a Derivative File?

A derivative file is any new version of an image made from the RAW or original file. Any time you change and save a file, you have made a derivative file. This includes *master files* (those conversions that are the best versions you can possibly make from an image) and *proofing files* (batch conversions that are used to show the client what the images look like, or that you make just to have prints of the images). It also includes Delivery files, which are generally simplified versions of Master files that have been sized and converted for the purpose at hand.

What we will look at here are the kinds of file conversions you are likely to make, how to create them, and how to integrate them into your archive.

Reasons to Make Derivative Files

As always, form should follow function. Before we examine the tools useful in creating a derivative file, we must first define what we want the file to accomplish. Is it an image to show to a client for selection purposes, an image file that will be extensively retouched, or an image being sent off for some kind of final reproduction? Listed below are the broad categories that derivative files fall into.

Proofs

I will use the term "proof" pretty broadly in this chapter. In general, it will refer to a batch-converted image. These conversions may be used for traditional proofing purposes, such as selecting among many images, or they may be ends in themselves (e.g., proof prints made to show Mom what the vacation was like). The essential quality that makes a file a proof is that it is batch-converted, rather than custom-converted.

Remember in Chapter 6, when I talked about "virtual printing" in Camera Raw? The gist of that concept is that the decision-making part of darkroom printing is analogous to what we do in Camera Raw: we make adjustments to the image to bring it closer to how we want the photograph to look. The printing part is what we are doing in this chapter: we are making the actual physical print or electronic proofing image.

If you need to send proofing images to someone, you will generally want to send out some kind of conversion file. There are several kinds of conversions that we may need to make for proofing. These include:

- Proof prints
- Web galleries
- Contact sheets
- Electronic image files sent to the client via email or FTP

NOTE

While DNG files are technically derivative files, they take the place of the RAW files for me, so I treat them as the original files. The creation and use of DNG files is covered in other chapters.

Before the introduction of the DNG format, I often needed to make JPEG conversions for my own proofing needs. If I wanted to see images in my cataloging software in black and white, for example, I had to convert the files to black and white and save them out.

If you are using the DNG format, and you have it set up to always update the preview (as discussed in Chapter 5), there is generally no reason to generate *internal* proofing documents. Since your cataloging software can see the file as you have adjusted it in Camera Raw, your proofing file is contained inside the DNG.

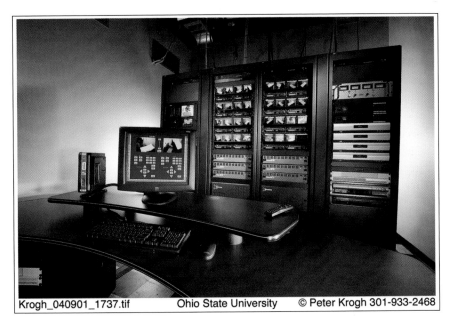

Krogh_040901_1737.tif Ohio State University © Peter Krogh 301-933-2468

Figure 8-2. This is a proof file. It has been run through Caption Maker to add information visibly to the frame.

Master Files

Master file is a designation I use for files that have been color-corrected, retouched, sharpened, or otherwise made ready for final usage or output. The term comes from the audio recording business, where the final tweaked, adjusted, and mixed version is the "master."

Ideally, a master file could be repurposed for many different uses. It might be converted to CMYK for offset printing, sent as an RGB file to a desktop printer, or downsized and optimized for web usage. For maximum versatility, there are certain practices that you should apply to your master file workflow:

- Work in a large color space, such as Adobe RGB or ProPhoto RGB.

- Keep as many of your adjustments as is practical on layers, rather than making alternative versions of the files.

- Use some capture sharpening at the start, but do most of your sharpening for specific output.

Since master file preparation typically involves the conversion of fewer images than proofing, it is less important that the process be automated. Most of the batch conversion tools covered in this chapter are focused on proofing uses rather than on master file workflow.

Figure 8-3. This is a master file. It is a finished version, ready for usage or output.

Delivery Files

Once you have created a master file, you will often want to convert it again to create a *delivery file*. There are several reasons why you might want to do this:

- The master file, which may contain layers or 16-bit information, would confuse the client.

- The master file would reveal techniques that you would rather keep secret.

- The master files are inconveniently large for delivery.

- The client requires a CMYK conversion

Each of these file types—proofing, master, and delivery—requires a strategy for creation, naming, and handling. This chapter will examine some strategies for efficient derivative file creation, but it will by no means be comprehensive: there are just too many different needs for finished images. With that in mind, let's take a look at some of the issues involved in the derivative file workflow.

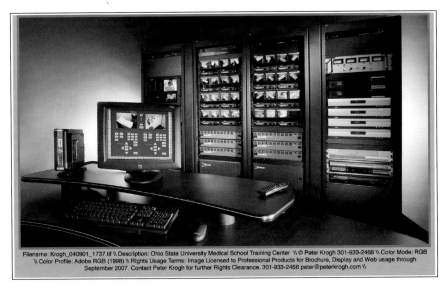

Filename: Krogh_040901_1737.tif \\ Description: Ohio State University Medical School Training Center \\ © Peter Krogh 301-933-2468 \\ Color Mode: RGB \\ Color Profile: Adobe RGB (1998) \\ Rights Usage Terms: Image Licensed to Professional Products for Brochure, Display and Web usage through September 2007. Contact Peter Krogh for further Rights Clearance. 301-933-2468 peter@peterkrogh.com \\

Figure 8-4. This is what a delivery file looks like. By using the Caption Maker script, I can include essential information in a visible frame around the file so that a client can see important metadata about the file.

Conversion Options

Your work converting your RAW files to DNGs really pays off here. Because the Camera-Raw-adjusted preview works as a "pretty good print" of the image, your conversion options will be greater and faster to use. More and more applications will simply use the embedded JPEG file as the source for the conversion. If you have chosen to embed the full-size preview, and to always update the preview (using the preferences set in Chapter 5), you are more than halfway toward efficient conversion.

We will want to make use of that embedded preview or a straight conversion from the DNG for nearly all the *proofing* work we do. If the adjustments have been well made, we will probably need to readjust the RAW data of the DNG only when we are making high-value master files.

Converting Using Bridge

Bridge offers several ways to convert RAW/DNG files into derivative files. The most basic is achieved simply by opening the file into Photoshop (select File→Open in Photoshop, or double-click the image in Bridge to launch Camera Raw and then choose Open from the Camera Raw menu). However, Bridge also offers a number of automation tools when you want to open and save a number of image files at once.

DNG

Figure 8-5. DNG becomes your digital job jacket.

> **NOTE**
>
> *If you want to open an image in Photoshop and bypass the Camera Raw dialog box, select the image and use the keyboard shortcut Shift-Return. The file will open with whatever settings are there.*

Image Processor

Dr. Brown's Image Processor—a script developed for Photoshop CS—has now become part of Photoshop CS2. It is a very handy tool for batch-processing many files in Bridge or Photoshop. To open the Image Processor in Bridge, go to Tools→Photoshop→Image Processor (Figure 8-6). In Photoshop, you find it at File→Scripts→Image Processor.

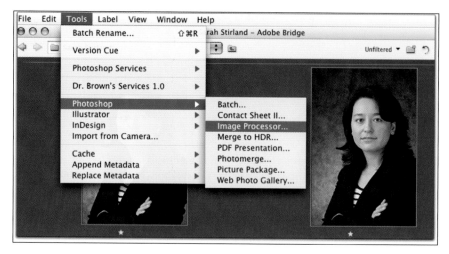

Figure 8-6. Here is how you access the Image Processor from within Bridge.

Rudy's Image Processor

The Image Processor that comes with Bridge does not have a sharpening command. Instead, it gives you the opportunity to run an action that you can create for sharpening. However, it has a design flaw: it runs the action at the beginning of the sequence rather than at the end. Sharpening should always come after resizing.

I have modified the script to run the action after resizing. This new version, Rudy's Image Processor, is available for free download at *http://www.theDAMbook.com*.

Note that if you open the Image Processor in Bridge, it will operate on any folders or files that are selected in Bridge. If you open it in Photoshop, you get the choice of operating on all open files, or on a folder full of images.

Once you select the Image Processor, you get a dialog box that looks like the one shown in Figure 8-7. (Well, almost like this—the dialog shown here is the one for Rudy's Image Processor, which is identical in appearance to the stock version except for the name.)

As you can see here, I have created an action for sharpening for this particular output size; we'll discuss how to do this in a moment.

The Image Processor enables you to work on many images at once. You can do all of the following to the images:

- Convert them to another format.

- Resize them, and add some compression for TIFFs and JPEGs.

- Convert the color profile of JPEG files to sRGB (the most commonly used color profile for proofing).

- Run an action on the images.

- Apply your copyright to the images' metadata.

Figure 8-7. The Image Processor dialog.

The functions the Image Processor performs were formerly available only if you had written an action. While actions (automations of common Photoshop tasks) are not terribly hard to create, there is a certain sequence that you use for processing RAW files that gets a bit confusing. The Image Processor makes quick and easy work of a simple conversion of many files, or of selecting multiple image files to run an action on.

Adding a sharpening action to the Image Processor

(The following assumes you already know how to create an action.) If you are reducing the size of the file, I suggest that you do a bit of sharpening as part of the Image Processor actions. Make a sharpening setting for each size that you resize *to*. In order to make this action, resize an image to the specified size, and see what level of sharpening is appropriate. (Remember that this is for proofing, and needs to be "pretty good" rather than perfect.) Save your action in a set called "Image Processor," with a title that references the

You Might Be Wondering...

I Heard sRGB Was a Bad Color Space and JPEG Was a Bad File Format—Why Should I Use Them Now?

The sRGB color profile is a smaller color space than Adobe RGB or ProPhoto RGB (which are two good *working* profiles). Because it has fewer colors than those other spaces, it's not a great working color space. It is, however, a pretty good *delivery* color profile, (particularly for proofing) because it is so common.

If you are sending your images to a minilab for printing, or off to web galleries, or in email to your clients, I suggest that you convert the images to sRGB. Most of these uses will show more accurate color if the profile is first turned to sRGB.

Likewise, the JPEG format is not ideal as a *working* file format. It discards information when it saves, and it can't keep all the cool layers and smart objects and vector stuff that a PSD or a TIFF can. A JPEG is good, however, for delivery. If you are only compressing it once and you save it at a high quality (10 or above), it's nearly impossible to see any difference in most output.

I save most of my electronic proofs with a quality of 6 or 8, because they are generally just being used to judge expression.

We'll discuss choosing a color profile further later in this chapter.

final size of file you are making, and perhaps the original size, if you use cameras that shoot differing size images.

Caption Maker

Caption Maker (Figure 8-8) is a script that I helped Russell Brown and Tom Ruark of Adobe develop. It is based on the Image Processor, but it adds an extra layer of functionality: it can pull metadata out of a file and enter it as text into a border around the image. This is useful for making personal prints as well as for entering important client information. We saw earlier in this chapter (in Figure 8-4) what it can produce; now let's see how it works.

The first two sections in the Caption Maker dialog work as they do in the Image Processor dialog, letting you specify which images to work on and where to save the new files.

Section 3 controls the appearance of the finished file. There are two border styles to choose from: Captioned Print and Professional Image Delivery. Captioned Print is intended to produce a pleasing image with a small amount of caption information underneath. Professional Image Delivery is intended

Figure 8-8. The interface for Caption Maker, a free script that can add a written caption to the border of a set of photographs.

for instances where the images being delivered need to carry important information about the subject, filename, color space, or rights granted.

You can use the image icon at the right to get a rough idea of how the image will look—note that it is *not* showing you the actual extracted data, just a rough estimate of how it will line up. Section 4 lets you choose which information to imprint on the image, from a list of metadata fields.

If you would like to include some text in the caption that is not part of metadata, you can click on the pull-down menu (Figure 8-9) and go down to the "Create Custom Text" item. This will bring up a box that lets you enter any text you wish. You can also use this function to add metadata fields that are not listed in the drop-down menu.

─── NOTE ───

To get Caption Maker and other nonstandard Bridge scripts (including Rudy's Image Processor), surf on over to http://www.DAMuseful.com.

Russell Brown has made an excellent instructional movie on the use of Caption Maker, available free on his web site, http://www.russellbrown.com. It gives you a step-by-step guide for how to use the script. If you have any trouble understanding the functionality outlined below, I suggest that you look at Russell's movie.

Figure 8-9. You can choose a metadata field to imprint on the image, or choose to enter custom text.

> **NOTE**
>
> *If you would like to output to a size different from the pre-selected options, you will first have to resize the image(s) in Photoshop (perhaps using the Image Processor, if you must resize many images). You can then run Caption Maker on these images with the Resize box unchecked.*

Using Metadata to Note Rights Granted

The new IPTC Core includes a field for the rights granted. This can be very useful for photographers and clients alike. By entering the terms of your license or sale in the Rights Usage Terms field, you will help clarify what rights have been purchased.

Since digital files have a way of getting copied many times over, it's not unusual for people to find that they have a bunch of digital images and have no idea who owns them or what license has been granted. By entering this information in the File Info panel, you will help everyone track the ownership and rights granted.

The Caption Maker script goes one step further. By putting the ownership and usage rights information in a visible border on the file, you make this information available even to people who have never heard of metadata or the File Info panel. As a matter of fact, I believe that by using Caption Maker, you will be raising awareness that File Info exists; hopefully, this will encourage more people to check the File Info even if there is no visible caption.

Section 5 lets you specify how the image is saved. The only two options available here are JPEG and TIFF, since they are the most universal formats for image delivery. The resize options are limited, due to concerns about making type sizes work with the output size. The options are set up for the most common kinds of batch-resizing uses.

Using Actions to Make Derivative Files

Photoshop offers a way to automate certain tasks without the use of a scripting language. The *Actions* function lets a user record a set of commands as they are performed, and then play them back on a single image or set of images.

Actions are still useful for many functions within Photoshop, but the automation commands have made them much less necessary for batch-processing proof images. (Creating actions is described in the Photoshop manual, and in every complete book on Photoshop. There are also many excellent resources on the Web for exchanging actions with other users.)

Using DAM Software to Batch Out Files

One of the things that DAM software can do for you is the kind of image conversion that is described above. The DNG format offers a great boost in the functionality of third-party DAM software. Since the embedded preview reflects the changes that you have made in Camera Raw, it can be used to generate a much better proof than a plain RAW file can.

As you evaluate cataloging software (as discussed in Chapter 7), one of the key functions to check is the ability to use this embedded preview for all the types of proofing file that the software can create (web galleries, JPEG conversions, contact sheets, etc.).

Conversion Issues

As you make conversion files, you will have to make some choices about file handling. These include deciding on naming strategies, color profile usage, and size and resolution settings. Let's take a look at how these choices can be handled for the various kinds of conversion files we will make.

Naming Strategies

The first question we need to answer is what to call the converted files. As with all of our DAM strategies, we will do ourselves a favor by adopting a universal system and sticking to it. I outlined the strategy I use for derivative file renaming in Chapter 3, and I suggest taking a look at it if you have not formulated a good file naming protocol. Here are the essential elements:

- Every camera-original image should have a unique filename.

- Derivative files should append to this filename rather than changing it.

- Standardize what you append to the filenames, such as "Master" for master files and "BW" for black and white conversions.

Color Profiles

This section is by no means a "how to" on using color profiles, since that is beyond the scope of this book. Rather, I present here some suggestions on how profile assignment fits into a comprehensive DAM workflow. I assume you know what color profiles are, and generally how to use them.

The working color space

Your working color space is the one that you will use when you open files into Photoshop. The profile is a "key" to describe what the color values in a file actually mean, and how they are translated. Ideally, your working color space should be a large color space, so that you can keep the maximum number of different colors in the image. You will likely be reducing the number of colors (converting to a different profile) later in the production process. For now, it's best to keep as much color information in the file as possible.

You will notice in Figure 8-10 that Camera Raw gives you the option to choose between four different profiles when you open a RAW image: Adobe RGB, ColorMatch RGB, ProPhoto RGB, and sRGB.

Figure 8-10. Camera Raw gives you four color space options.

Here's a short synopsis of what each is for:

- Adobe RGB is a big color space, and this is probably the most common working space among Photoshop professionals. You are very safe working in Adobe RGB, although it is not the largest color space of the four.

- ColorMatch RGB is a space that is generally not recommended.

- ProPhoto RGB is a very wide color space, and it is popular among Photoshop power users. However, because it can describe colors that your monitor can't show, you might make some changes to images in ProPhoto RGB that adversely affect the image, even though you can't see it at the time.

- sRGB is the lowest common denominator color space. It can describe many fewer colors than the others. However, it does have the advantage, as pointed out earlier in this chapter, of being compatible with more output and display devices than the other three. It's not a good choice for a working space, but it is a good delivery space for many uses. It is included in Camera Raw in case you want to take the conversions straight from Camera Raw to a minilab, for instance.

The delivery color space

Adobe RGB is a good general choice for a delivery color space, especially if you think the client is likely to be using a color-managed workflow. If you hear back that the files are too flat and too dark, they are probably not using color management properly, and it may be best to give them an sRGB file. As noted already, sRGB is a good choice of delivery color space for images going to minilabs, the Web, or other on-screen displays.

CMYK conversions

When you convert your images from RGB to CMYK, you are throwing away quite a bit of color information. There are some entire color palettes (such as deep blues) that cannot be reproduced by conventional CMYK printing, no matter how you manipulate the files.

While you might get a good CMYK conversion simply by converting in Photoshop, there are a number of underlying principles that you should understand if you are offering this service to clients (this topic is outside the scope of this book). Remember that you may be liable for excess proofing charges if the CMYK conversions you supply are badly done.

Size, Layers, Versions, and Sharpening

When working with master files and proofing images, you will have to make some decisions regarding size, layering, version creation, and sharpening. Here are some guidelines on how I handle these choices.

Size: Bigger is, well, bigger

When I make master files—particularly ones that require a considerable amount of retouching—my rule of thumb is to work on a version of the file that is as big as I will ever need. Thus, if the first usage is as a small web image, but the image is likely to be used in a double-page ad, I will do the retouching to a large file so that I don't have to repeat it later.

If an image (say, a headshot) is never likely to be used at a size larger than 5×7, there is no reason to make a huge master file.

If I am going to make a large master file from a RAW file, I always do my upsizing in Camera Raw. By interpolating up using the original sensor data, I feel that I get the best-looking enlargement possible.

Size, Pixel Dimensions, and Resolution

When people speak about the "size" of a file, typically they are either talking about the pixel dimensions of the file (the width in pixels, multiplied by the height in pixels) or the file size (how many kilobytes, megabytes, or gigabytes the file takes up when it is closed). Two images can have the same pixel dimensions but vastly different file sizes. JPEG compression can greatly reduce the file size, and using layers in a file can greatly increase its size.

Resolution (the number of pixels per inch) only really means something when it is used in conjunction with a size—a 2-inch-wide image at 1,000 pixels per inch (PPI) is the same as a 20-inch image at 100 PPI. When the term "high-resolution" is used, the size is often undefined.

If you need to reduce the size of your image, you will find that it needs to be sharpened (more on that later).

Using layers in master files

One of the greatest improvements in the last several versions of Photoshop has been the increasing capability of layers. Layers let you do work to a file *non-destructively*. That is, you can change the color, say, by using a Curve layer, without changing the color values in the underlying image. This lets you make all kinds of changes—and even create different versions of a file —without having to *save* many different copies of the file.

As a matter of fact, I use the layer capability of Photoshop to make a master file into a kind of virtual job jacket for the processed images. I can keep alternate retouching, alternate color correction, and even different-sized versions of a file all within multiple layers of a single master file. Figure 8-11 shows what a complex master file looks like when viewed in the Layers palette.

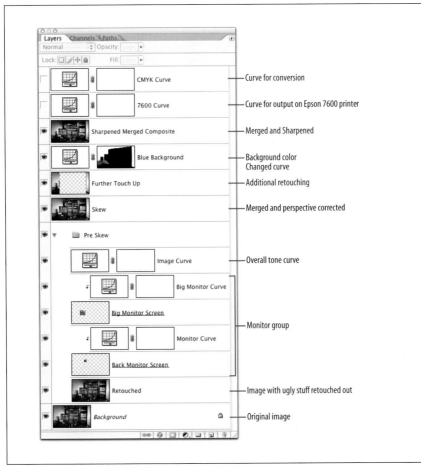

Figure 8-11. My master files may have many different layers, depending on the amount of retouching, color correction, or compositing that must be done. Although this makes them pretty large, it greatly reduces the confusion that would come with many different versions of the file.

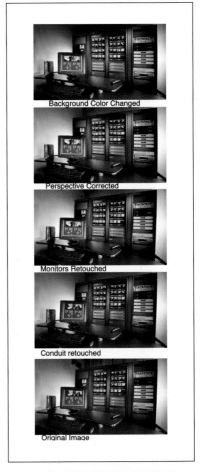

Figure 8-12. Many different versions of a file can be contained in the master file.

Use Command-Option-Shift-N-E to create a new single layer from all the visible layers. This gives you a "flattened composite" of the file as it currently appears. This can be particularly helpful when you have to sharpen an image and don't want to do it to the underlying file.

Remember to label your layers with names that make sense to you. You might return to a file later and find that you've forgotten what the layers were made for. If you get in the habit of labeling your layers right away, you will thank yourself later when you have to reopen old files.

Managing versions

I try to keep the different versions I make of a file to a minimum. Using layers helps considerably in this regard, since many different versions of a file can be kept inside the same master file. I try to only make different versions of a file when there is an actual need (typically, to prepare for some output or display, or for delivery files).

There are version-tracking applications out there (if you bought the entire Creative Suite you got one—Version Cue), but I have not found any that serves the needs of professional photographers well. Version Cue, for instance, will make a new copy of an image file every time you change it. This can be a big problem for a photographer with terabytes of image files.

Whenever possible, use layers—having dozens of version of a file lying around is an organizational nightmare. When you do need to create different versions of a file, make sure you use a clear and consistent naming scheme, incorporating the original name.

Applying sharpening

Sharpening is a process that must be applied to all image files to one degree or another. Generally, what sharpening does is to accentuate the difference between light and dark pixels. This makes a harder edge, and gives the

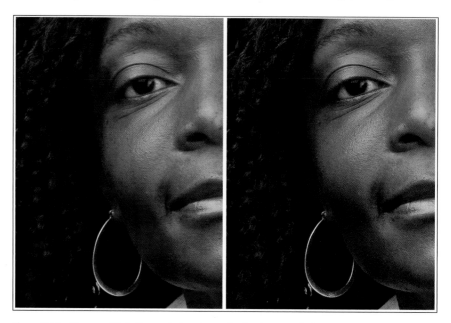

Figure 8-13. The same file before and after sharpening has been applied.

appearance of the image being sharper. For example, Figure 8-13 shows the same image before and after sharpening has been applied.

Sharpening is known as a *destructive* process: that is, it changes the pixel information in an unrecoverable way. Many people—but not everyone—believe that sharpening at the point of conversion from a RAW file is helpful. This is called *capture sharpening*, and it can be done in Camera Raw. (I suggest turning off in-camera sharpening.)

Almost everyone believes, however, that sharpening *must* be done in preparation for output. This is called *output sharpening*. Output sharpening should be different depending on the final size and output device used. We won't get into the details here, but *Photoshop RAW* by Mikkel Aaland (O'Reilly, 2005) has an extensive discussion on image sharpening as it relates to RAW files.

When I sharpen an image file in preparation for delivery, I don't do it to the main image data in a master file. I typically do it in one of two ways. If the master file is the correct size for delivery, I merge all the layers into a new layer (Command-Option-Shift-N-E) and then sharpen this new layer (Figure 8-14). If the delivery file that I am making is considerably smaller than the master file, I flatten the master file, downsize it using Bicubic Sharper, save it as a delivery file, and then sharpen for output. This file will then be saved as a TIFF file if the delivery is by disk, or as a JPEG file if it is to be sent by email.

You Might Be Wondering...

My Clients Tell Me Not to Sharpen Files—Is That Really What They Want?

Like the ubiquitous "send it to me at 300 DPI," many clients tell photographers not to sharpen files. This is because many photographers have a tendency to oversharpen images, and this can't be undone. If you are going to deliver master files, you will need to learn about sharpening.

Another reason that printers ask for unsharpened files is that some CMYK prepress equipment also adds sharpening—so images that may not seem to be oversharpened on your monitor or your Epson printer may end up with too much sharpening by the time they get onto a CMYK press.

Figure 8-14. Learn to use Smart Sharpen instead of the old standby, Unsharp Mask.

File Format

One of the last decisions we need to make when creating derivative files is the format to save the files in. For our master files, we want to preserve flexibility, compatibility, and image quality. The clear choice for these files is TIFF. Although it is owned by Adobe, it is an open standard, and it's a very safe file format to save in. It offers amazing flexibility in layering, and it is a lossless format, meaning that images can be resaved an infinite number of times without degradation.

I suggest that you always save large previews. Although it makes for a larger saved file, it will enhance compatibility with your cataloging software. I also suggest checking the thumbnail compatibility options, as illustrated in Figure 8-15.

Figure 8-15. Maximize your saving options, so that your files are compatible with the most number of applications.

For delivery files, I use two file formats: TIFF and JPEG. I use TIFF when file size is not a concern, or when the client wants a layered file. I use JPEG when the files need to be transmitted electronically, or when I suspect that I am delivering files to someone whose computer will be unhappy with a very large file. If you use JPEG for delivery, save at maximum quality.

Cataloging Strategies: What to Keep

When you look at all the derivative files you make from an image, an obvious question arises: which of these files should I keep? Some of the answers are universal, and others will depend on the type of work you do, what your budget for storage is, and how much of a pack rat you are. Listed here are some strategies for how to determine which derivative files to keep:

RAW/DNG files

As I've stated earlier in this book, I suggest keeping a lot of these files. The only ones I get rid of are mistakes and unnecessary similar frames. For commercial images, the obvious mistakes are chucked out at the first edit. The negatively rated images from a take will get purged at a later date: perhaps during my end-of-year review, or perhaps when I am migrating storage.

For personal images, I keep pretty much everything. Black frames and pictures of the bottom of my camera bag get culled immediately, but I keep most of the rest.

Proofing images

I treat the proofing images differently, depending on their use:

- I keep all my *web galleries*—they are small, and they are very useful if a client wants to come back to see the best of the shoot for a reorder. I do not catalog these files however.

- I also keep *contact sheets* (although I don't make many of them), because of their utility and relatively small size.

- If I generate a set of *JPEG images for electronic proofing*, I consider that these can be tossed once the client has received them.

- If I make a set of *JPEGs for hard-copy proofing*—4×6 prints, for instance —I might keep these. In particular, if the images are personal work, I generally keep them in case I want to reprint any of the photographs.

Master files

Master files are kept forever, as these are typically the most valuable images in the collection, and represent the greatest amount of production work.

Delivery files

I keep client delivery files primarily for business record-keeping purposes. Even though these images can be recreated easily from the master files, I keep the delivery files so that I can definitively reference them, should there be any issue with the client. If they say that the color is off, or that there is some other problem with the file, I can open the file as it was delivered, and check to see if the problem lies with my file or somewhere else.

Catalog (Most of) Your Derivative Files!

At the end of a work session making master files, you should always catalog your images. These will be your most valuable images, both in terms of what they mean to you and your clients, and by virtue of the work you have put into them. You are more likely to want to find these images than any others in your collection.

I also suggest that you catalog many of the other derivative files you create. For example, I like to catalog the delivery files I make—they are a rich mining ground for portfolio images, and clients occasionally want to reorder or have the files resent. It makes sense to have these images close at hand.

Before the advent of the DNG format, I used to keep many of my batch-conversion images as well. There were a couple of reasons to do this that are no longer operative. Before DNG, whenever you wanted a conversion of a file, you had to work from the RAW file. However, the DNG has that good embedded preview, which is much faster to extract. Also, before DNG, your RAW files showed up in your cataloging software with the camera-embedded preview. Now that the DNG shows the file the way you want it to display, corrected batch-conversions are much less valuable.

Derivative files catalog

I keep all my derivative files in a separate catalog. One catalog is sufficient to hold all the derivative files I have ever made and chosen to keep (about 18,000 images). If I am looking for portfolio images, or something to print, I am likely to come first to this catalog before I start combing through the original files catalogs.

Strategies for Successful File Migration 9

One of the challenges of digital archiving is the need to periodically migrate the images from one storage medium, file format, operating system, or software application to another. This process will be absolutely essential to the long-term survival of your photographs.

In this chapter, I will present some workflow tips that can help you successfully navigate this transition. Included here are strategies for two kinds of file migration: migrating existing work, and the file-migration challenges you are likely to encounter in the future.

The migration of existing work falls into these categories:

- Bringing older, unorganized digital work into a comprehensive archive

- Migrating existing RAW files into a new format, such as DNG

- Integrating your film archives into your digital archive structure

What future file migration may entail is a lot less clear, since we don't know yet what we will be migrating *to*. However, you will surely be able to make use of some of the same strategies that are useful today to make this process both easier and more reliable.

Overview of the Migration Process

Let's spend a little time establishing some general principles and methods for file migration. As everyone's situation will be a little different, you may have to customize your procedures; however, these general guidelines should still apply. Here's the overall work order for any file-migration process:

- Get comfortable with your new system. It doesn't make sense to start the process until you know exactly what you are migrating to.

- Create a comprehensive plan. Think about what you are doing (the totality of the task ahead), and break it into manageable chunks. Make sure you have all your materials at hand.

- Make catalog snapshots along the way. Saving a catalog of the material at different steps of the migration process can be very helpful. This will let you reconstruct what you have done if you make any mistakes or omissions.

- Keep a parallel structure for a while. Don't immediately erase the old configuration until you are sure that everything has gone as planned.

- Make sure to back up the new configuration.

Let's take a closer look at each of these steps.

Figure 9-1. Moving on down the road. **Keywords:** Stock, Roads, Taconic State Parkway, New York, Open Road, Fall, Autumn Colors

Get Comfortable with Your New System

Don't worry too much about integrating your legacy images until you have settled on a comprehensive DAM system for your *new* work, and gotten very comfortable with it. If you work all the kinks out of your new comprehensive workflow before you try to migrate over all your older files, you make it more likely that you will only have to do this work once, and that you can do it most efficiently.

Test, test, test

There are thousands of possible combinations of computer systems, operating software, imaging software, image file formats, metadata storage, and user behaviors. It would be impossible for any one resource to be able to lay out all the file-migration options. And even if you could get an accurate picture of today's variables, it would change weekly as new hardware and software became available. To ensure that you wind up with a system that you are comfortable with and that works well for you—and that your

images keep their adjustments and their metadata when you do your file migration—there is no substitute for good old-fashioned testing.

If you are migrating from RAW files to an archive of DNG files, for example, you will want to try the conversion on several different files to make sure that the metadata comes through properly. If you have used a number of different programs to enter metadata over the years—as well as several different cameras to create images with—it may be that some of it does not come along automatically: different programs enter metadata into RAW files in different ways.

It might be necessary to add an extra step to the conversion process. This could take the form of running the files through a different program first, or transferring the metadata to another, more readable, field. (We'll examine this later.)

Experiment with trial software

Most cataloging software manufacturers these days will give you an opportunity to use the program on some kind of trial basis. This can be very helpful as you go through the migration process. If you find yourself needing to accomplish a task that your current configuration cannot do, you might be able to find another program to fill the gap.

You should also test out trial versions of the new DAM applications that you are considering migrating to. It's worth spending a bit of time with a program before committing to it.

When you're evaluating trial software, be aware that the trial period is usually time-limited. The clock typically starts running when you install the software, so make sure you expect to have time to do a thorough evaluation before you install the software.

Make sure your metadata is coming along for the ride

If you have been entering metadata into your digital images, you will need to make sure that that metadata will be preserved when you migrate the files. Since images can store metadata in a number of places and formats, you can't be totally sure it has survived the conversion unless you check.

Some programs, for instance, store metadata in the resource fork of a Macintosh file, and that information is invisible to Windows. Some programs use XMP fields to store metadata, and others use IPTC fields and will not see the XMP data. The only way to be certain that your metadata is preserved is to test.

If you find that your metadata is not visible to other applications, you have a bit of sleuthing to do. This can be a frustrating experience, but it's not impossible. I would first check to see if Photoshop can see your metadata: if it cannot, there is probably something nonstandard about the way you have

entered it. You might then want to check with whomever made the software and see if there is a way to get it to show up in Photoshop.

Keep in mind, of course, that the metadata that you enter for RAW files in Photoshop—and that gets written to the XMP sidecar files—cannot be seen by any other application. These files need to be converted to DNG for this metadata to become usable by other applications.

Create a Comprehensive Plan

Part of developing a comprehensive plan includes deciding which files you need to work on, and when. Some of the migration tasks that you will be faced with should be done to large numbers of files at once. These include storage and OS migration—the type of task that affects the entire archive.

Other migration will best be done a little at a time. For example, it may only make sense for you to add film images to your digital archive when you actually have a use for those particular images, rather than trying to add all of them at once.

Still other tasks may require part of the work to be done comprehensively, and part of it to be done incrementally. For instance, I suggest that you bring all of your legacy digital images into the information structure at one time. This will reduce the probability of duplication and encourage thoroughness. However, you may prefer to do the work *sorting* these files for duplicates, or entering metadata into the files, on an as-needed basis.

Keep an eye out for opportunities to thin the archive

Any time that you are doing collection-wide work, you should consider whether this presents an opportunity to thin your archive. If you have marked files as Outtakes, file-migration time might be a good time to do some deleting. You may decide that older jobs (which may include many similar frames) can be thinned out significantly.

If you have a ranking system, it should be easy to get rid of a lot of unneeded frames. As an added benefit, this reduces the file migration workload.

Keep Some Catalog Snapshots Along the Way

One of the most useful tools that cataloging software offers for collection-wide work such as file migration is the ability to create "snapshots" of your collection as you proceed. If you save your catalog as a separate dated document at each critical step, you will have a reference as to exactly what you did during the process, and when.

Because the catalog shows where files are, how many images are included, and what metadata is associated with them, you can reconstruct your steps and make sure that everything worked as expected. For instance, you might find that something you did erased some kind of metadata from the

NOTE

As we discuss the migration tasks, I will make suggestions as to which functions should be done all at once, and which can be done incrementally.

catalog, or that somewhere along the way you lost a bunch of files. By looking through the saved catalogs, you can see where the problems occurred and thus have a better chance of correcting your mistakes. If you don't save versions along the way, you will only know where you started and where you ended up.

Keep a Parallel Structure for a While

Whenever you make any major changes to your computer configuration, I suggest you try to keep a parallel structure for a while. What this means is that you get the new system up and running without dismantling the old one. You can then do some real-world testing of the new configuration, while keeping the currently functioning system available in case anything goes wrong.

For instance, when I want to do a major upgrade of my system software, or install a new version of a mission-critical application such as Photoshop, I like to keep a fully functioning version of the current configuration at hand as I get the new one set up. That way, if I have any serious problems, I can go back to the known system and get the day's work done. If you have done the upgrade to your *only* copy of the system, you have no choice but to work out all the problems before moving forward.

How do you maintain a parallel structure? It's pretty simple: just buy a fresh hard drive and install it in your computer. You can then "clone" the whole system over to this drive, and have a perfect duplicate of your boot drive (on a Mac, use Carbon Copy Cloner; on a PC, use Norton Ghost). If your internal drive bays are full, or if you are working on a laptop, you can clone to a FireWire drive.

If you are installing a new version of the OS, you might want to start fresh on the new drive with a clean install of the system software. You can then add programs one at a time, making sure that everything works as you go. If you need to access some programs that are only on the other configuration, you can boot up from the old drive and find things just as you left them.

I also know a number of photographers who advocate buying a new computer at the time of a significant upgrade. The new OS comes with the new computer, and the photographer can make fresh installs of all mission-critical software. The older system may run on the desk next to the new one for a week or two—or just be put in the corner for a couple of weeks, until the new system has proven itself—and then be sold. Alternately, the demoted computer might get a different job in the studio (file server, MP3 jukebox, client workstation, or scanner workstation).

Keeping the parallel structure is also useful if you are transferring images from an old drive to a new, larger one. I suggest that you keep the old drive intact for a while, until you are comfortable that the new one is complete

and functioning correctly. Running the DNG converter on the transferred files is a good way to know that the transfer went well.

Migration of Disorganized Digital Files into an Organized Information Structure

Once you've started using cataloging software for the organization of your new images, you will soon want your older digital images to be cataloged as well. Additionally, the information structure that you are building will be of more value if it includes *all* your images—and the longer you wait before bringing in this legacy work, the harder it may be.

So, let's take a look at how you can bring your older digital images into your new information structure.

Step 1: Determine How Much Storage Space You Will Need to Hold the Existing Material

The first thing to determine is how much drive space you will need to store your legacy images. To do this, you will need to get a pretty good idea of how much data you have to migrate. Do the best job you can of counting the CDs, DVDs, and/or hard drives that your images are on. Make some provision for duplicate files, if you think you have a significant number of them.

I would suggest that you get *at least* 30% more space than you think your images actually occupy. If you have to swap files around, or want to keep temporary versions, this extra space will be useful.

Step 2: Gather the Existing Material

This is clearly one of those places where you will want to be comprehensive in your migration protocol. You will leverage your work much better by transferring everything at once. This event—transferring all your older images to a permanent information structure—is a real milestone in the life of your collection. Don't kid yourself that images that you don't convert now will be picked up later. If they are not worth converting now, when you're right in the middle of it, they will probably never look worthy of conversion. Just be honest with yourself that you are probably leaving these images behind forever: maybe not immediately, but eventually.

When I did this with my own scanned image archives, I brought everything onto the new drives as efficiently as I could. There were many instances when I was not sure which was the best copy of the several versions I had. In most of those cases, I simply copied all the versions onto the new drives. The most important point here is that you want to transfer *at least one* version of every image that you intend to keep, rather than focusing on narrowing it down to *only one* version of each file.

If you transfer over multiple versions of a file, you'll find that using cataloging software is the easiest way to sort out which one(s) to keep. Cataloging software lets you compare the images' sizes, color spaces, modified dates, pixel dimensions, and more. All of this can help you to easily find duplicates and determine the best versions. Your cataloging app is also the right place to make notations about the files, so that you can save all your sorting work as you do it.

Figure 9-2 shows a collection of some of the versions I had of a particular image. My cataloging software's tools made it easy to choose which to keep and which to throw away. As you can see in the figure, iView gives you lots of information about each file.

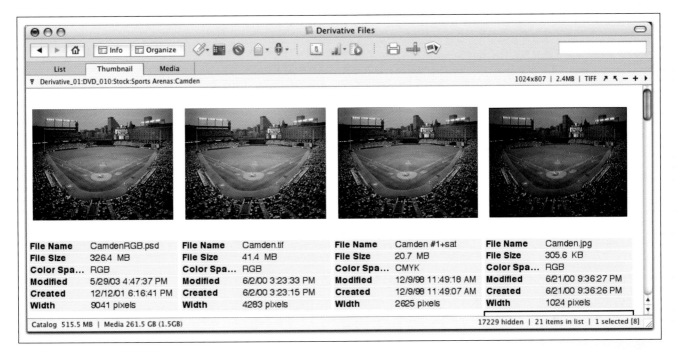

Figure 9-2. Cataloging software tools can help you choose which versions of a legacy file to keep, and which to throw away. This screenshot shows just some of the data that cataloging software can display.

Step 3: Rename the Legacy Files

Renaming legacy files is a tricky business. On the one hand, if you have kept the original filenames (e.g., *DSC_1234.CRW*), you will need to do something to ensure that each image has a unique name. On the other hand, renaming files can make it very difficult to find a file at a client's request, if there is no way to easily reference the old name. There are a couple of ways to approach this problem.

One option is to prepend or append something to the name (a date, perhaps) that will help to make it unique, while at the same time preserving the components of the old filename. It may be possible, for instance, to use one

of the naming schemes I advocate in Chapter 3 for your legacy files. In this case, *DSC_1234.CRW* could become any of the following:

- *Krogh_040101_1234.CRW*

- *Krogh_040101_DSC1234.CRW*

- *PHK_040101_1234.CRW*

Alternatively, if you are using a CD or DVD index number as an integral part of your file-management scheme, there are a couple of strategies you can use. For example, you could add the CD name to the filename: if your CD was named *Client/Job* and your files were named *DSC_1234.NEF*, *DSC_1235.NEF*, and so on, you could name all these files *Client/Job_1234. NEF*, *Client/Job_1235.NEF*, and so on.

You could also decide to drop entire CDs into your buckets, as shown in Figure 9-3. This would give you continued access to the organizational information provided by your CD naming scheme, without making it the most *important* organizational information.

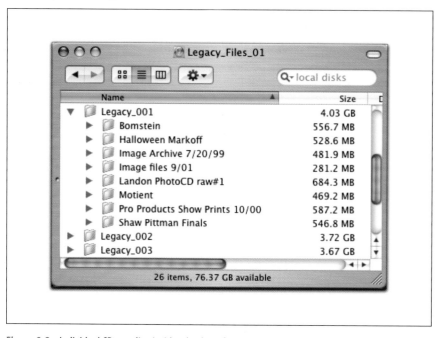

Figure 9-3. Individual CDs can live inside a bucket. If you have used CD titles as a way to index images, this technique can preserve that organizational information while still giving you all the benefits of the bucket system.

There are a few other tools that cataloging software offers to keep renamed files connected to the legacy images. You can choose to preserve the original name of a file in metadata, so that it can be found if the client ever comes back for a further order. The Import from Camera script in Bridge will write this information to XMP data, and Rank and File will also write it to the Preserved Filename field. iView MediaPro can also write it to the more discoverable IPTC data.

You can also use content-based keywords or virtual sets to help you keep files findable after renaming. If you make a set of all the Client X files, or write the term "Client X" to the Keywords field, it might not be too hard to find your renamed images for that client when necessary.

Here are my recommendations for renaming legacy files:

- If your files have the original camera names, rename them with a method that incorporates a date along with the original camera unique identifier. This can be done in batches with the Import from Camera script. (Make sure to write the original name to metadata.)

- If your files have unique names, but these names do not conform to your new naming scheme, leave them alone and do not rename them.

Step 4: Make the Buckets

As you bring in the legacy material, you'll have to make some decisions about how to configure the information structure. When I did this, I chose to use the bucket system to organize these files (actually, that's when I developed the system). I started numbering at *DVD_001*, and I dumped in CDs until I had 4 GB of data. I then created *DVD_002*, and started filling that folder.

Figure 9-4. Load your images into your archive in an orderly way.

NOTE

You don't actually need to worry about transferring all of your images in chronological order, because cataloging software can easily sort them chronologically. The only thing that really matters at this point is ensuring that you don't miss anything.

I made the decision that I would be using this new information structure —the buckets—and that there was no real need to reference the CDs that the files had come off of. This made it very simple to just dump images together. (Of course, it also made it important to know which CDs had been loaded and which had not. As I worked, I put the CDs in a "CD Cakebox" labeled "Archived" to indicate that they had been transferred.)

As I said earlier, at this point getting *at least one* version of each file is more important than getting *only one* version of each file. This transfer can take quite a bit of time, and I suggest that you make it as simple as possible. Line up all the CDs to be transferred, and start working through the stack.

If you are just starting to use the bucket system for your *new* material, and you have a lot of *legacy* material, you'll want to do some planning regarding the sequencing of the buckets. Here are my recommendations:

- Keep camera originals separate from derivative images, if possible. (If everything is already commingled, though, it's probably easier to just load it all up without segregating originals from derivatives.)

- If you can separate original from derivative files, make a good estimate of how much data you have for each, and make sure to leave enough room for the previous material to be grouped in lower-sequence buckets when you start your numbering for new file buckets. For instance, if you have 100 GB of original legacy files (roughly 25 DVD-buckets' worth), start the numbering for *new* file buckets at *RAW_030*. Then, when you have time to bring the older material into the archive, you can be sure that it will all fit in at the start of the sequence. If you are splitting up the file types, do the same calculations for derivative images that you have done for the original files.

- Alternately, if the steps above seem too complicated, you could just come up with a parallel information structure for all legacy files. These buckets could be called *Legacy_001*, or something like that, and include all previously existing original and derivative images.

Step 5: Back Up

Even though this new archive will not be the *only* copy of your images, it will be the most *valuable*, and depending on how large your legacy archive is, you will be putting in a good bit of time to organize it.

One of the reasons to delay working with legacy files until after you have your new system figured out is so that you can get your backup system up and running with a smaller number of files. Once you are comfortable that it works well, you will be in a better position to deal with the large volume of backups that the legacy material can demand. (Of course, if your legacy material is not backed up well as it stands currently, you'll probably want to do this transfer sooner rather than later.)

You might be tempted to consider the original CDs or DVDs to be good enough backups for these files. This *might* be the case if, for instance, you have kept everything on DVDs and there is a one-to-one correlation between the old material and the new buckets. Remember, however, that you will be investing some time in this new information structure, and you won't want to lose this work. I suggest you use hard drives as backup for these legacy files until you have gotten them straightened out.

Step 6: Make a Catalog of the Legacy Items

Once you have put the legacy files into the new information structure, you can start to catalog them. In my case, this extended only to putting them in an iView catalog so that I could browse for the images with my cataloging software, rather than with the Finder.

Step 7: Search for Duplicates, and Add Metadata as Practical

Unless you have a real imperative to remove duplicates (if, for instance, you know that you have a huge number of duplicate files on your older archive media, and you did not buy enough drive capacity to hold all these copies), you can probably wait and do the work of searching for and removing these files incrementally.

In my legacy files, I had more than a dozen versions of some of my favorite images. I had reproduced these images many times and had made a backup CD of each of these variations. I knew when I dumped these images into the new information structure that there were duplicates, but I was not concerned with that, nor did I have the time to deal with them right away.

Each time I went through my archives for some specific purpose—gathering images for a portfolio, perhaps—I collected all the variations of an image together into a virtual set, and then evaluated them to see which to keep. Because cataloging software lets us see information about an image (date, size, color space, etc.), this is a good place to winnow down these multiple versions of a file. It was not uncommon for me to see a file reproduced three times with the same modification date and the same file size. At that point, I erased the duplicates and kept only one copy of that particular version.

The rest of the work that you do to the images in the catalog is very similar to the work outlined in Chapter 7. *The smart way to approach this is to do the work to the files on an as-needed basis.* Any time you do a search, save the results in a virtual set, or in embedded metadata, and you will gradually start to sort out this material. In doing so, keep two of our universal rules in mind:

Do it once...

If you search for duplicates in the catalog of images, rather than searching in the Finder/directory, you can collect these files in a virtual set and do some basic annotations or deletions. Even if you don't resolve *all* issues of duplication and metadata assignment immediately, at least you get to save the searching work you do.

But don't overdo it

If you are like me, you probably have many versions of your favorite files. It feels good to get them sorted out, but it could become an obsession, and a place to sink quite a few hours. I suggest that you approach this work incrementally, and only do the work as needs present themselves. A quick cost/benefit analysis can help here. You can see how much file duplication really costs you by multiplying the number of duplicates by the cost of storage. I think you will find that you'll have to do a lot of work just to save a few dollars.

Step 8: Sync Your Legacy Ratings and Keywords with Your New System

If you have spent some time applying any kind of ratings to your files, you will want to make sure that this work will carry over to your new system. (At the time you may not have thought of what you were doing as rating, but that work may be very applicable. For instance, if you were putting selects into a separate folder, you were applying a kind of rating.)

There are a couple of strategies that can help here. You first need to examine where the information lives, and then figure out how to translate it into some kind of metadata that your cataloging application and/or Bridge can use. There are two steps to this process: you need to standardize this information, and then you need to make sure it translates to your new system. Let's look at some situations.

Developing ratings definitions

Here again, you will make life easier for yourself if you start work on new files first, and then bring your legacy images in once you have become comfortable with your new system. You will need to develop a rating system that works for your kind of photography and the way you like to work. Keep in mind another one of our rules: be comprehensive. You will want your keywording and ratings designations to mean the same thing system-wide.

It will be much easier—and you will be less likely to have to redo work—if you first implement your system on new work as it comes in. This will enable you to hone your ratings definitions and give you some practice dividing your images into usable categories of quality. Once you've developed a system that works for you, it's time to start bringing your legacy work into compliance with the new protocol.

Making utility sets

When I have had to migrate files, I have made good use of utility sets. I have found it useful to save information in these sets so that I can more efficiently handle the files. I use these sets kind of like notes ("these images used to have this rating"). Figure 9-5 shows what my utility sets looked like as I brought the legacy images from my 2002 original files catalog in line with my new rating system.

Extracting directory-based rankings and image information

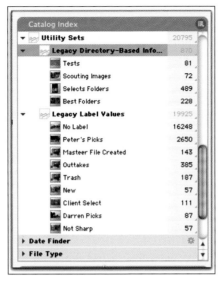

Figure 9-5. These are the utility sets I made of previous label values. Utility sets are a handy place to store information temporarily as you bring the old images in line with the new system.

One very common way that photographers designate image quality or content is to use the directory/folder structure. They often create folders for each client/subject/project, and use subfolders within them to designate quality. This makes the information universally accessible—any application will be able to see that a particular image is in the folder named *Job X Selects* —but it does not make it very durable, because if the image is moved out of that folder it will shed this important designation.

Once we have cataloged them, one of the first things we will want to do with our legacy images is to harvest the existing ranking and image information and write it somewhere that is more permanent. This is best accomplished by changing it to embedded metadata, such as keywords. iView, for instance, has the ability to run an AppleScript (Make Keywords from Folders) on an entire collection that makes keywords based on the names of the folders that images are contained in. This script even gives you the option of how many folder levels up you want this keywording to go.

Gathering all this information in one place, such as a group of utility sets, keeps it handy for the time when you will want to apply it to the migrated files.

Transferring private (non-embedded) metadata. It can be quite a bit trickier to extract private metadata from some applications and port it over to your new cataloging software. This particular ability was the first thing I looked at when I was evaluating cataloging applications. If there is no way to export this information, you will have to either leave behind all your sorting work when you go to a new application, or re-enter it by hand. Let's look at the situations that you might find yourself in.

If your application can embed information into files so that other applications can read it, you can probably extract all your previous work and make use of it in your new cataloging software. Even if some of the information that the software creates is private metadata, you should still be able to translate that into an embedded field. Select all the images that share a particular designation, and write that designation to Keywords or some other field that can be seen by other applications.

Make sure that your application will embed this information in all the types of files you use. Some applications can write to the Keywords field of a TIFF or JPEG file, for instance, but cannot write to the Keywords field of a RAW file. Make sure you test this for each file type in your collection.

If your application cannot embed information into files, there are three possible workarounds:

1. You can try to export the database of information as a text or XML file, as shown in Figure 9-6, and import it into the new program. This can be a time-consuming and difficult process, and in the end it may not even work. If you would like to try it, see if your existing cataloging software can export a *tab-* or *comma-delimited file*.

Figure 9-6. iView MediaPro allows you to export information about your images as an XML file, but it can be difficult to manage this process successfully.

2. You can use the folder name to hold some information about the images it contains, and use that as the vehicle to transfer the information. If the program allows you to transfer images to folders, you can put them in

folders that represent the information you would like to communicate (using a *Selects* folder inside a *Job X* folder, for instance). This is more straightforward, to some degree, but it still involves a lot of manual work.

3. You can manually reenter the information. Depending on the size and complexity of your collection, this may be fairly straightforward or incredibly time-consuming. It's also an error-prone procedure.

Migration from Film to Digital

For many photographers, one of the most daunting prospects that awaits them when moving to a digital workflow is the migration of their legacy film archives. We may have lots of valuable imagery on film—possibly tens or hundreds of thousands of images in various film formats. If you have ever tried to sit down and make a hundred scans on a conventional film scanner, you've probably given up hope that your film archives could ever be integrated into a digital archive.

For most photographers, it doesn't make any sense to scan *every* image, but it makes a lot of sense to scan *some* images. Different images will require different treatments. In this section, we'll take a look at some strategies for bringing your film images into your digital archive, with an eye to doing it in the most cost-effective way.

ROI Is King

And not just to the French. ROI means *Return on Investment*. As you think about digitizing your film archive, you have to consider cost and benefit. What is the cost associated with digitizing the images? This can range from very high (more than $100 each) to very low (under a dollar each). You'll also have to take into account the needs you have with respect to each image. Is it a portfolio image? A valuable stock image? An important personal photograph? A *possible* stock image?

Instead of trying to make one solution fit all your imaging needs, I suggest that you adopt at least a couple of levels of quality for your film scans. The most valuable of your images should get the best scan that you can afford to do: either a good desktop scan or a drum scan. (I assume you know about these, so I won't go over them here.) Down a notch from that level will be images that need a pretty good scan. For these—especially for black and white negatives and for color transparencies—I suggest that you make camera scans.

Making Camera Scans

There are a number of pieces of hardware that you can use with your digital camera to capture the camera scan original. These range from simple

Transferring CS1 Flags to CS2

Here's an example of the transfer of Private Metadata to Embedded Metadata that many of us will have to do. If you have spent time in CS1 flagging or ranking images, you will need to do a little work to make those tags visible to CS2. This is the kind of work you will want to do before too much time has passed, since you will need an operating copy of CS1 to accomplish it. The best way to save this information is to write it to the keywords field.

1. Begin by opening the folder of images into CS1.

2. Show all Flagged images.

3. Write the term "CS1 Flag" into the keywords with the Keywords panel.

This can be repeated for any Ranking information you might have generated in CS1.

When you open the images in CS2, you'll see the keywords. If either of these tags (flags or ranking) is a quality designation, then I suggest that you assign the appropriate star rating right away.

devices that screw onto your macro lens and hold the film, to the deluxe slide-copying devices that custom labs use to do high-end film copywork.

Figure 9-7 shows a digital camera with a copy attachment. Using a digital camera in this way, you can create very usable scans of film images, much more quickly than you could with any conventional film scanner I have ever seen. Once you get your workflow down, you can make more than 60 scans an hour. (This time figure assumes only a batch-conversion to positive, and it does not include time to custom correct or remove dust.) Image quality is top-notch for black and white negatives, acceptable for many purposes for color transparencies, and good for at least identification purposes for color negatives. I think this is the best way to bring lots of film images into a digital archive.

Figure 9-7. A digital camera with a copy attachment screwed onto a 60-mm macro lens.

The essential components of this system are:

- A "film stage" that holds the negative or transparency.

- A diffusion screen that sits behind the film and provides even light distribution. Usually, this is a piece of translucent plastic.

- Some kind of apparatus that holds the camera perpendicular to the film.

- The lens. This could be a regular macro lens for your camera, or it might be a special enlarging lens for a device such as the Illumitran slide duplicator, pictured in Figure 9-8.

Figure 9-8. An Illumitran slide duplicator can be used for camera scans for film sizes from 35 mm to 6x7 cm.

- A light source. The screw-in copy attachments will need some kind of external light source. A strobe with added diffusion, such as a softbox, can work well for this purpose. The higher-end models have their own light sources and will also typically have some way to adjust the color.

There are a lot of used devices out there that have been taken out of service because there is so little call to duplicate slides these days. Among the choices are:

- Slide-copier attachments for the camera brand of your choice. Almost every camera manufacturer has made some kind of copy device to work with its close-up lenses. Because of the difference in size between 35-mm film and many digital camera sensors, you'll need to check that the attachment is compatible with your current digital camera body

- Pro-quality film duplicators such as the Bowens Illumitran 3 and 3C. These were the workhorses of 35-mm slide duplication, and they can now be purchased on eBay for under $100. These devices are capable of copying 35 mm up to 6×7 cm—and in some cases 4×5"—originals. Check *http://theDAMbook.com* for recommendations on devices and lenses.

Making a calibration image

Once you have acquired the copying hardware, you need to do a bit of testing to see how the light sources interact with your camera settings. I suggest that you start your calibration process with slides, because positives will be easier to correct. I have a link on *http://www.theDAMbook.com* to a site that walks you through a calibration of one of these images using a Greytag Macbeth color chart (shown in Figure 9-9).

Figure 9-9. This is a calibration slide useful for generating camera scan defaults. I have included skin tones in the photograph, as well as the MacBeth Color Checker.

Figure 9-10. Camera scans from transparencies can rival the best desktop scanners. **Keywords**: Very Large Array, Stock Submission 030215, Storm, Sky, Extraterrestrial, Communication

"Scanning" slides

For your first test shot, pick an image with lots of color and good skin tones. If you are using the flash as your copywork light source, set the camera white balance to Flash, and see what you get. If it's pretty close to the original, bring the image into Camera Raw and see how closely you can make it match the slide.

You might want to save these Camera Raw adjustments as a custom setting named for the film type, so that you can use it as a starting point for color correction in the future (Figure 9-11). Every type of film has its own color

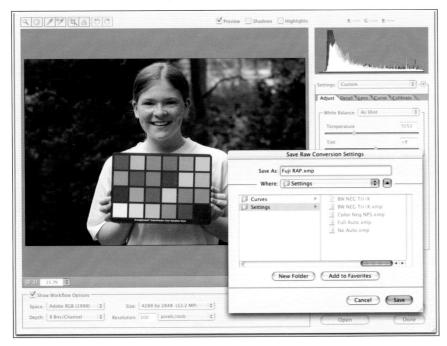

Figure 9-11. Saving out a custom setting.

rendering biases (kind of like a color profile), so a calibration that you make for Kodachrome will be different from the one you want for Fujichrome.

"Scanning" B&W negatives

Figure 9-12 shows an original camera scan on the left, and what that scan looks like after processing on the right. You can see the "black border effect" that I have created by filing out the negative stage on my copy attachment. I always loved this look in darkroom enlargements, and I'm very happy to get it back in my scanned images.

Figure 9-12. The original camera scan on the left, and the image after processing on the right.

When you shoot a copy shot of a negative, you will need to invert the image to get it to display correctly. For black and white images, you can do most or all of this work in Camera Raw. The trick is to use the Curve panel, as shown in Figure 9-13. Flip the curve upside-down, and you will now have a positive.

Once you have the image looking right, you can decide whether you want to save it out as a DNG file, or save it as a TIFF and convert it to grayscale. I suggest saving the original camera scan file as a DNG, in case you ever want to go back and readjust the settings or up-size the image.

I have found that the camera scans I make from black and white negatives with my Kodak PRO SLR/N are every bit as good as the scans I make on my Nikon 8000 scanner. I don't ever expect to have to use the scanner again for B&W images.

Figure 9-13. Use the curves in Camera Raw to invert the image. The Crop tool can also be helpful if the image is not lined up right.

"Scanning" color negatives

Camera scans of color negatives are not quite as good as the black and white ones, and definitely not as easy to make. Because the film base has an orange cast, and because color negative film compresses the color information in a pretty extreme way, you can't really get a good color-accurate camera scan quickly. However, you can make a very serviceable proofing image, or For Position Only (FPO) scan, from a color negative.

Figure 9-14. Lucy and me on top of Mount Washington. Scans from color negatives are not quite as good as those from slides, but they're fine for proofing.

In order to get a good baseline color correction for a color negative, I suggest that you make a calibration image, as described earlier. It won't always be prefect, but it will typically work fine for identification and FPO purposes.

Naming film scans

When naming scanned images, we'll encounter the same problems that we faced earlier with digital originals. And we'll add to that a further need: we must be able to *find* the film originals as well. If you have already instituted some kind of numbering system for your film images, I suggest that you simply extend that system to your scans.

In my case, I have a numbering system for my personal black and white images, but I do not have one for my color slides. The black and white negatives live in a set of notebooks, in the sequence in which they were shot. This starts in 1979 with Roll 0001 and goes up through the summer of 2002, when I stopped shooting B&W film entirely. Since there is already an orderly structure, there is no need to reinvent it. The naming system I use for my B&W scans looks like this: *Krogh_BW_0001_1234.DNG*. Here's what the individual elements of the name are for:

- *Krogh* is there to let people know where the image came from.
- *BW* indicates that this is a B&W film original from my notebook.
- *0001* indicates the number of the negative page.
- *1234* is the unique ID number the camera assigned to the file.

Note that I don't feel the need to make the name line up exactly with the frame number. I expect the instances where the camera scan will not be sufficient for the usage at hand to be very rare. In those rare cases, I will be able to find the original very quickly if I am pointed to the negative page, since I mark the images to scan as I am getting them ready (Figure 9-15). Entering the frame number for every image scanned would be overkill for me.

Naming color transparencies

For color slide images, I have adopted the following practice.

I have created a separate filing drawer for images that have been scanned. These images are higher-value images, pretty much by definition.

Images that were scanned previously have kept the names that I had already given to the digital files. This relatively small group of photographs (just a few hundred) has been gathered together into one hanging file folder and labeled *0001*.

Images that have been scanned since I adopted DAM practices get a new naming scheme: *Krogh_Scan_0002_1234.DNG*. Here are the elements:

Figure 9-15. I mark my negative pages to indicate which images I've made camera scans of.

- *Krogh*, as in all my other filenames, points to me.

- *Scan* indicates that this is a color scan.

- *0002* indicates that this transparency lies in folder 0002 of my scanned images.

- *1234* is the unique identifier for this photograph.

Numbering this way enables me to easily find the original film, should I ever need it. How do I decide when to make a new folder? Well, when it feels full. It doesn't really matter all that much. I'll be able to find the image in the folder easily enough, as long as there are no more than a few hundred images in it. The important points are that each filename has a unique frame number, and that it points to the physical location of the transparency.

——— N O T E ———

Making scans of film images is definitely one of those tasks that needs to be done incrementally. I suggest that you only do this work as you have an actual reason to do so.

File Format Migration (RAW to DNG)

As you get comfortable with using the DNG format to archive your new RAW files, you should think about converting your older RAW files to DNG as well. This can be a big project, depending on how many legacy images you have, and it will take some planning.

I expect that some utilities to help automate this procedure will be developed as DNG becomes more universal. Let's take a look at the issues at hand, so that you will be able to evaluate the available solutions when you are ready to make the big switch.

Important Components of the DNG Conversion Process

You need to make sure that the DNG conversion captures all the work you have done adjusting and annotating the files. This includes Camera Raw adjustments, embedded metadata, and private metadata. Camera Raw adjustments and embedded metadata should transfer automatically— indeed, that is currently part of the DNG conversion process performed by both CS2 and the free Adobe DNG Converter.

Saving private metadata

Private metadata is another story. There are a couple of strategies you can pursue to transfer private metadata into your DNGs. One option is to convert this private metadata into embedded metadata before making the conversion to DNG. To accomplish this, you might have to go through all your virtual sets and embed keywords representing the virtual designations. In iView MediaPro, you can automate this process using the Field of Sets AppleScript developed by Daniel Robillard (Figure 9-16).

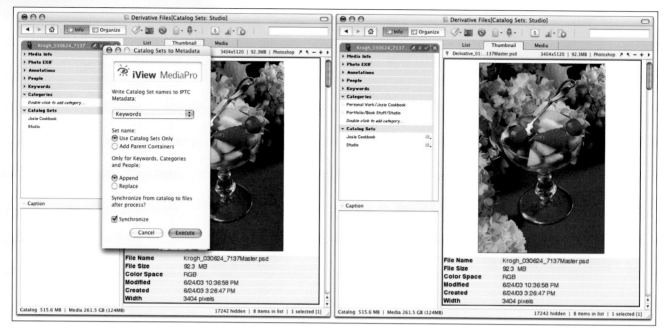

Figure 9-16. The Field of Sets script can transfer private metadata into embedded metadata fields. In this case, I have put it into the Categories field.

You can also investigate the possibility of synchronizing the private metadata *after* the conversion to DNG has taken place. You can already do this in iView MediaPro, thanks to another handy AppleScript called Duplicate Annotations. (This is the same script I mentioned in Chapter 7 as being useful to synchronize metadata from JPEG to RAW files of the same name.) As long as you name your DNG files identically (except for the extension, of course) to the RAW files, this script will transfer over all the private metadata.

Saving the directory structure

The next consideration in the migration to DNG is the directory structure itself. If you would like to keep your information structure constant, you will need to replicate the directory structure for the RAW files with the directory structure for the DNG files. Here is where the free Adobe DNG Converter (Figure 9-17) can be very helpful. You can drop a folder full of images onto it, and it will create a new folder structure that is exactly the same, except that it is populated with DNG files instead of RAW files.

Thinning the archive

Any time you're migrating files is a great opportunity to think about thinning your archive. If you have older shoots with many similar frames, it may make sense to get rid of the lowest-rated items, to streamline the conversion and save drive space.

Figure 9-17. The DNG Converter can replicate the directory structure if you check the "Preserve subfolders" box.

Keeping a parallel structure

When you are making a big change like this—migrating thousands of files from one format to another—you'll want to poke at the new structure for a little while and make sure everything is as it should be before erasing the old structure. It makes sense to keep the old structure around until you are satisfied that you have done a good job of migrating the old files. As you prepare for this migration, you will want to ensure that you have plenty of hard drive space so that you will not have to erase anything before you have been able to confirm the integrity of the conversion process. Make sure to check the DNG converter's log file each time you convert files to make sure everything was done properly.

Does this look too DAM hard?

Some of this no doubt looks like a lot of work—and not just work, but headache-inducing, brain-bending work. Well, to some degree that's true. But that's the price you pay for being an early adopter: you started shooting

digital before all these issues got worked out, and now you're paying the price. At least you won't run into these conversion problems with the work you do from now on (we hope).

I have lots of faith that someone will come up with tools to make this whole migration process easier. Check out this book's web site periodically, and we'll see if we can find something that makes all this less painful.

Here's my synopsis of the work order for DNG conversion of legacy files:

- Test, test, test. Before you attempt to convert your entire collection, run the process you expect to perform on a small group of files to make sure everything works correctly.

- Review the RAW files and make sure that you have embedded any metadata that you want to keep.

- Alternately, make sure that you can synchronize any private metadata from the RAW files to the DNG files after conversion.

- Thin the archive of unneeded frames, if practical.

- Make sure you have enough hard drive capacity to make your conversions without having to erase the originals right away.

- Make the conversions with the DNG Converter, or some other utility that automatically creates a parallel directory structure (see Chapter 6).

Migration from One Storage Medium to Another

Migrating storage media should be a relatively painless process. In general, we will just be copying images from one storage space to another. I'll divide this process into two categories: migrating to a new primary storage device, and migrating to new backup "bucket" sizes.

New Primary Storage Devices

As you outgrow the capacity of your current storage configuration, you will need to add more. You might add additional drives, or you might replace the current drive(s) with bigger one(s).

Adding volumes is pretty simple: just name the new volume with the appropriate sequence number (*Capture_03*, for example) and start building buckets where you left off with the last drive. This can be as simple as plugging in a new FireWire drive, renaming it, and heading off to the races. Review the storage media considerations in Chapter 4 to get more insight into the actual installation process.

Upgrading to a larger drive is also pretty simple: just transfer the files to the new drive and check for file integrity. RAW and DNG files can be checked

by running them through the converter. JPEG files can be checked by recataloging the item with your cataloging software.

New Backup "Bucket" Sizes

Sometime in the future, new "write-once" media will become cost-effective. Currently, it looks as though Blu-ray and HD-DVD are the leading contenders. Once one of these proves itself in the marketplace, and prices drop to an acceptable level, you will want to consider switching.

Because I suggest building your information structure around the size of your backup media, this development will trigger a revision in bucket sizes. We will handle this new protocol in much the same way that we handled folding our legacy digital photographs into our new information structure —implement it for current work, and then bring the legacy work along as time permits.

Once you decide to switch to a new write-once medium, you will want to migrate your old files to the new storage format. You will want to do this for a couple reasons:

- Since we don't know how long any of this media will really last, it's a good idea to put it on new formats as they become available. This will give you an extra level of protection against media degradation and obsolescence.

- Long-term management of your archive will be simpler if everything is in a uniform structure. It's a neater arrangement, and that will make it easier if you need to recover from any problems at a later date.

I suggest you use the following work order:

- Recalculate bucket size and numbering. Start your new bucket numbering high enough to bring all the legacy work on board in a way that preserves the order and information structure you have already created. Since 25 GB represents 5 or 6 DVD-sized buckets (depending on how full you make your buckets), you can start your Blu-ray bucket numbering at your present number divided by 5.

- Combine buckets. As time permits, place the old buckets into the new, larger buckets and re-burn your backup discs with the new structure (see Figure 9-18).

- Confirm cataloging software compatibility. Make sure that your cataloging software can keep track of the legacy material as you move it around. Do a test on this, and see how much work (if any) is involved in pointing the catalog to the new directory.

- Confirm integrity.

- Run backups. Make sure that your primary backup (the hard-drive backup) will reflect the newly consolidated information structure.

Figure 9-18. Your new bucket numbering scheme will depend on how the legacy material fits into the new bucket size.

OS/Software Migration

When you do a major operating system, cataloging software, or imaging software migration, you will have to do some testing to ensure that your legacy work will port easily to the new configuration. The best advice I can give here is to go through the principles and practices outlined at the start of this chapter. Test thoroughly, and keep your parallel structure intact for a while.

A major upgrade of a mission-critical system is a lot like changing a tire at 60 miles an hour. You have to figure out how to keep moving while you are swapping out important components. Having some training wheels at the time can be a big help, and can keep you from incurring costly losses.

Make sure that you give yourself enough time to do the work involved with a major system change. Putting new equipment and software into service can take quite some time, and you may be locked out of your normal workflow during the transition.

Conclusion

Digital photography is a rapidly changing technology. If you've been doing it for a while, you know that in the space of a few years, revolutionary changes have been made in all parts of the workflow. As a matter of fact, about the only constant in the entire process has been Photoshop.

We have finally arrived at a real threshold in the development of the medium. With the tools described in this book, you can now manage your image archive in a comprehensive and integrated manner, ensuring the safety and integrity of your collection.

Even at this moment, however, the tools continue to evolve. I will continue to work hard to push for resources that benefit both the photographer and the photographic image. As these tools become available, I will link to them on my web site, and I will show you how you can integrate them into your workflow.

For the moment, however, the best thing you can do is to use this wonderful hardware and software to create—and distribute—great pictures.

Happy shooting.

Index

About the Author

Peter Krogh is a commercial photographer in the Washington D.C. area. He is an Alpha Tester for Adobe, helping with the development of workflow and asset management tools for Photoshop and Adobe Bridge. He is on the board of directors of ASMP, the American Society of Media Photographers, and speaks frequently on digital asset management to photographers' groups and other computer users.

You can see Peter's photography work on his web site, *www.peterkrogh.com*. You can also view some of his work regarding the promotion of digital standards at *www.digitalphotographystandards.com*.

Colophon

Our look is the result of reader comments, our own experimentation, and feedback from distribution channels. Distinctive covers complement our distinctive approach to technical topics, breathing personality and life into potentially dry subjects.

Darren Kelly was the production editor for *The DAM Book: Digital Asset Management for Photographers*. Rachel Wheeler was the copyeditor. Philip Dangler was the proofreader. Anne Kilgore did the typesetting and page makeup. Claire Cloutier provided quality control. Julie Hawks wrote the index.

Michael Kohnke designed the cover of this book using Adobe Photoshop CS and Adobe InDesign CS, and Karen Montgomery produced the cover layout with Adobe InDesign CS using Linotype Birka and Adobe Myriad Condensed fonts.

Anne Kilgore composed the interior layout using Adobe InDesign CS based on a series design by David Futato. This book was converted from Microsoft Word to InDesign by Andrew Savikas. The text and heading fonts are Linotype Birka and Adobe Myriad Condensed; the sidebar font is Adobe Syntax; and the code font is TheSans Mono Condensed from LucasFont. The illustrations and screenshots that appear in the book were produced by Robert Romano, Jessamyn Read, and Lesley Borash, using Macromedia FreeHand MX and Adobe Photoshop CS.

Better than e-books

Buy *The DAM Book: Digital Asset Management for Photographers* and access the digital edition FREE on Safari for 45 days.

Go to www.oreilly.com/go/safarienabled
and type in coupon code VXM7-WXZL-6ZFU-1IL5-WYR1

Search
thousands of top tech books

Download
whole chapters

Cut and Paste
code examples

Find
answers fast

Search Safari! The premier electronic reference library for programmers and IT professionals.

Related Titles from O'Reilly

Digital Media

Adobe Creative Suite CS2 Workflow

Adobe InDesign CS2 One-on-One

Adobe Encore DVD: In the Studio

Adobe Photoshop CS2 One-on-One

Assembling Panoramic Photos: A Designer's Notebook

Creating Photomontages with Photoshop: A Designer's Notebook

Commercial Photoshop Retouching: In the Studio

The DAM Book: Digital Asset Management for Photographers

Digital Photography: Expert Techniques

Digital Photography Hacks

Digital Photography Pocket Guide, *3rd Edition*

Digital Video Pocket Guide

Digital Video Hacks

DV Filmmaking: From Start to Finish

DVD Studio Pro 3: In the Studio

GarageBand 2: The Missing Manual, *2nd Edition*

Home Theater Hacks

Illustrations with Photoshop: A Designer's Notebook

iMovie HD & iDVD 5: The Missing Manual

iPhoto 5: The Missing Manual, *4th Edition*

iPod & iTunes Hacks

iPod & iTunes: The Missing Manual, *3rd Edition*

iPod Fan Book

iPod Playlists

iPod Shuffle Fan Book

Photo Retouching with Photoshop: A Designer's Notebook

Photoshop Elements 3 for Windows One-on-One

Photoshop Elements 3: The Missing Manual

Photoshop Photo Effects Cookbook

Photoshop Raw

Photoshop Retouching Cookbook for Digital Photographers

Windows Media Hacks

Our books are available at most retail and online bookstores.

To order direct: 1-800-998-9938 • *order@oreilly.com* • *www.oreilly.com*

Online editions of most O'Reilly titles are available by subscription at *safari.oreilly.com*

Keep in touch with O'Reilly

Download examples from our books

To find example files from a book, go to: *www.oreilly.com/catalog* select the book, and follow the "Examples" link.

Register your O'Reilly books

Register your book at *register.oreilly.com* Why register your books? Once you've registered your O'Reilly books you can:

- Win O'Reilly books, T-shirts or discount coupons in our monthly drawing.
- Get special offers available only to registered O'Reilly customers.
- Get catalogs announcing new books (US and UK only).
- Get email notification of new editions of the O'Reilly books you own.

Join our email lists

Sign up to get topic-specific email announcements of new books and conferences, special offers, and O'Reilly Network technology newsletters at:

elists.oreilly.com

It's easy to customize your free elists subscription so you'll get exactly the O'Reilly news you want.

Get the latest news, tips, and tools

www.oreilly.com

- "Top 100 Sites on the Web"—PC Magazine
- CIO Magazine's Web Business 50 Awards

Our web site contains a library of comprehensive product information (including book excerpts and tables of contents), downloadable software, background articles, interviews with technology leaders, links to relevant sites, book cover art, and more.

Work for O'Reilly

Check out our web site for current employment opportunities:

jobs.oreilly.com

Contact us

O'Reilly Media, Inc.
1005 Gravenstein Hwy North
Sebastopol, CA 95472 USA
Tel: 707-827-7000 or 800-998-9938
 (6am to 5pm PST)
Fax: 707-829-0104

Contact us by email

For answers to problems regarding your order or our products:
order@oreilly.com

To request a copy of our latest catalog:
catalog@oreilly.com

For book content technical questions or corrections: **booktech@oreilly.com**

For educational, library, government, and corporate sales: **corporate@oreilly.com**

To submit new book proposals to our editors and product managers:
proposals@oreilly.com

For information about our international distributors or translation queries:
international@oreilly.com

For information about academic use of O'Reilly books:
adoption@oreilly.com
or visit:
academic.oreilly.com

For a list of our distributors outside of North America check out:
international.oreilly.com/distributors.html

Order a book online

www.oreilly.com/order_new

Our books are available at most retail and online bookstores.

To order direct: 1-800-998-9938 • *order@oreilly.com* • *www.oreilly.com*

Online editions of most O'Reilly titles are available by subscription at *safari.oreilly.com*